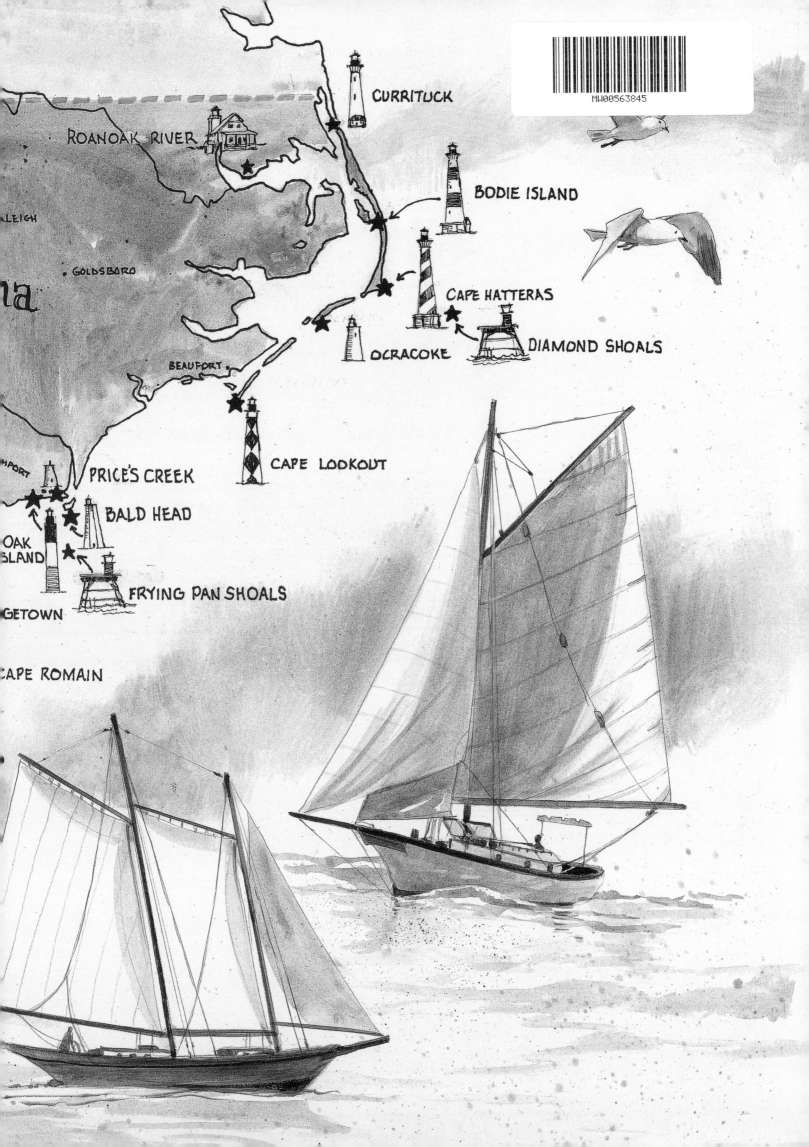

RALEIGH

ROANOAK RIVER

GOLDSBORO

na

BEAUFORT

CURRITUCK

BODIE ISLAND

CAPE HATTERAS

OCRACOKE

DIAMOND SHOALS

CAPE LOOKOUT

PRICE'S CREEK

BALD HEAD

OAK ISLAND

FRYING PAN SHOALS

GETOWN

CAPE ROMAIN

PORT

MW00563845

Bansemer's
Book of
Carolina & Georgia
Lighthouses

Bansemer's
Book of
Carolina & Georgia
Lighthouses

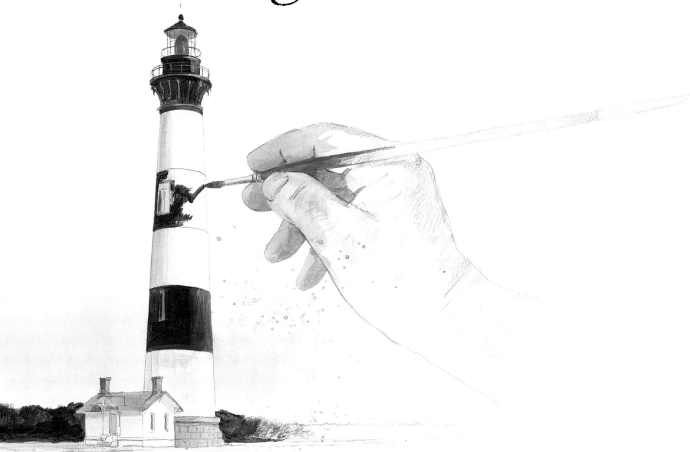

Roger Bansemer

 Pineapple Press, Inc.
Sarasota, Florida

Acknowledgments

Thanks to Anita Massey, Lloyd Childers, Cullen Chambers, Jerry Calhoun, Rob Bolling, the National Park Service, and all the others who generously offered their time to assist me with this project. I especially thank my wife, Sarah, who is my constant inspiration and guide.

Inquiries should be addressed to:

Pineapple Press, Inc.
P.O. Box 3899
Sarasota, Florida 34230
www.pineapplepress.com.

Library of Congress Cataloging in Publication Data

Bansemer, Roger.
 Bansemer's book of Carolina and Georgia lighthouses / Roger Bansemer.— 1st ed.
 p. cm.
 Includes index.
 ISBN 1-56164-194-4 (alk. paper)
 1. Lighthouses—North Carolina. 2. Lighthouses—South Carolina. 3. Lighthouses—Georgia.
4. Lighthouses in art. I. Title.

VK1024.N8 B36 2000
387.1 '55' 0975—dc21 99-053480

First Edition
10 9 8 7 6 5 4 3 2 1

Design by Roger Bansemer
Printed in China

Dedicated to my loving wife, Sarah,
whose spiritual gentleness holds us together,
and to my precious children, Rachael and Lauren.

Contents

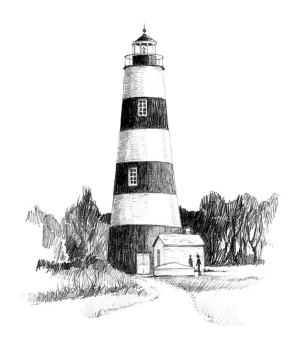

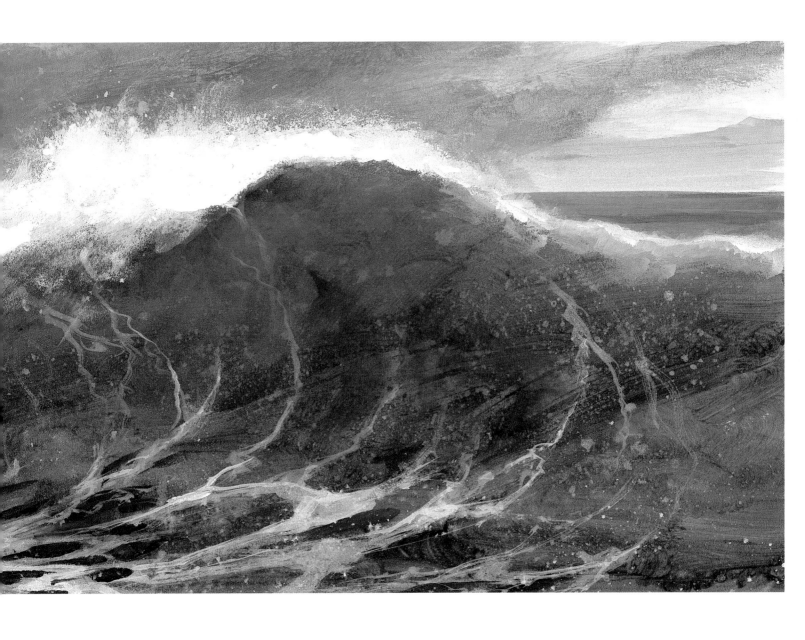

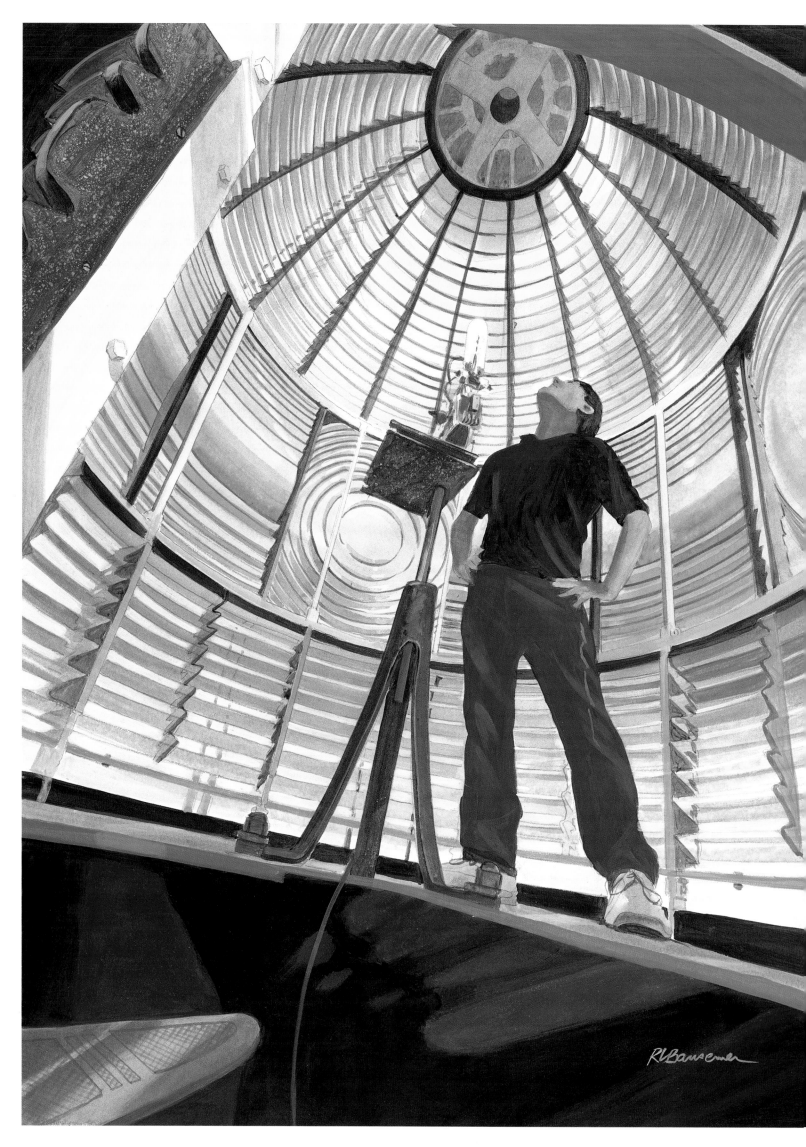

The Lights

The very first lighthouse in the United States was built in Boston Harbor in 1716. At the height of lighthouse construction, over six hundred lighthouses dotted the shores of our country. These structures—which have fascinated us since their creation—have saved the lives of countless sailors, helped establish commerce and trade, and in many ways made our country what it is today. Dedicated men and women spent their entire lives or gave their lives in order to keep the lights burning.

Lighthouses are among the oldest buildings that exist in the United States. Many still function, but many more have fallen because of storms, erosion, and neglect. As I visited each lighthouse, I tried to accurately portray each one as it exists now rather than illustrate it as it might have appeared in the past.

The lighthouse's primary purpose is to be seen far out to sea, so there were a few major considerations for lighthouse builders. Most importantly, a light must be powerful enough and high enough to shine a long distance, particularly through haze and rain. For instance, if a lighthouse is one hundred feet tall, its light can be seen for about seventeen miles out to sea from a small boat before the curvature of the earth cuts off the beam. A large ship with a lookout sixty feet high can see the same lighthouse from twenty-four miles away.

When fog sets in, there is little advantage in having a lighthouse at all. On one of our foggy lighthouse expeditions, we were no more than one hundred yards from a powerful lighthouse in our small boat before we saw the flash. If we had been in a large boat, without a doubt we would have hit the island before we could have stopped. Foghorns were used when conditions like these existed but were more common in the Northern states and Great Lakes.

Standing inside a first-order Fresnel lens

Candles 1700s

The early lighthouses in the United States used candles made from tallow, or beef fat. Although candles were more effective than the wood or coal stoves used previously to provide light, candles were smoky and burned quickly. Some lighthouse keepers used chandeliers to hold many candles, and the addition of a reflector behind the candles improved their intensity. Still, this was not very effective. To give you an idea of how weak these lights must have been, you can read a book if you're one foot from a candle. Move ten feet away, and the light is diminished one hundred times.

Oil Lamps 1790

Improvements were slow in coming and were not very significant. This was called the Spider lamp and replaced candles but made lots of smoke and soot. Its large wicks protruded up from a reservoir of refined oil made from the blubber of a sperm whale. The Boston Harbor Lighthouse was the first in the United States to use it.

Wicks

Argand Lamp 1812

Actually invented in 1781, the Argand lamp was not used by the United States until 1812. Named for the Swiss physicist who invented it, this design used a hollow circular wick. This allowed for more oxygen to pass along the inside and outside of the wick, creating a brighter flame and less soot buildup. One Argand lamp produced the light of seven candles. The development of the glass chimney was a significant improvement because it allowed for controlled ventilation of the flame, which produced a brighter and cleaner-burning light.

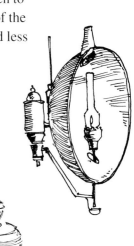

Lewis Lamp 1812

The Lewis lamp was adapted from the Argand lamp and put in use at the same time. It was a sort of chandelier grouping of Argand lamps with reflectors on the back of each lamp and a lens in front. Some of the chandeliers revolved, providing a flashing characteristic. By 1815, all of the lighthouses

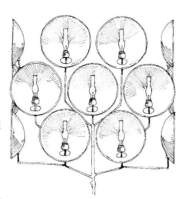

in the United States had been outfitted with Lewis lamps. Unfortunately, they weren't constructed very well: the flimsy reflector soon became misshapened and its silver coating quickly wore off, and, worst of all, the greenish glass bulls-eye lens actually absorbed so much light from the lamps that it dimmed rather than magnified the lamps' intensity. Politics had a lot to do with the Lewis lamp's staying in use as long as it did; some were still being used up until the Civil War. Although there isn't very much reference material available about these lamps, they looked something like this.

Fresnel Lens 1822

Invented in 1822, the Fresnel *(pronounced freh-NEL)* lens was not put into serious use in the United States until 1852. It proved to be the single most important advancement in lighthouse technology and made the Lewis lamp obsolete.

A single Argand lamp in conjunction with the Fresnel lens outshone the chandelier arrangement of multiple lights from the Lewis lamp. An Argand lamp that shone the equivalent of one hundred and fifty candles could, with the aid of a Fresnel lens, magnify that light to over thirty-three thousand candlepower. The Fresnel lens was really the answer to the problem of shining lights far out to sea.

Frenchman Augustin Fresnel perfected the lens that bears his name and to this day remains the standard of excellence in lighthouse lenses. Early in life, Fresnel was frail and ill; he was also a poor student and found it difficult to master even his native language. However, he excelled in geometry and mathematics. His Fresnel lens was so per-

fectly made that today, with all our technology, it cannot be duplicated. The precise formula for the pure and highly polished Fresnel glass was kept secret and unfortunately destroyed in France during World War II. Despite his handicaps, Augustin Fresnel, who died at the age of thirty-nine, is known around the world for his accomplishment.

Fresnel lenses came in several sizes. The first-order Fresnel lens was the largest, weighing several thousand pounds and standing twelve feet high not including the base. It was so large, you could walk inside it. The lenses got consecutively smaller down to the sixth-order lens, which stands only eighteen inches tall. Variations were also developed, such as the huge clamshell lens used at the Hillsboro Inlet and Cape San Blas Lighthouses, and a smaller lens called the third-and-a-half-order lens.

The earliest Fresnel lenses were fixed and didn't rotate. Later, however, it was necessary for the lights to revolve to produce a flash so mariners could distinguish lighthouses from lights in the growing cities. In addition, lighthouses needed different flash characteristics so they wouldn't be confused for one another.

The Fresnel lens was turned by a clockwork mechanism attached to a heavy weight that hung down into the light-house tower below. Every two to four hours, or even more frequently, the mechanism had to be cranked back up in order for the light to keep turning. The principle of the Fresnel lens is used in many items today such as headlights, taillights, traffic lights, and even those flat magnifiers you see on the back of motor homes to give the driver a wide view.

New Lamps 1850s

The Argand lamp saw improvements during this period. New versions used several circular-shaped wicks, one inside the other, making the light much brighter. Many different lamp fuels came into use at this time as whale oil became more expensive and harder to get. Coal and olive, fish, shark, seal, and even porpoise oils were tried but with poor results. Colza oil, made from wild cabbage, was used for a while, and farmers were encouraged to grow the plant, but it didn't catch on. Lard oil was finally adopted as the standard because it was both cheap and efficient.

Kerosene Lamps 1878

A new fuel called mineral oil, commonly known to us as kerosene, was adopted as the best fuel to burn in lighthouse lanterns. It burned brighter and cleaner than any previous fuel.

I.O.V. Lamps 1910

Oil wick lamps that used kerosene started to become obsolete around 1910, when many lighthouses began to switch over to the incandescent oil vapor system, called the I.O.V lamp. This type of lamp still used kerosene but instead of a simple wick, kerosene was forced under pressure into a hot chamber and was vaporized. Then it was driven through small holes where the fuel was ignited. It was very much like today's campers' lantern. A clean, white-hot flame and a light much stronger than anything before it were the result. This innovation also made trimming the wick every couple of hours unnecessary and soot was less of a problem that it had been previously.

Lighthouse keepers still had to clean the lenses even though the lamps burned cleaner. It was part of the keepers' daily chores. To clean the glass, they used spirits of wine—known to us as vinegar, which, by the way, still makes a great glass cleaner if you can stand the smell. As often as once a week, the glass prisms of the Fresnel lens would be buffed with rouge. Since a Fresnel lens was so expensive—costing from five to ten thousand dollars back in the mid 1800s—keepers were required to wear linen aprons to prevent their rough woolen uniforms and metal buttons from scratching the precious lens glass.

Hot and heavy wool doesn't seem to be a very practical material to wear in the South, but it was the common material of the day. It was rugged and long-wearing, and also shed water to some degree, so it provided some protection from the rain. More than that, it was readily available. Soldiers in the Civil War wore it for the same reasons.

Electricity 1920s

Acetylene lights were used for a time and were very reliable for unmanned operation and had such automatic features as a sun valve to turn the light on at dusk and off at dawn. Acetylene gave way to the advent of electricity and the automatic lamp changer, which essentially made lighthouse keepers obsolete. Most automatic lamp changers used two thousand-watt lamps; when one lamp burned out, a spring automatically swiveled the second one into place. By the 1920s and 1930s, most lighthouses had been converted to electricity. The electric light needed little attention since it burned no oil and gave off no smoke to dirty the lens. If a timer was used to turn on the light at night, the keeper's job was reduced to a bare minimum. Only weekly or quarterly visits were then necessary.

Most lighthouses in the United States became automated in the late sixties, and all have been maintained by the United States Coast Guard since 1939. The days of the lighthouse keeper—who had once had such a huge part in establishing commerce in our country—finally became a thing of the past.

Aeromarine Beacons 1960s

Today, rather uninteresting-looking aeromarine beacons have replaced many of the traditional Fresnel lenses. These beacons use the automatic lamp changer and come in a variety of sizes and shapes. Some have a clear glass front and a large polished reflector in back, while others use a thin, plastic Fresnel lens in the front. The intensity of these lights can reach into the millions of candlepower, a far cry from the dim lights of the past.

Lighthouses had a hard time keeping up with the electronic age as well. As early as the 1940s, radio beacons that transmitted a short Morse code signal were placed in lighthouses. Ships equipped with a special radio direction finder could home in on the signal and locate their position.

Global Positioning System 1990s

The massive lighthouse structure, with all its support equipment and personnel, has in many ways been reduced to an inexpensive gadget small enough to fit in the palm of your hand. Developed by the military and known as the Global Positioning System, or GPS, it works by picking up three or four signals from various satellites and gives mariners, drivers of automobiles, and even hikers precise information about their position to within a few yards, as well as their direction, speed, and even altitude. In addition, ships' radar can show rain quite clearly, and weather information is always available over the radio via the National Weather Service.

Even with all these sophisticated and readily available marvels, the mariners I've talked to still find it comforting when they're sailing the seas to see that flashing beacon or tall tower. Hopefully, the lighthouses that still exist will continue to be an aid and comfort not only to mariners, but also to all of us who treasure the beauty and rich heritage of our lighthouses.

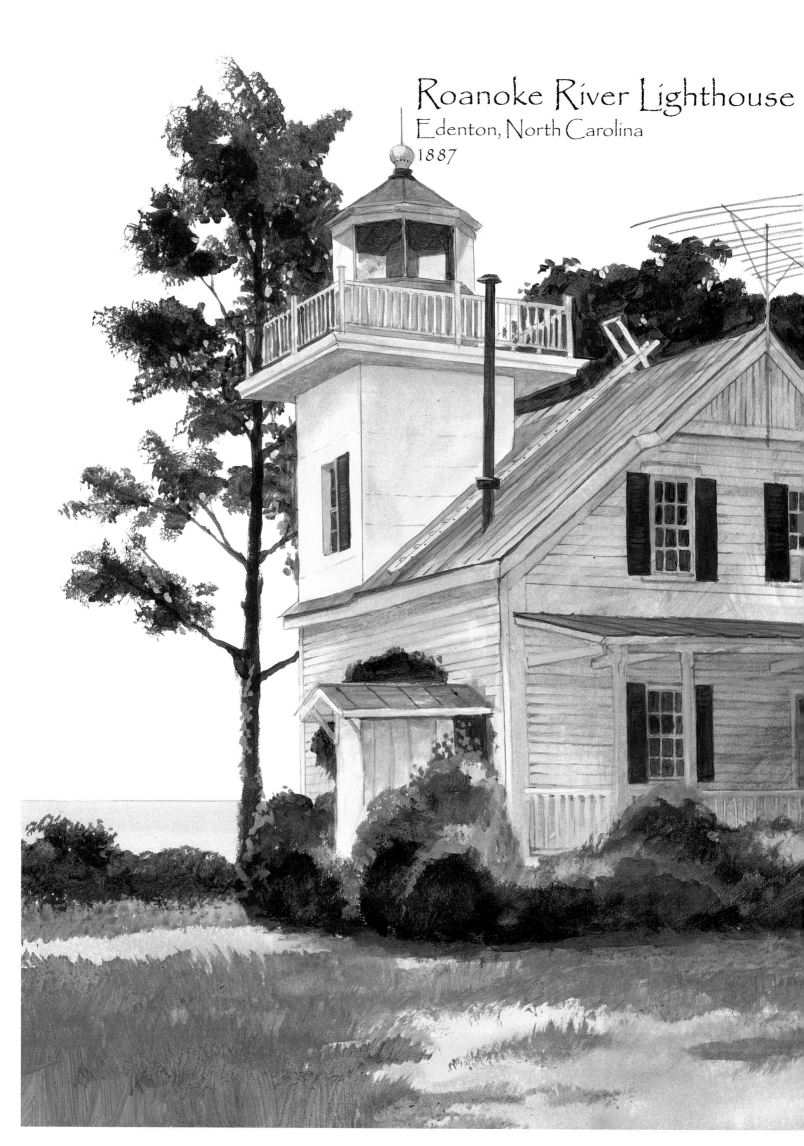

Roanoke River Lighthouse
Edenton, North Carolina
1887

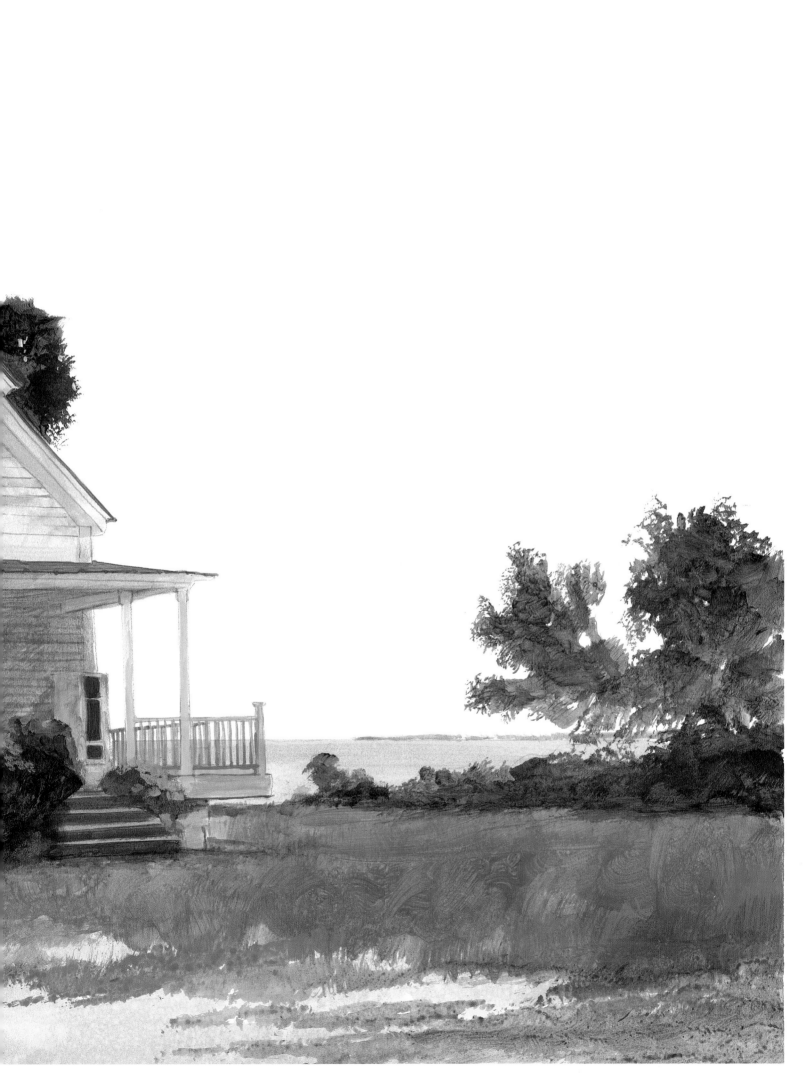

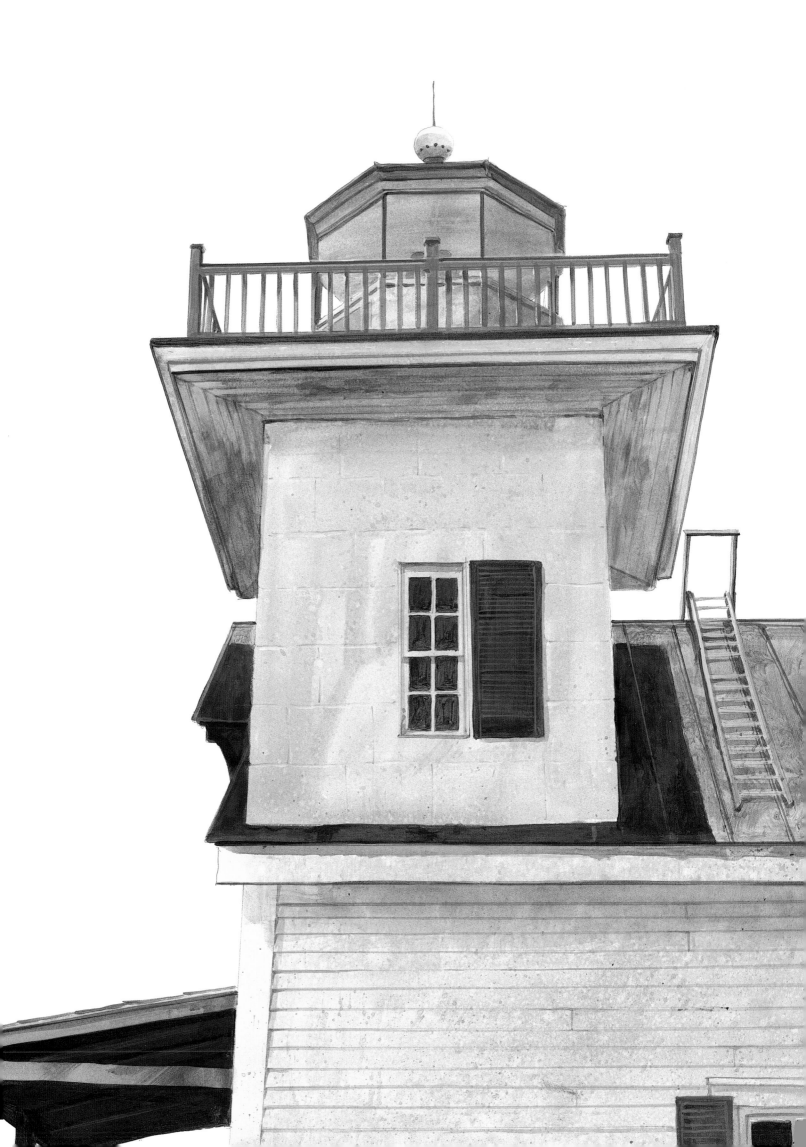

This little-known river lighthouse has escaped the attention of most lighthouse books, but to my eye, it has more character than any other lighthouse in the state.

The lighthouse, built in 1887, was one of three that guided ships up the Roanoke River. Sitting on pilings in the river, these lights outlived their usefulness and were sold in 1955 to Elija Tate, who tried to move two of them by barge. The effort was unsuccessful and they ended up on the bottom of the river. He sold the third one to his friend Emmett Wiggins, who was an eccentric collector and talented salvager by trade. And more than that he was a dreamer, always having big plans that often ended up as half-finished, discarded projects, forgotten as the next dream opportunity arrived, like his idea for an internal combustion engine that ran on water.

Emmett carefully removed enough pilings from under the lighthouse to slip a barge beneath it, and in the summer of 1955, the last of these remaining lighthouses successfully made its way across Edenton Bay and was placed on land owned by Emmett. The whole town turned out to witness the event but not everyone was overjoyed, since Edenton is quite upscale, with a beautiful historic district. Emmett was a pack rat and had a reputation for lengthy court battles that lasted years on end over odd things. He knew that his newly acquired lighthouse might be an eyesore to those who were accustomed to the neat and tidy surroundings, and it caused some contention. The strong-willed and confident Emmett has since passed away, but this gorgeous lighthouse that has so much potential remains almost as it was when it was placed there a half century ago. The present owner now has difficulty getting to his own lighthouse as there are problems with right of way through other property. It sits about twenty feet from the water on Albemarle Sound, and the only legal way for even the owner to get there is by boat. Hopefully it will be worked out and something can be done with the building.

The lighthouse even has a Fresnel lens that sits in the lantern room. It isn't the lens that was originally installed in the lighthouse, but it is a fine specimen and is on permanent loan from the Coast Guard. The original lens was placed in a warehouse in Plymouth but it has long since been missing and is probably gone forever.

The future of this lighthouse is uncertain. As I was doing these paintings, Edenton was showing interest in purchasing the lighthouse and possibly moving it to a location nearer to the downtown area or maybe even reinstalling it on piles in the water as it was originally. A lighthouse with so much personality is certainly worth saving. In addition to making a fine historical attraction, it would also be a great nautical art gallery.

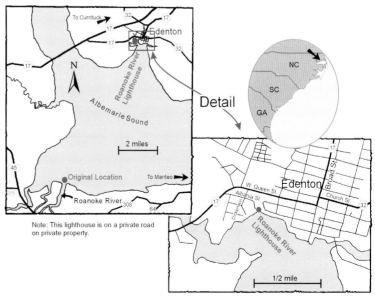

Note: This lighthouse is on a private road on private property.

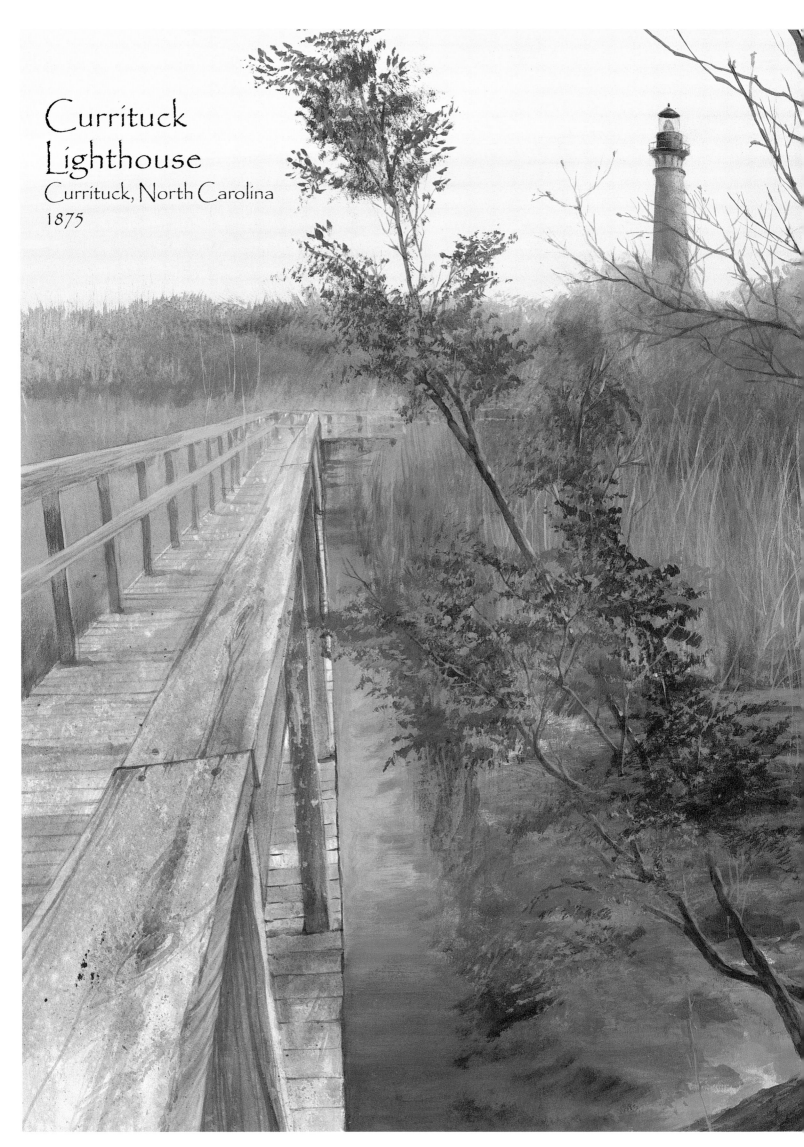

Currituck
Lighthouse
Currituck, North Carolina
1875

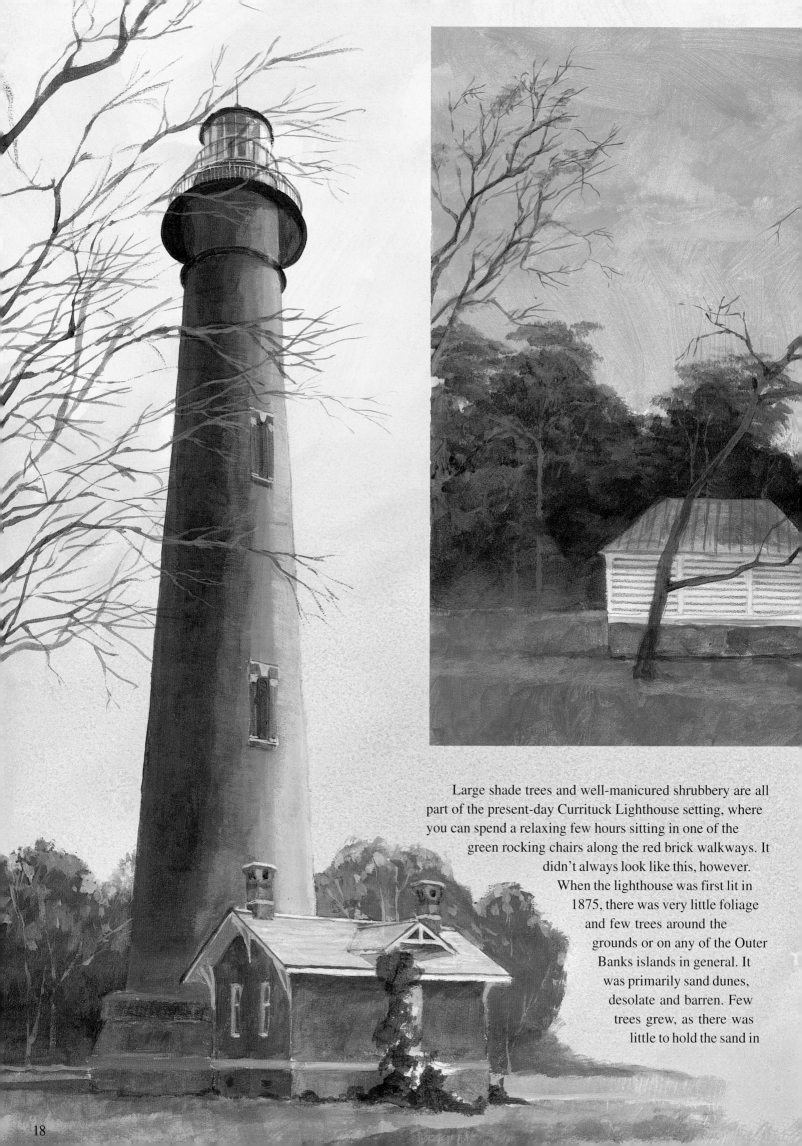

Large shade trees and well-manicured shrubbery are all part of the present-day Currituck Lighthouse setting, where you can spend a relaxing few hours sitting in one of the green rocking chairs along the red brick walkways. It didn't always look like this, however. When the lighthouse was first lit in 1875, there was very little foliage and few trees around the grounds or on any of the Outer Banks islands in general. It was primarily sand dunes, desolate and barren. Few trees grew, as there was little to hold the sand in

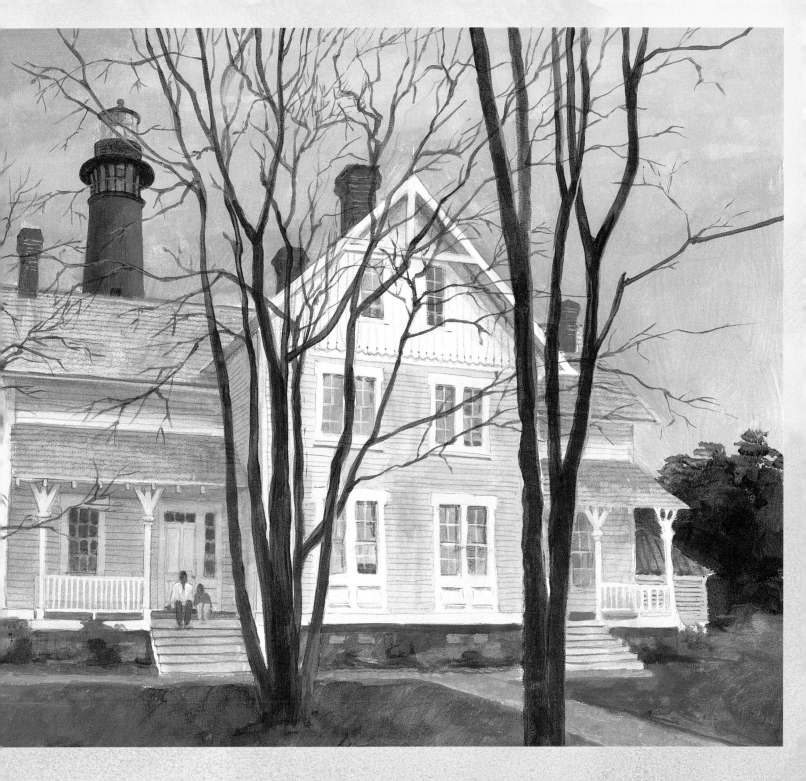

place for vegetation to get a foothold. In the 1930s, the Civilian Conservation Corps, began to haul shipwrecks, which literally covered the beaches, up into the dune line, creating a barrier to prevent erosion. Vegetation was then planted, which began the stabilization of these islands. Today the dunes are covered with large homes, and the area has been built up considerably. The lighthouse is welcome visual relief from all the development.

Building the lighthouse—along with the lighthouses to the south including Bodie Island, Cape Hatteras, and Cape Lookout—was a difficult task. It is very shallow in this area and ships had to offload their supplies, including the million bricks it took to build the lighthouse, onto smaller, shallow draft boats as far as eight miles offshore. These in turn brought the material to the back side of the island, where it was transferred to a long dock and then onto a tramway that led to where construction was taking place. Of the four lighthouses on the Outer Banks, all very similar in design, it was decided that the Currituck Lighthouse be left its natural brick color to help distinguish it from the others, which are all painted with distinctive stripes and bands.

The Victorian stick-style, two-story keepers' house is a duplex, split vertically in the middle, with both sides identical, each side with its own cistern for water. The house was originally constructed from pre-cut materials, each piece labeled and shipped by the U.S. Lighthouse Board on a barge and then assembled onsite. Children were born and schooled here at the lighthouse, but when the lighthouse was automated in 1939 it eliminated the need for a keeper, and the house began to deteriorate almost beyond repair. Doors and windows were broken or missing, and the porches had fallen in. Vines covered the outside and parts of the inside as well.

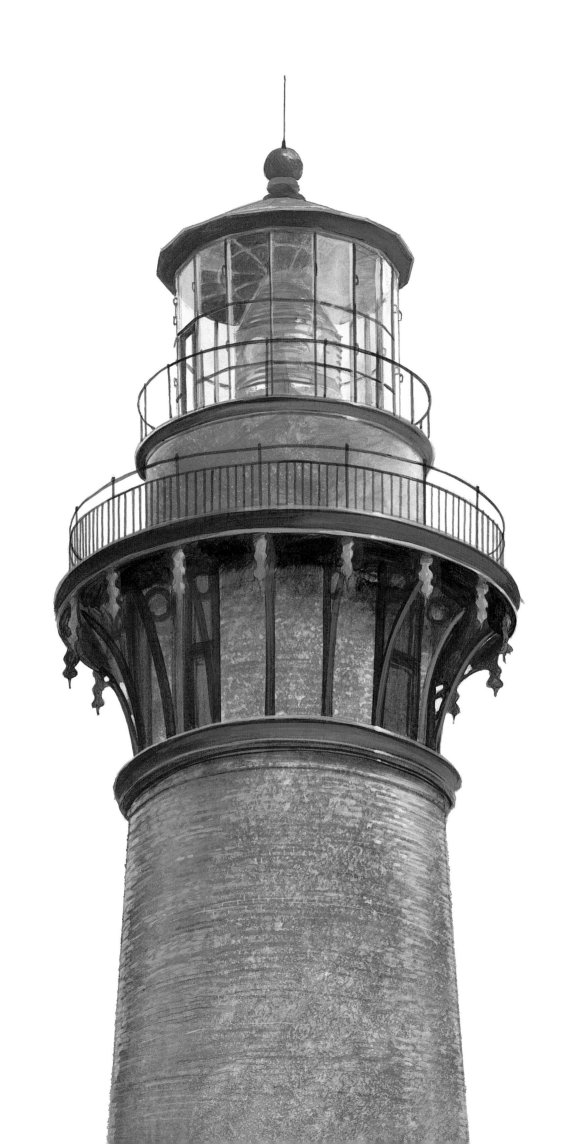

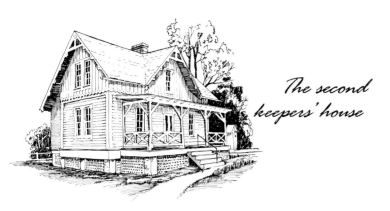

The second keepers' house

In 1980, the Outer Banks Conservationists, Inc., began restoring what was left of the keepers' house. Today it is beautifully restored—complete with period furnishings, but used only on special occasions—and you never would guess that it was once about to fall down entirely. Thanks to these conservationists, the rest of us are able to enjoy these wonderful treasures from the past. They have done a remarkable job, and even though originally pre-fabricated, the keepers' house imparts a sense of how beautifully things were made and the caring way they were constructed. I think it must have gone along with values in general back when this lighthouse was the most important structure on the beach.

A second and smaller keeper's house also sits near the keepers' house. It was moved to the island around 1920 as a residence for a third keeper and his family. That too has been restored and serves as a museum shop. Best of all, you can climb the 214 steps to the top of the 162-foot-tall lighthouse and be rewarded with a grand view of the island. Climbers are restricted from the gallery only during bad weather or high winds. The lighthouse is open to the public every day from Easter through Thanksgiving. During the height of the summer season, almost a thousand people a day visit the light and beautifully kept grounds. A nearby boardwalk from the lighthouse leading down to the inland side of the island offers a distant view of the tower and a chance to view nature at its quietest moments.

You can't talk about the Outer Banks without mentioning the wild Spanish mustangs. Thought to have come ashore from the wrecks of galleons some four hundred years ago, these horses once roamed freely along the shores. In 1926, there were an estimated six thousand horses on the Outer Banks. In recent years, however, roads have been extended through Corolla, opening the northern Outer Banks to unprecedented development. Unfortunately, the horses were being struck and killed by automobiles, so many were relocated. Today there are only about fifty horses remaining. With the exception of a stray horse here and there, the very northern end of the beach is the only place to see these marvelous Corolla horses, which are distinct from other wild horses on the Outer Banks. This twelve-mile, relatively undeveloped

section of beach covering fifteen thousand acres has been fenced in for their protection.

Not far south of the lighthouse at Corolla is Kitty Hawk, where the Wright Brothers first took to the air. The lighthouse played a small but significant part in the history of early flight. It happened when the wife of lighthouse keeper W. J. Tate received a letter from Wilbur Wright asking for a report on the lay of the land in regard to hills around nearby Kitty Hawk and information about weather conditions in that

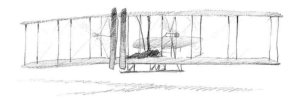

area. She replied with a full accounting, and several months later Wilbur arrived by boat followed by brother Orville. The Tates hosted them and during this time the obliging lighthouse keeper and his wife lent their moral support to the Wrights despite ridicule of their project from most others. They also gave them a place to construct one of their experimental gliders and helped sew the fabric for the wings. Friends from the start, they remained so throughout their lives.

Orville and Wilbur Wright flipped a coin to see who would test out their aircraft made of wood and fabric, and Orville won the toss. December 17, 1903, went down in history as Orville flew for 12 seconds and 120 feet for man's first successful powered flight at nearby Kill Devil Hills. The brothers subsequently made over a thousand flights from the high dunes. A memorial to the Wrights and their achievements at Kill Devil Hills is open to the public.

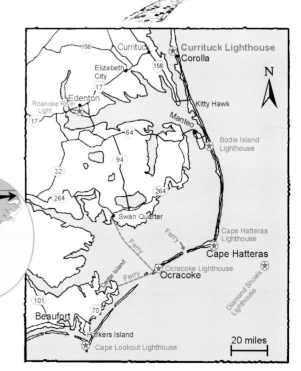

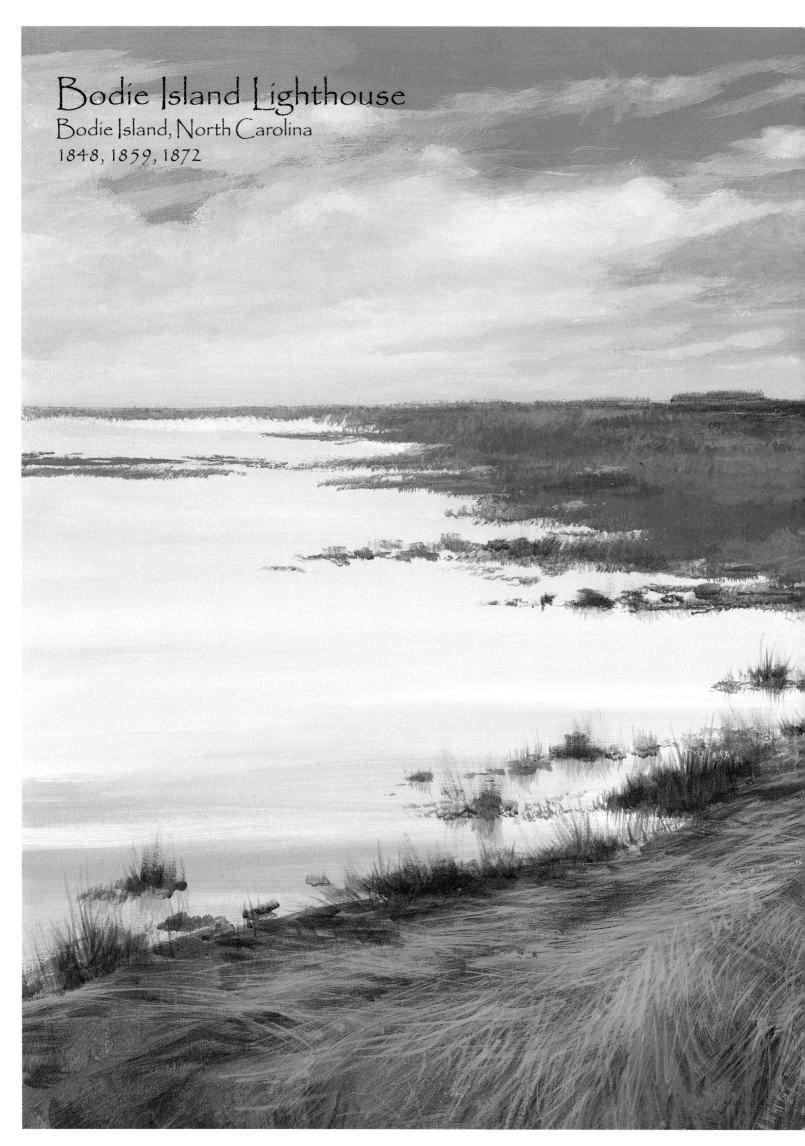

Bodie Island Lighthouse
Bodie Island, North Carolina
1848, 1859, 1872

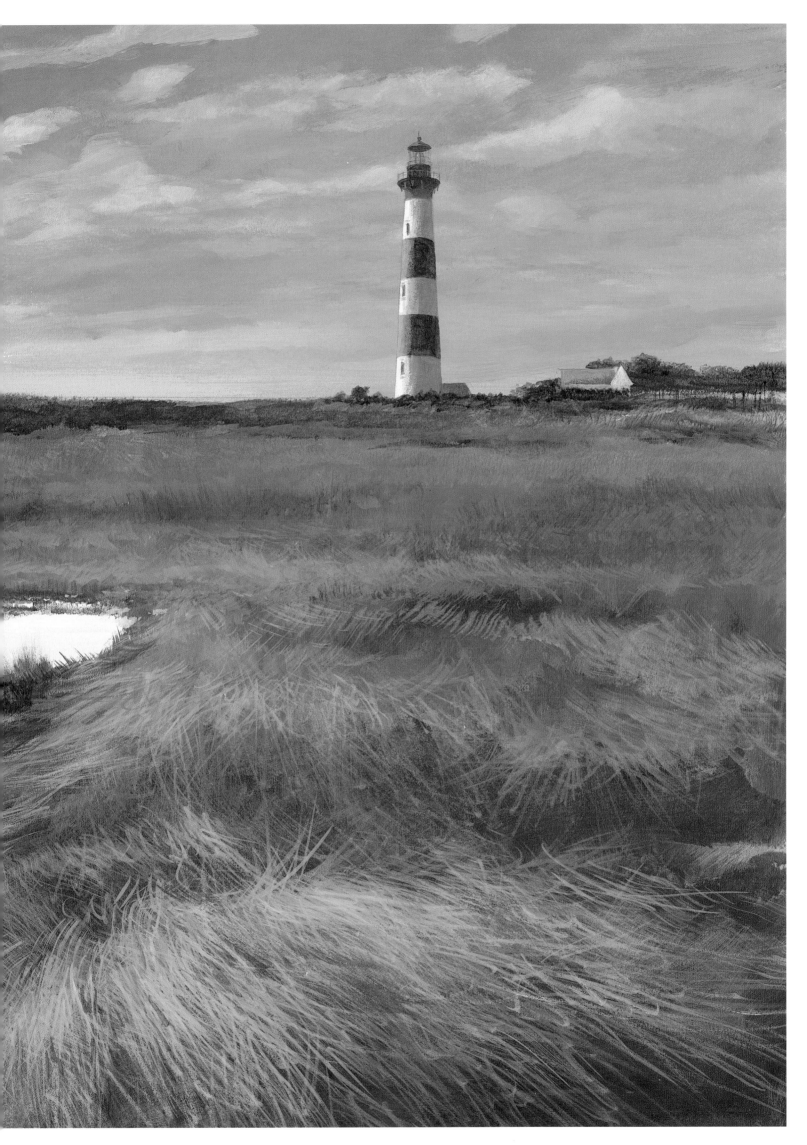

Many ships were lost off the coast in this area, more in fact than in any other area along the Outer Banks. Ships heading south tried to hug the coast as best they could to take advantage of the inshore current and to avoid getting into the Gulf Stream, so the lighthouse at Bodie (pronounced "body") Island was necessary. It allowed mariners to stay on course and away from the dangerous shoals.

Two other lighthouses were built near here before this one. The first one, built, in an effort to save money, on a poor foundation of mud and only a few layers of brick to support the tower, was lit in 1848. The lighthouse was already leaning one foot out of plumb just two years later. A second lighthouse was constructed in 1859 but it didn't last long either: two years after it was built, the Confederates blew it up.

The third and present lighthouse was finished in 1872, just a year after the Cape Hatteras Lighthouse was lit. Leftover supplies and materials from Hatteras helped out in the building of the Bodie Island light. These included leftover bricks, the shallow draft boats used to haul materials near shore, the tram railway used to transport materials from the pier to the lighthouse, and even the storage houses, which were moved and used in the new project.

This is a sturdy lighthouse with a solid foundation. It has to be when you consider the immense weight of this 150-foot-tall lighthouse, with its five-foot-thick, solid brick walls and the huge granite blocks making up the base. Building a foundation for such a heavy structure posed a challenge. The sandy island would appear to make a poor foundation to build on—and generally speaking it is—but the sand at a depth of a few feet is damp and very dense. Also, since certain types of wood will not rot if submerged in water, a hole was dug seven feet below the water level, where several courses of six-by-twelve yellow pine timbers were placed crossways to each other, forming a flat base. Then large blocks of granite were cemented together on top of the wood to produce the base for the tower. The hole had to be pumped out to keep from filling with water while the work was being done, but after all was completed, the pumps were turned off and water was allowed to seep back in, covering the pine timbers. Upon completion, the lighthouse was fitted with a first-order lens that crowned the 156-foot-tall tower.

Only a month after the light was in operation, a flock of geese flew into the lantern and damaged the lens. Geese can have wingspans of forty-eight inches and can weigh up to twenty-four pounds, so it's no wonder they can do a lot of damage. It was a problem many lighthouses encountered, so

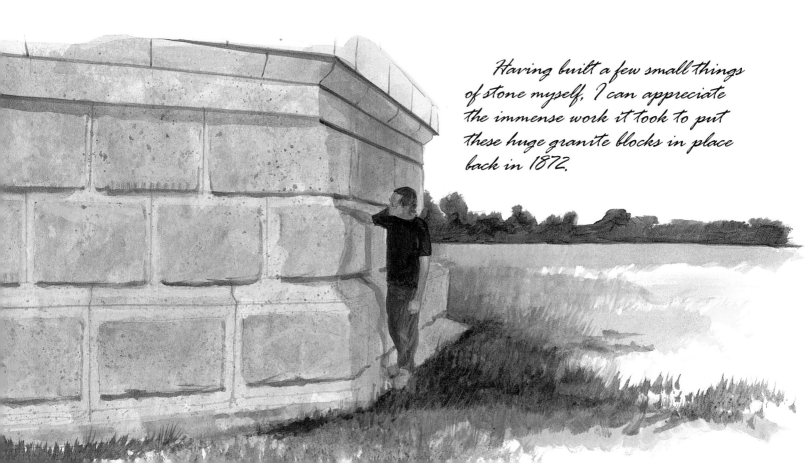

Having built a few small things of stone myself, I can appreciate the immense work it took to put these huge granite blocks in place back in 1872.

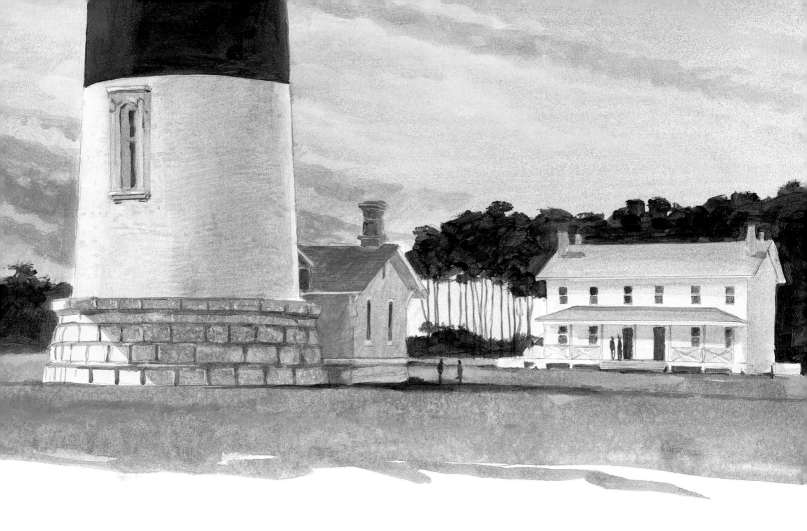

Surrounded by nothing but dunes and marshes, this lighthouse still gives its visitors a sense of remoteness.

striking appearance from any angle. The large white keepers' house was divided in the middle to accommodate separate living spaces for both the keeper's and assistant keeper's families. Now one side is used as a book store and the other for lighthouse exhibits. The old keeper's house is open to the public, but the lighthouse itself is not.

Just to the north is the Wright Brothers Memorial at Kill Devil Hills, where the historical flight of Orville and Wilbur took place on December 17, 1903.

screens were often constructed to protect the glass. This didn't help the birds any, but it did keep the lantern room safe. On some mornings lighthouse keepers or their children would often have to shovel up buckets of the birds, some of which would end up on the dinner table that night.

The Bodie Island location was important to shipping, as it was the only light at the time between Cape Henry and Cape Hatteras. The lighthouse is set back from the Atlantic Ocean behind the beach and dunes. A lawn around the lighthouse makes a handsome contrast to the marshlands and gives the structure a

A cistern at each end of the keepers' house served each family.

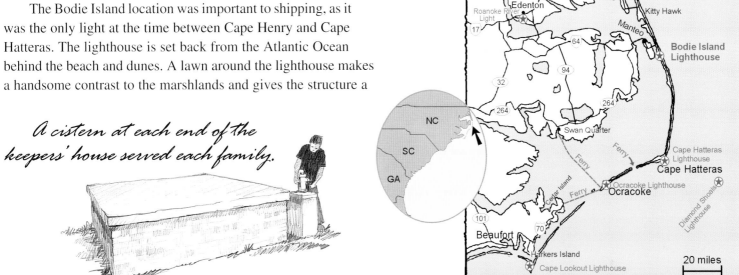

Oregon Inlet Life Saving Station

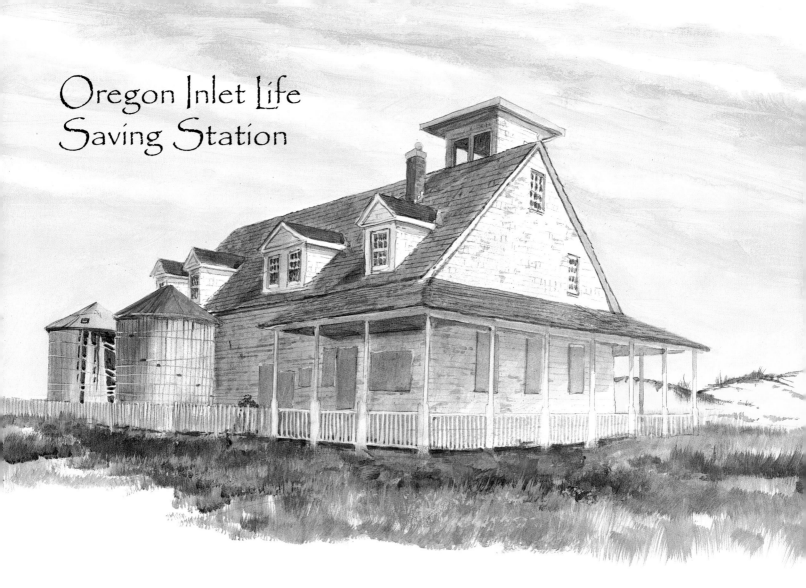

Lighthouse keepers didn't have the comfortable life that most of us are accustomed to today. Their surroundings were remote and luxuries sparse. Even with these hardships, they tended their lights in the safety of the lighthouse itself when storms raged. Some lighthouse keepers did act as lifesavers at times but more often than not the lighthouse keeper was puffing on his cigar when the night outside was rough.

For the men who were a part of the U.S. Life Saving Service, it was a different story altogether. They rowed out in small boats through treacherous seas to the rescue of ships in distress and risked their own lives in the process. Where it was the lighthouse keeper's job to be reliable, it was the life saver's job to be courageous.

During the day, life savers maintained a lookout from atop the life saving station, and at night they patrolled the beaches on foot between stations. One man from each station would walk the beach with lantern in hand, looking seaward for ships in distress. After several miles, the two men would meet at the halfway point. The two would exchange a tag to prove they had hiked the distance and would return to base, then another patrol would begin the trek again. Sometimes the grizzly discovery of bodies washed ashore awaited them. You have to remember that there were thousands of ships that wrecked along these shores.

The U.S. Life Saving Service was established in the late 1870s and lasted until 1915. At that time there were other agencies in place that helped govern the seas: the Lighthouse Service, the Steamboat Inspection Service, the Bureau of Navigation, and the Revenue Cutter Service (whose job it was to patrol the coast and stop smuggling). All these agencies were finally united into one organization, the U.S. Coast Guard.

The Life Saving Service was the sister service to the lighthouses themselves but has largely been forgotten by the general public even though there are organizations that help preserve and promote its historical significance. Light stations just don't share the visual and romantic appeal of lighthouses. They were, however, a huge part of the maritime landscape. Light stations, like this one at Oregon Inlet, dotted the coastline about every seven miles along the Outer Banks. By 1883, twenty-five life saving stations were located on the Outer Banks.

The buildings varied somewhat but all had a similar architectural style. Many of the life saving stations still exist, but none function any longer as they originally did. Some have been converted to houses or restaurants or are still used by the government for other purposes. Some are in good repair, others in disrepair or destroyed throughout the years by storms or fires. The most notable example still remaining on the Outer Banks is the Chicamacomico Life Saving

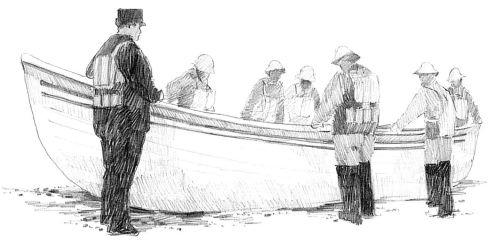

Station located on Highway 12 in Doranthe Village on the north end of Hatteras Island. This life saving station is nicely restored, and a life saving drill is conducted weekly for visitors to observe.

Most of the boats used by the Life Saving Service were called surfboats. They were between twenty and twenty-seven feet long, had a shallow draft, and were light enough to be dragged from the life saving station down to the beach and into the surf. Sometimes they were put on carts that helped get them through the sand and down to the shore. The boats were kept inside the station in a separate room that had large boathouse doors that opened toward the beach.

Another type of boat, simply called the lifeboat, weighed between seven hundred and a thousand pounds and held twelve to eighteen men. These sturdy boats were rowed out through mountainous seas, with the basic model no more than about thirty feet long. It had air chambers in the bow and stern and a heavy iron keel that helped right the boat should it get overturned. These boats were not used as much as the surfboats, however, except around the Great Lakes and on the West Coast because of their weight.

At the very end of the Life Saving Service, most boats were equipped with small engines of about twelve horse-power, not much power against heavy seas. But during most of the Service's existence, all that these men had were oars.

Safety gear as we know it today didn't exist then. Canvas life vests filled with blocks of cork were about the extent of it. There were no helmets for the men's heads, just yellow rain hats to keep some water off. The high boots they wore could quickly fill with water, making it even more hazardous than not having them at all. These guys were out there with nothing more than bravery when trying to save others' lives.

During the time the Life Saving Service was in operation, about 275 ships were wrecked along the Outer Banks.

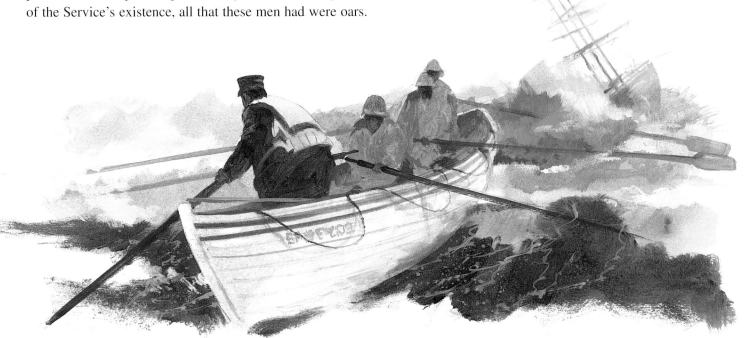

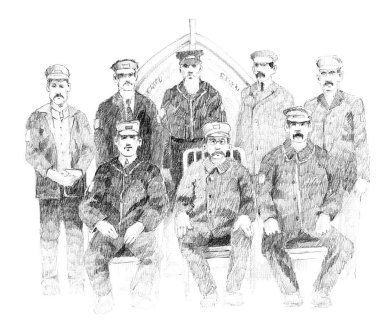

Amidst surf as high as twenty feet, they would come to the aid of frantic sailors, who would often make the rescues themselves more dangerous than the elements.

In the very early days of the Life Saving Service, drills to sharpen the skills of the men were not practiced regularly, but later they became an important part of the schedule. Weekly practice became a popular show for the public as the surfmen launched and intentionally capsized their boats, then tried to right the boats in about twenty seconds. They displayed their skills and were the feature attraction at many public events, such as Fourth of July celebrations.

Boat rescues were the least complicated but most dangerous type of rescue, so other types of equipment, known as beach apparatus, were used in addition to the boats. If a ship wrecked close to shore and the surf was extremely rough, a small line was projected to the ship in distress in order to establish a lifeline. Several methods were used, including arrows and even kites, as silly as that sounds, but eventually a device called the Lyle gun was developed. Looking like a miniature cannon, it could throw a small line to a ship as far as eighteen hundred feet away. To that line, a heavier line was attached and hauled out to carry the weight of a person or a life car.

A "breeches buoy" was typically used to haul sailors back to shore after a line was shot to the distressed ship. It was basically a round life ring with canvas pants attached. It had the advantage of being light but could handle only one person at a time. The life car, which looked like a short submarine, had room for about a half dozen people inside but was very awkward,

heavy, and pretty scary. Once the hatch was closed, it could be hauled to shore through the surf or even underwater but had enough air inside for only a few minutes.

All these practices seem quite crude to us now, but they were the best thing available at the time. The methods and, above all, the heroism of the U.S. Life Saving Service were responsible for saving many lives that otherwise would have been lost at sea along this treacherous area of coastline.

The breeches buoy

The life car

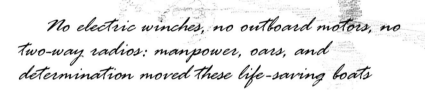

No electric winches, no outboard motors, no two-way radios: manpower, oars, and determination moved these life-saving boats

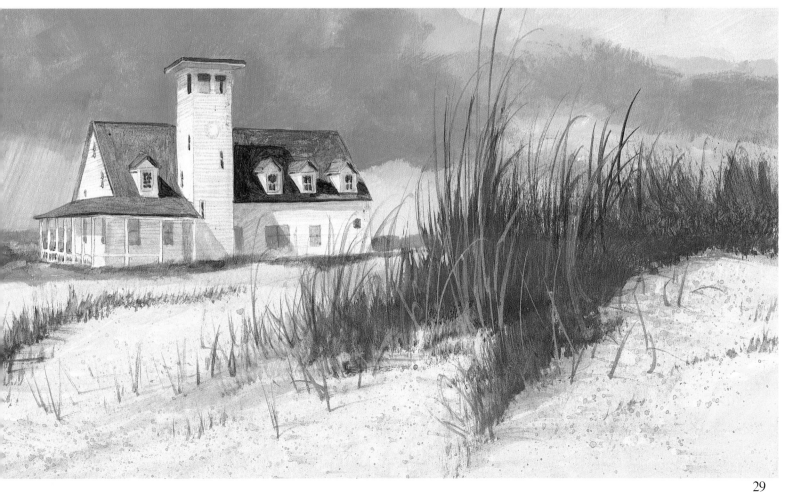

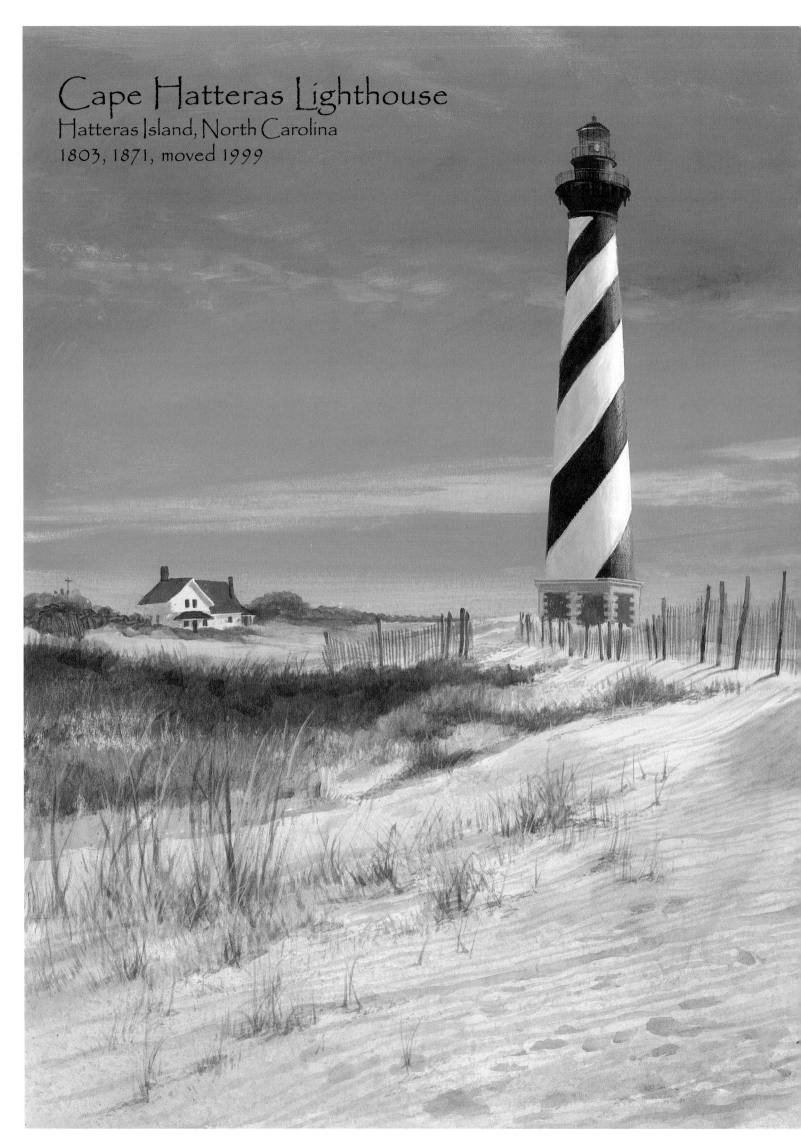

Cape Hatteras Lighthouse
Hatteras Island, North Carolina
1803, 1871, moved 1999

In 1803, the first Cape Hatteras Lighthouse was completed. It stood ninety feet high and had a bad reputation. Many mariners complained that they never even saw it when passing the area. Others ran aground just looking for it. The years to follow saw complaints about the light being lit only a few hours each night or not being lit at all. Accusations were cast about that the lighthouse keeper would intentionally let ships run aground and would share in the spoils of the wrecks as salvage, but no evidence of that really existed. Chances are that the Lewis lamps, used before the Fresnel lens was adopted, were just insufficient and didn't work very well. Nevertheless, the keeper should have kept a better eye on them, and eventually he was replaced. He wasn't the only thing replaced. By 1854, the lantern room was removed, the lighthouse was raised to a height of one hundred fifty feet, and a new first-order Fresnel lens was installed. It finally gave a satisfactory light that could be seen far out to sea.

After the Civil War, there was concern that the wooden staircase in the lighthouse presented a fire hazard. When the government got an estimate of $20,000 to replace the stairs with iron ones, it was decided to build a new lighthouse for a cost of $75,000 rather than repair the old one. But that estimate ended up being $150,000 when the lighthouse was finally completed.

That decision gave us the most famous of all the lighthouses in the South. The Cape Hatteras light we see today towers skyward two hundred feet from its base, the tallest lighthouse and once the tallest brick structure in the entire United States. It is a magnificent sight as you approach it, either from sea or from land. For me, the spiral stripes make the ultimate classic design. This lighthouse and the one at St. Augustine, Florida, are identical in design. The only differences between the two are that St. Augustine is shorter by thirty-two feet and has a red lantern room on top instead of black. The lighthouse was built with a double wall, meaning there is a space between the inner and outer walls. This design accomplished several things. First of all, it used fewer bricks and so cost less to build than if it were solid. Secondly, the weight of the tower was decreased, and the foundation was constructed on ground that might not otherwise support a heavier structure. The space between the walls also acts as insulation to keep the air cooler in the summer and warmer in winter.

The heritage that this lighthouse has left us has touched the imagination of many, both young and old. I had never visited this area of coastline until I began this book, but even as a small boy, the name Cape Hatteras conjured up thoughts and images of shipwrecks and the sea. These boyhood daydreams of adventure were a reality to the many ships that have passed its shores and a nightmare for over two thousand ships that ran aground and were wrecked since the 1500s along what has become known as the "Graveyard of the Atlantic." At one time wrecks practically littered the

beaches along the coast. Ships were always in trouble around this part of the coast because Diamond Shoals, about ten miles offshore from Cape Hatteras, was shallow with sand bars. In order to get around the shoals, ships either had to go outside them or hug the coast and sail between the shoals and the Cape. Ships sailed the narrow passage to avoid the Gulf Stream, which flows north. Sailing on the outside of the shoals would slow sailing ships to a crawl or even make it impossible to make headway through the current. Inside the shoals, currents didn't have the forcible pull north, but they were unpredictable and often the seas

I always thought that one black band spiraled around the lighthouse. Actually there are two black bands.

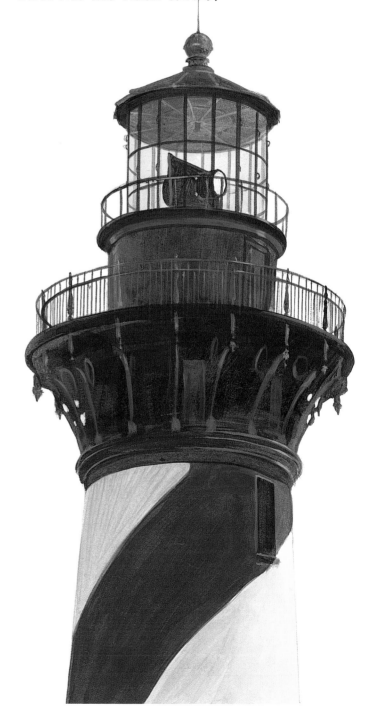

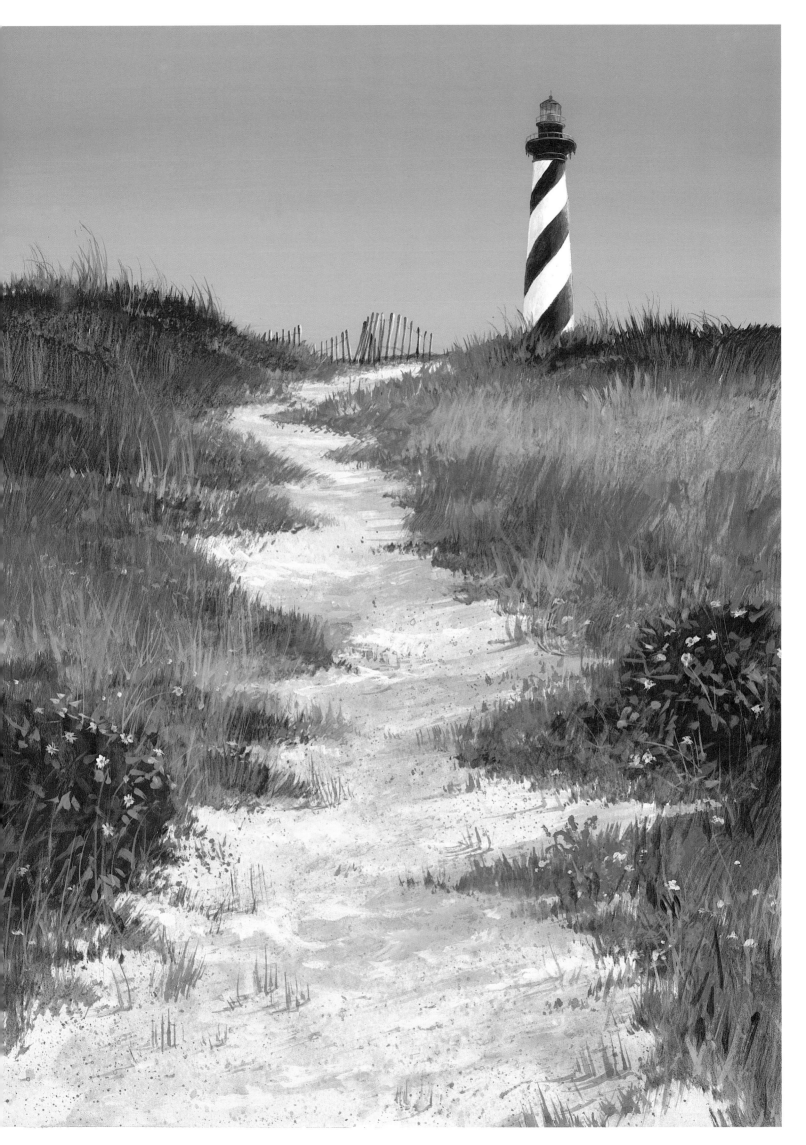

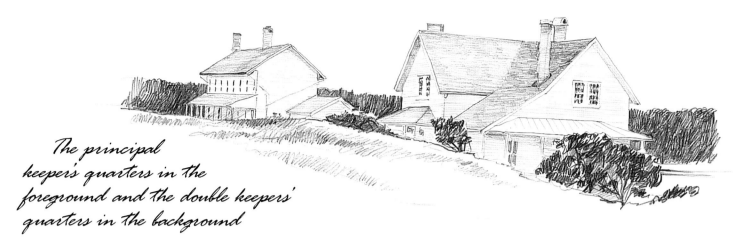

*The principal
keeper's quarters in the
foreground and the double keepers'
quarters in the background*

were very rough. It was not a good situation either way. A powerful, tall lighthouse that could be seen from about twenty miles out at sea was necessary for sailors if they were to navigate a passage through this area with any degree of safety.

Construction began on the present lighthouse just six hundred feet from where the first lighthouse was. It took a year and a half to build, and in 1868 it was completed but not

I did these paintings shortly before the lighthouse was moved.

without monumental hard labor. It's difficult to imagine how this huge structure was built on such an isolated spot over a century ago. There were no roads into the area and no trucks or cars either at that time. Steam power and brute manual labor got things done. Everything had to be constructed especially for this job, including places for the workmen to stay. Just having to transport the approximately one thousand granite blocks used to make up the base, ranging in weight from five hundred pounds to six tons each, was an immense task.

Small steamers or sailing vessels were used to bring all the materials into the sound on the back side of the Cape.

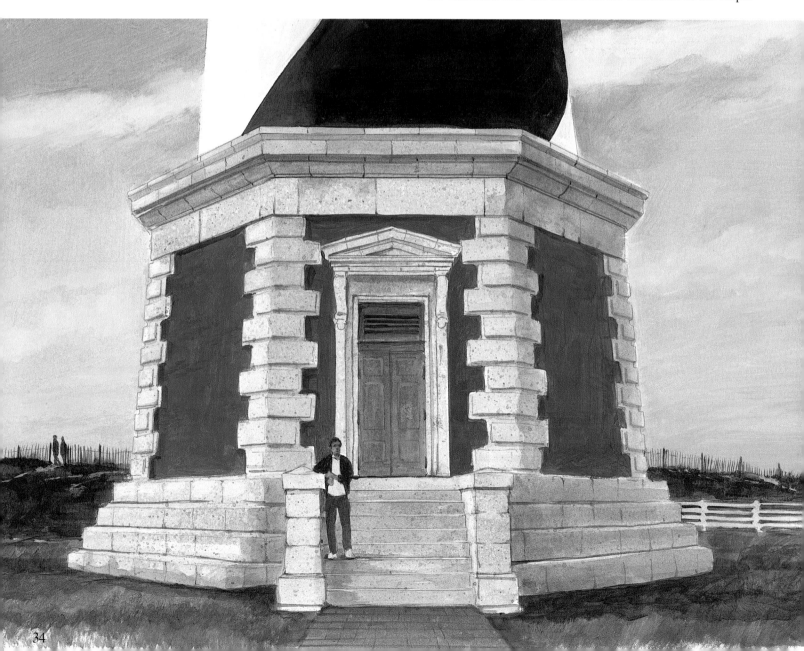

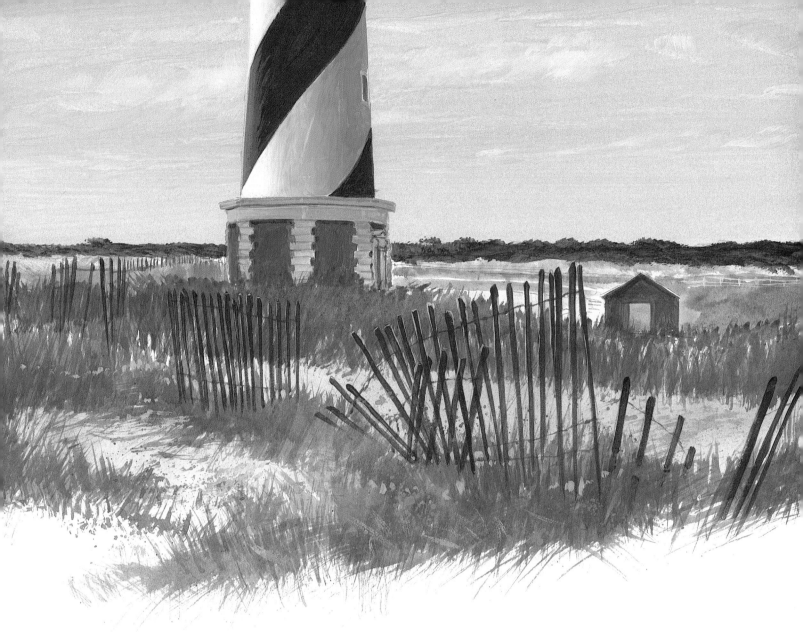

Difficulties started before the materials even got to the lighthouse, and several ships were wrecked in gales within view of the construction site, resulting in a loss of over 150,000 bricks (bricks back then cost just over a penny each). The bricks that made up the tower—all 1,250,000 of them—had to be transferred from the ships to specially built, shallow draft boats called "lighters." Even these shallow draft boats could not get in close enough to offload the material, so a long pier had to be built. One of the boats capsized and lost its load of cut granite that was to be used in the base of the lighthouse. The struggles continued even after the materials reached the island. The wharf and loading dock were over a mile from where the lighthouse was being built, and that distance consisted of soft sand and a marsh-land of thick, soft muck. To overcome the obstacle, a tram railway was built to carry the materials on the last leg of their journey. The loads were dragged along this track by oxen or other work animals.

On December 16, 1870, all work had been completed and the new lighthouse became operational. It stands, even today, as one of the best examples of lighthouses ever built. The old lighthouse, not needed any longer, was destroyed when three mines were placed at its base. The explosion blew out a large wedge at the base of the lighthouse, and seconds later it fell into ruin on the beach.

The lighthouse was moved in 1999 because of beach erosion. Today approximately one million people visit the lighthouse each year, and a quarter of those climb the two hundred sixty-eight steps to the top of this most famous light.

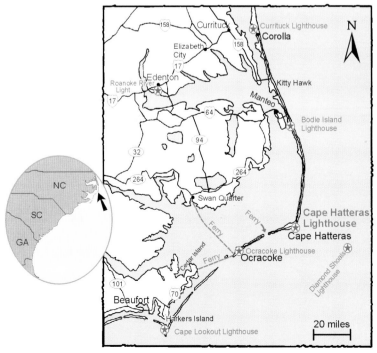

The Cape Hatteras Move

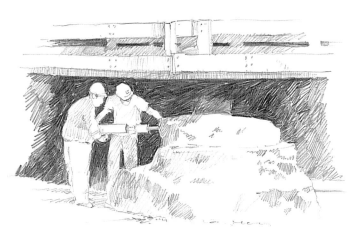

Removing the original foundation

Cape Hatteras Lighthouse was in danger because of sea erosion for many years. Originally it was eighteen hundred feet from the ocean, but when work began to move the lighthouse in 1999, it was less than one hundred feet from the water's edge. Large nylon bags filled with sand and concrete, plus three steel-pile groins extending out into the water, had been placed there to help keep the light safe, but there is no stopping erosion to barrier islands like these. The islands actually move from front to back. It's called "island migration" or "island rollover." As land is lost on one side of the

island, it is usually gained on the other side. Moving the Cape Hatteras Lighthouse seemed the best solution. After lots of debate and controversy, it was moved to its present location about 2,900 feet from where it once stood, but it's still only 1,600 feet from the Atlantic Ocean. The keepers' houses, cisterns, and oil house were moved first. Even the bricks in the walkways were numbered and replaced in their original configuration.

What seems to me to be a monumental job was, according to the people from the International Chimney Corporation who moved it, "a very simple process." Lifting

The specially prepared roadbed

a 4,400-ton lighthouse still seems to me a miraculous undertaking, especially when I have trouble moving a half-filled wheelbarrow from one side of my yard to the other.

The lighthouse move was accomplished by first installing sensors on the tower from top to bottom. These sensors monitored even the slightest perpendicular movement of the tower down to a fraction of an inch. The signals from the sensors were relayed to receivers worn not only by the movers but also by the engineers working on the project in Buffalo, New York.

The granite steps were removed, then the foundation under the lighthouse was excavated a piece at a time so that a hydraulic lifting system could be fitted underneath and slowly raise the structure. Large steel beams were then slid

The tower after it had been lifted from its foundation and set on beams

The oil house

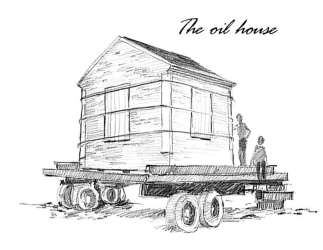

The double keepers' quarters raised and on wheels, ready to be moved to its new location

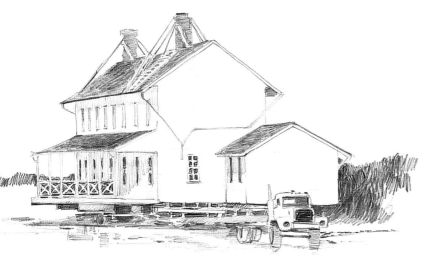

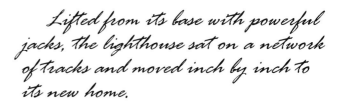

Lighthouse crossing

under the lighthouse and one hundred one-hundred-ton jacks lowered it onto the beams. With the lighthouse sitting on its steel undercarriage, which was also its rolling platform, it was then moved at an almost undetectable pace of one foot per minute using several hydraulic rams (a sort of long piston) doing the job as they pushed against the platform. The lighthouse rolled along a seventy-foot-wide roadbed that had been specially graded for the job. The undercarriage and lighthouse moved along on heavy tracks that carried it forward. The tracks were leap-frogged from the back to the front as the lighthouse moved forward. It looks like a structure this tall could easily tip, but actually the center of gravity is very low on the lighthouse, so the likelihood of that happening was not nearly as great as it looked.

The entire process took about forty weeks to complete, and now the light has a new home. It should be free from the dangers of erosion for the foreseeable future, but nothing is permanent. It's estimated that in a hundred years, erosion might once again eat up the beach and threaten the lighthouse.

The lighthouse that was originally built for $80,000 was moved at a cost of $1,454,000 for engineering work and $8,035,000 for actually moving the lighthouse, keepers' houses, and cisterns and for building the new foundation. My only guess is that the dollar isn't worth what it used to be.

Lifted from its base with powerful jacks, the lighthouse sat on a network of tracks and moved inch by inch to its new home.

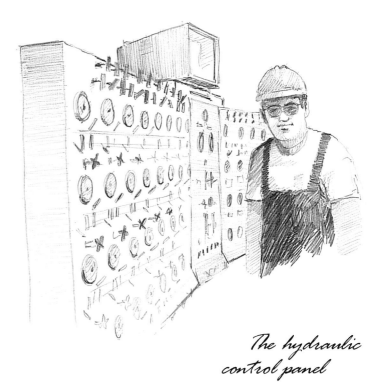

The hydraulic control panel

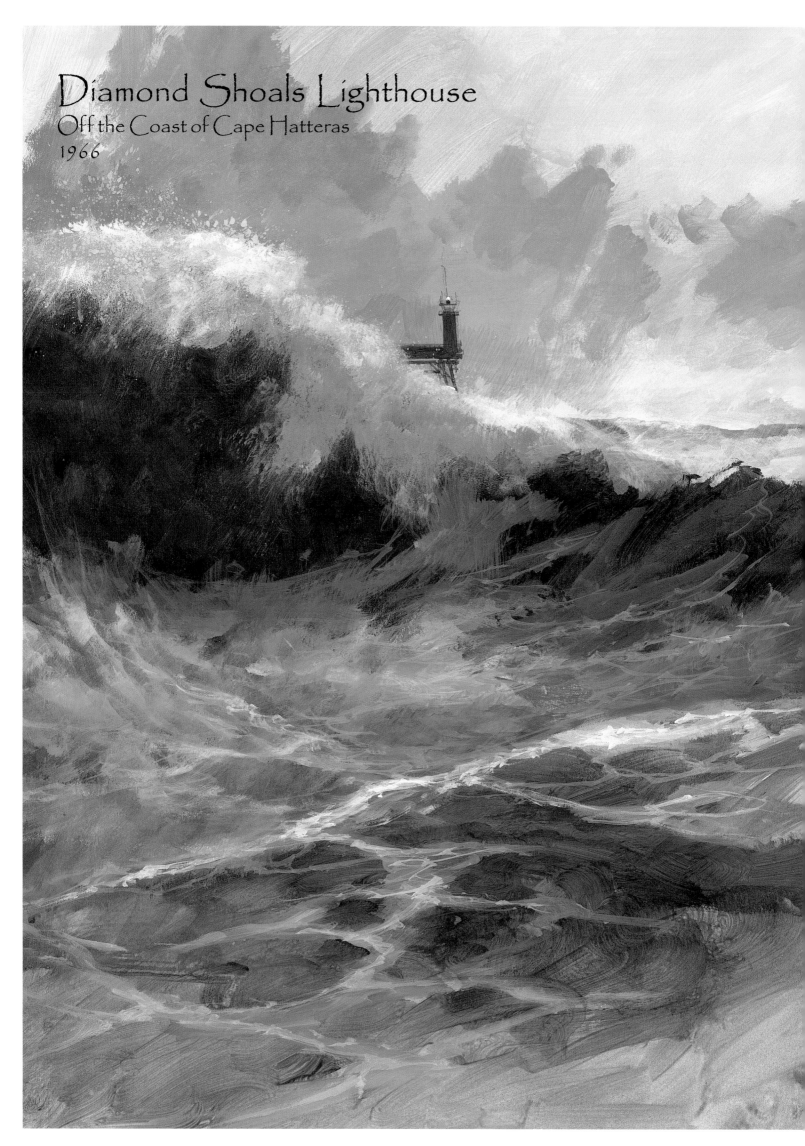

Diamond Shoals Lighthouse
Off the Coast of Cape Hatteras
1966

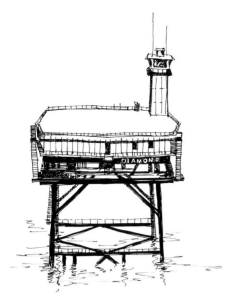

About seven miles out from Cape Hatteras, shifting underwater sand banks known as Diamond Shoals have long presented a threat to mariners. In the days of sail, it was the most feared spot anywhere up and down the East Coast. Sailing ships heading south were forced to use the narrow passage between Diamond Shoals and the shore of Cape Hatteras in order to avoid the Gulf Stream currents, which move north at about four miles an hour. But within this area, treacherous currents around the elbow at Cape Hatteras swirl in every direction, making any passage difficult. In addition, warm, moist air from the south mixes with the cold currents from the north at this point, often resulting in gales and unusually high seas. Old-time sailors said that it is more treacherous than going around Cape Horn in winter. In the twenty-five year period between 1875 and 1900, ninety-seven ships were wrecked and hundreds of lives were lost along this stretch of coastline.

The need for a lighthouse or some type of marker on Diamond Shoals was evident, but building such a lighthouse would not be easy. In 1888, Congress appropriated $500,000, a huge sum at that time, to build such a structure. The precarious site, with its shifting sand floor and heavy surf, would make construction so risky that the terms of the contract stated that the contractor would not be paid until the lighthouse had been completed. Twenty percent of that amount would also be withheld for five years, during which time the contractor had to operate the lighthouse. If it was still standing by the end of that time, only then would the contractor receive the remaining amount of money.

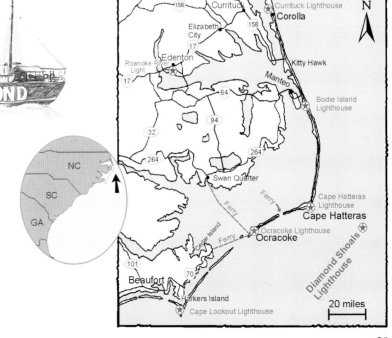

In 1890, a contract was awarded to a company in New Jersey which proposed sinking an iron-and-concrete pier fifty-four feet in diameter into the shoal. The total height of the foundation would be 154 feet, with thirty feet of it sticking up above the water. On top of this massive foundation they would build a 150-foot-tall tower. This ambitious project began as tugboats towed the first forty-five-foot-tall caisson into position and lowered it onto the floor of the sandy shoal. The structure, with its perpendicular sides, left no room for the currents to do anything but push directly against the massive column. Sloped sides might have worked better but it was too late. No sooner was it set in place than the block listed over seven feet to one side, then the currents began to eat away the sand from beneath it. That very night, heavy seas tore the caisson apart; within three days, the entire thing had totally vanished.

Another elaborate plan was made to sink an even larger caisson, this one cone shaped, into the shoal in 1904 as a base for a lighthouse. Although the plans were completed and were approved by Congress, the contractor didn't get around to beginning the project as scheduled in his contract. As a result, Congress bailed out of its commitment, and the second try to conquer Diamond Shoals failed.

Part of the funds set aside to erect the ill-fated lighthouse were used to build a lightship instead. The *Diamond*, as it was named, was put into operation in 1827. Several lightships, all named *Diamond*, were put into use over the years, but they too had problems and were dragged off their position by winter storms many times. In 1918, a German submarine torpedoed and sank the lightship.

Lightships were used right up until the time a tower was finally built in 1966. There's no real thrill in visiting the present-day 175-foot-tall tower, as it looks more like an offshore oil rig with a helicopter pad on top than it does a lighthouse. Besides that, it's miles out in open seas. Manned by the Coast Guard for ten years, it was automated in 1977 and no one lives there anymore. Solar panels power the batteries for the light and foghorn. It served its function well during its time, but hurricanes in recent years have damaged the structure so much that it is unsound. A layer of rust covers most of the structure, and parts of it have rotted away. All the windows have been broken; in general it is an unsafe place to be. It is destined for extinction quite soon.

Ocracoke Lighthouse
Ocracoke Island, North Carolina
1823

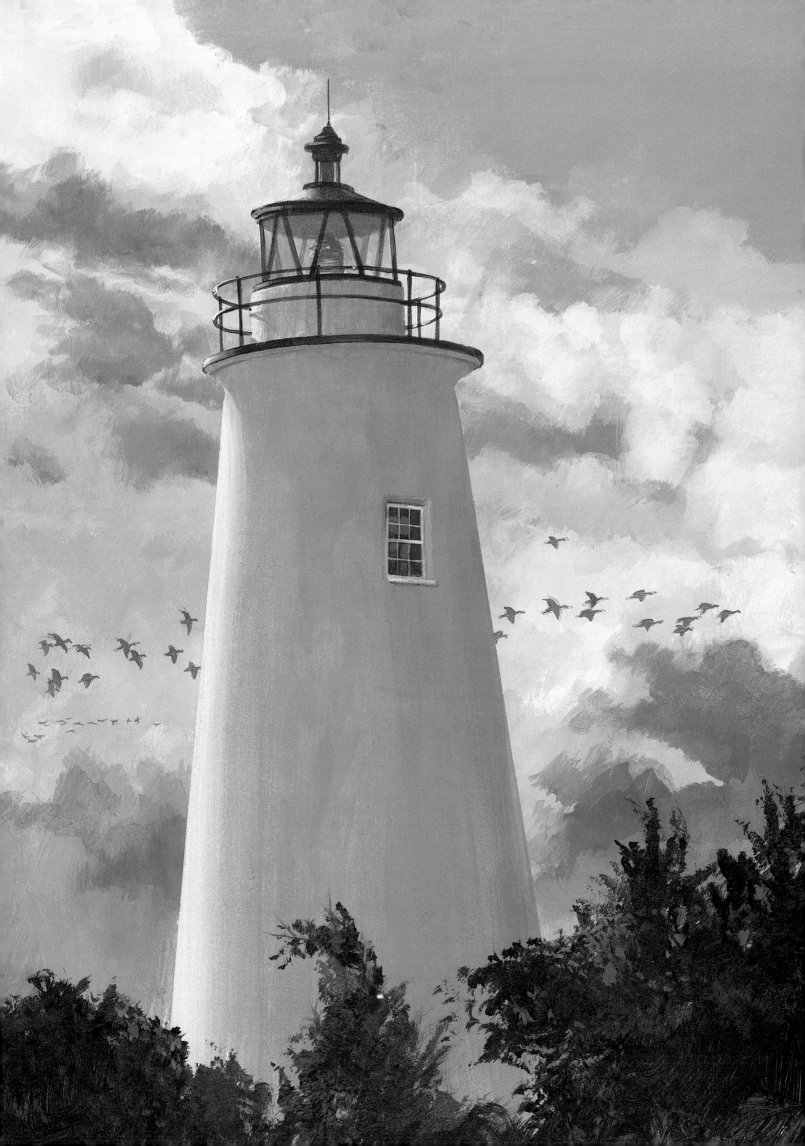

The small island community of Ocracoke is the site of the oldest lighthouse still operating in North Carolina. Built in 1823, it's considered an inlet light rather than a coastal light, but that made it no less important as it guided an average of one hundred oceangoing vessels a month into the Ocracoke Inlet during the mid 1800s. An earlier lighthouse built of wood in the late 1700s on nearby Shell Castle Island was destroyed by a lightning fire in the early 1800s, just fifteen years after it was completed. It never worked out very well anyway, as sand bars changed and the channel kept shifting to the point where the light was one mile from the inlet. A light vessel was used in the Ocracoke Inlet to replace the lighthouse, but it didn't work out very well either so Congress approved a new lighthouse to be built on Ocracoke at a cost of just over $11,000, which included the cost of the keeper's house.

The lighthouse stands today as it has for over a century and a half, although some changes have been made over the years. The wooden stairs were replaced with ones made of steel after World War II, and the two-story keeper's house was originally a one-story dwelling. The Coast Guard used it when the lighthouse was manned, and after automation in 1946, Coast Guard personnel continued to use it. Now the National Park Service owns it all, and the Coast Guard is only responsible for keeping the light burning. The lighthouse is not very tall, standing only seventy-five feet above sea level, but considering it is a harbor light it didn't need to be as tall as lights guiding ships up and down the coast. It's the shortest navigational light on the Atlantic Coast, measuring only sixty-five feet from its base. Even at that, the lighthouse, with its 8,000-candlepower fixed white light, is visible up to fourteen miles out to sea.

During the Civil War, the lens was removed by the Confederates (as were so many), but it was replaced after the war was over and has been lit ever since. The oil house, where whale oil was once stored, still remains next to the light. Kerosene was used later, and now of course electricity powers the fully automated light. The lighthouse is made of brick but is covered with masonry, unlike the many that maintain their brick exteriors, whether painted or not. Ocracoke has always been painted white, but the paint formula set forth by the U.S. Lighthouse Board was quite unusual. It consisted of ingredients including a half bushel of lime, a peck of salt, three pounds of ground rice, a half pound of whiting, and a pound of clear glue. That would all be mixed in boiling water, then applied as hot as possible to the outside of the lighthouse.

A story about Ocracoke wouldn't be complete without mentioning Edward Teach, better known as the pirate Blackbeard. He once used Ocracoke as one of his anchorages and hideouts. He was especially infamous around the Caribbean but came to know Ocracoke as one of his homes in 1718. He owned, or better described, stole four ships and

had four hundred pirates under his control. His lifelong illegal activities finally caught up with him at Ocracoke during a vicious and bloody battle. Accounts vary but some say that he lost his life only after receiving five pistol wounds, twenty stab wounds, and a deep gash to his neck caused by a cutlass. Legends tend to grow over the years.

Permanent residents on Ocracoke number only seven hundred, but many thousands more visit every year. When I talked to employees at the visitors center, they told me that 90,000 people come through their facility every year and 30,000 of those visit the lighthouse. Although the lighthouse isn't open to the public, visitors are welcome to walk around the grounds.

The only way to get here is by ferry. From May through October, a free ferry runs about every half hour between Cape Hatteras and Ocracoke. From November through April, it runs every hour from 5 A.M. to 10 P.M. Another ferry runs between Cedar Island, northeast of Morehead City, and the Beaufort area five times a day for a cost of $10. A ferry also runs from the town of Swan Quarter to Ocracoke three times a day and also has a fee of $10.

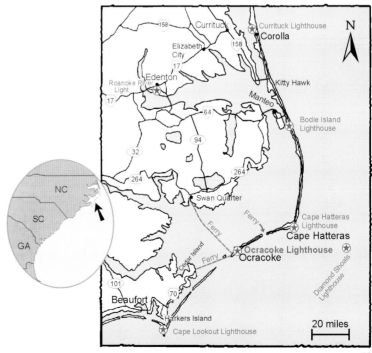

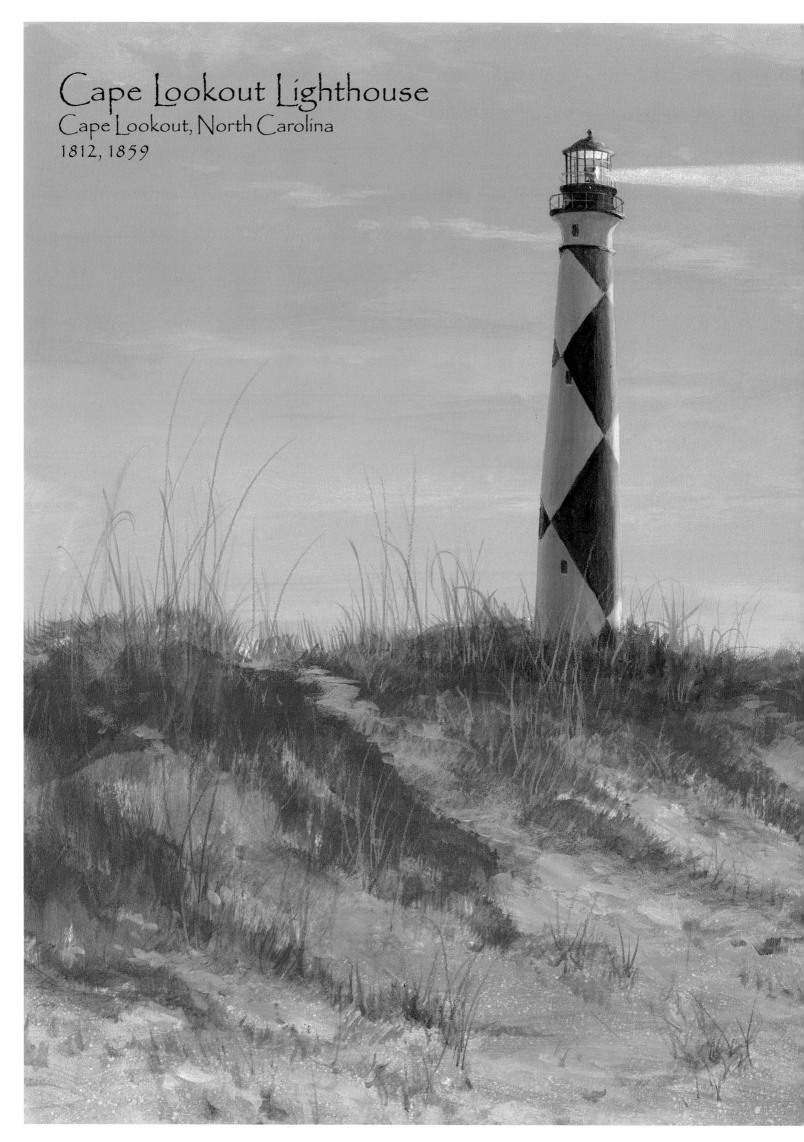

Cape Lookout Lighthouse
Cape Lookout, North Carolina
1812, 1859

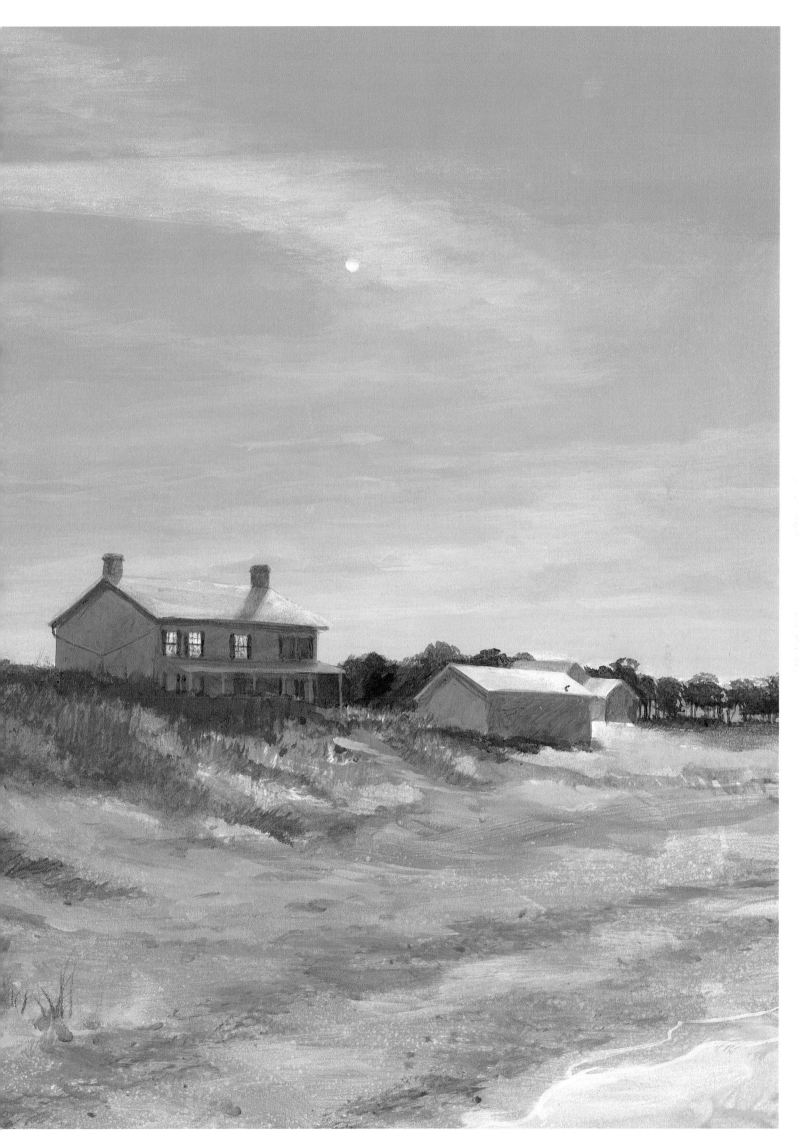

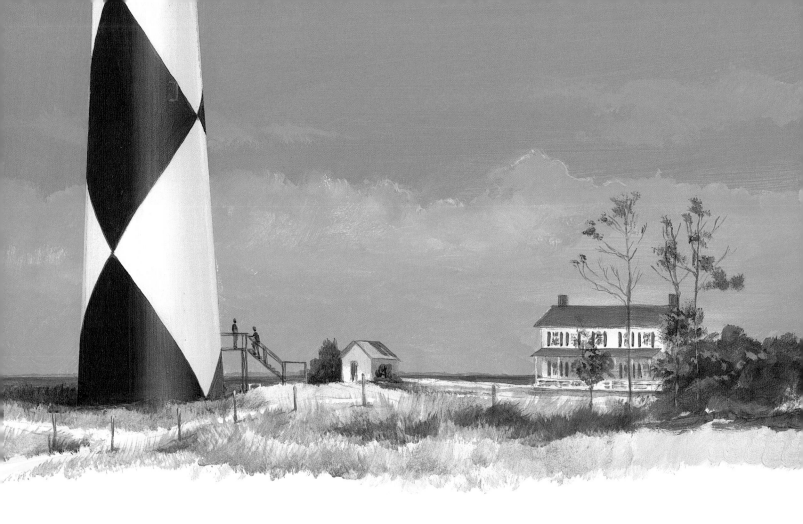

Shoals extending out ten miles into the Atlantic have made this area around Cape Lookout extremely hazardous to shipping, especially in the early days of sail and steam. It was nicknamed the "Horrible Headland" by many mariners and was a necessary place for a lighthouse. The first lighthouse at this site was built in 1812 and was quite different from other lighthouses of the day. It had an inner tower built of brick with an outer shell constructed of wood. It rose to a height of 104 feet, but its light was not very effective and seamen often complained about it. It was replaced in 1859 with the current lighthouse, rising 150 feet high from its base

The keepers' house has been changed over the years but originally it was a duplex, housing both the keeper's and the assistant keeper's families.

and crowned with a first-order Fresnel lens. During the Civil War, the Confederates damaged the lens and a third-order lens was put in its place. After the war, the first-order lens was repaired and put back into operation until 1972, when it was replaced with two aeromarine beacons. The wooden staircase in the lighthouse was used for only four years, then it was replaced with a metal one to lessen the fire hazard.

Erosion is always a threat to lighthouses, and the Cape Lookout Lighthouse hasn't escaped Mother Nature's plans. It's been a little different here, however, as it is not the Atlantic side of the island that is disappearing. In fact, the ocean side has actually built up over past years. It's the inlet side, nearer to the lighthouse, that is losing ground. Tidal currents and changes in the channel through nearby Barden's Inlet, since it was opened by a storm in 1933, have cut almost a thousand feet of beach from in front of the lighthouse. The keepers' house now stands only two hundred fifty feet from the high-tide mark. In order to help save what is left of the beach, an old channel was dredged and reopened, diverting much of the water flow to other areas and somewhat reducing the risk of further erosion to the beach.

The lighthouse doesn't have many trees or vegetation around it, like so many other lighthouses I have visited, so the full impact of its size and strength can be realized when you look at it from most any angle. Being an old sign painter, I wondered how they drew those large black-and-white diamond patterns on the lighthouse, but it occurred to me that they're just two opposing spirals that intersect each other. I haven't found out how someone first actually laid out the

spiral pattern to paint it, but it appears that the painter would perhaps measure down eight bricks and over four and strike a point. That would give him an angle to draw a straight line. He would then repeat the same procedure all the way down. The spirals appear to be at forty-five-degree angles, so if a brick is twice as long as it is high, then that formula would be about right. The diamond pattern was painted on the tower in 1873 to increase its effectiveness as a daymark.

You won't be driving your car to Cape Lookout, but several ferry services that run from Harkers Island will take you there for a fee of about ten dollars. The ferries, actually just small power boats, are privately owned and run quite regularly or on demand. It takes about fifteen minutes to get to the lighthouse from Harkers Island. There is a dock on the island, but the boats usually pull up on the beach for passengers to jump out onto the sand. A ferry also runs from Beaufort. There are a few small motels on Harkers Island, but don't look for anything very fancy. If you can't get over to Cape Lookout, you can still see the lighthouse from Harkers Island, even though it's quite distant.

If you're lucky you might see some wild horses on nearby Shackleford Banks on your way out to the lighthouse.

This little building was called the kitchen house. It was built some distance from the keepers' house to prevent the chance of fire to the house should that pot roast get away from the cook. It also kept the house cooler in the summer months. Kitchen houses were common back then.

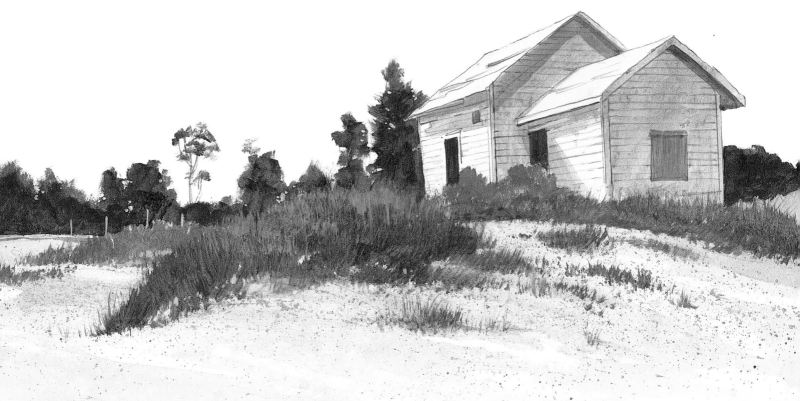

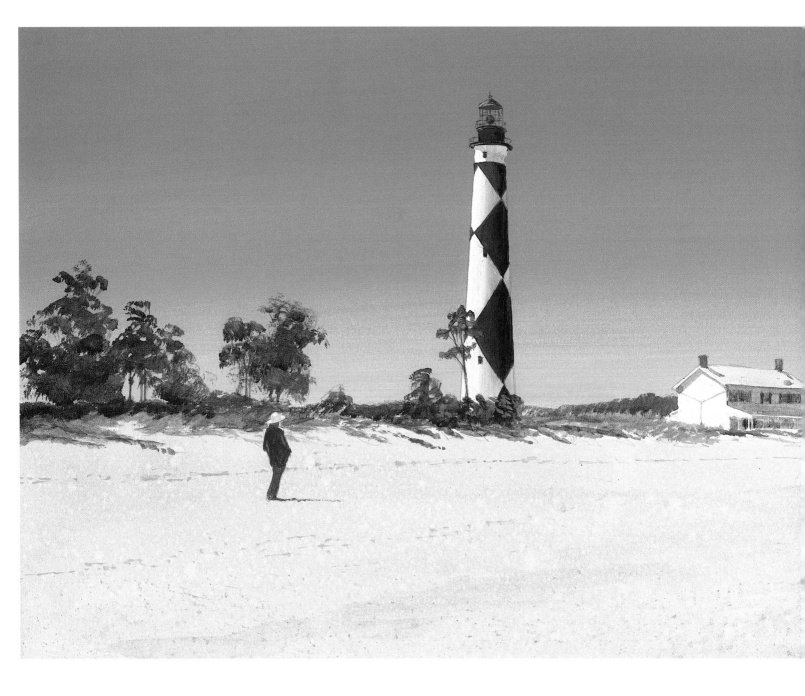

The island used to have a population of sheep, goats, and cows that made the island their home, but they were removed in the 1980s. At one time there was a community on Shackleford Island called Diamond City, named after the lighthouse, but it was abandoned prior to 1900. It's all disappeared, washed away, and not a trace of it remains today.

Once you get to the island, the lighthouse is impressive. If you like to take time to examine the little things in nature or to observe the many species of birds, it's a good place to visit, though it's also a somewhat barren place. Flocks of birds stop here during the spring and fall migrations, and in the summer, terns, egrets, herons, and shore birds make this their nesting area.

You can't get to the top of the lighthouse as it's not open to the public, but you can walk around it. The keepers' quarters is open from April until Thanksgiving. During that time a volunteer couple lives in the keepers' house, runs the book shop, and tends to the displays and the many visitors who come to the island. There are few trees and little shelter on the island, which can make it uncomfortable and very hot in the summer months. If you visit, be sure to bring food, water, and something to keep from getting sunburned. Insect repellent is also a good idea. If you want to stay for a few days, camping is available on the island. You have to take everything with you as there are no stores or supplies on the island. Everything you take over there, you are asked to bring back with you since there are no trash containers or garbage pickup there either.

There is also a Life Saving Station on the island but it's about two miles down from the lighthouse. It would be a long walk in soft sand. It's run by the North Carolina Maritime Museum and is used as a research center.

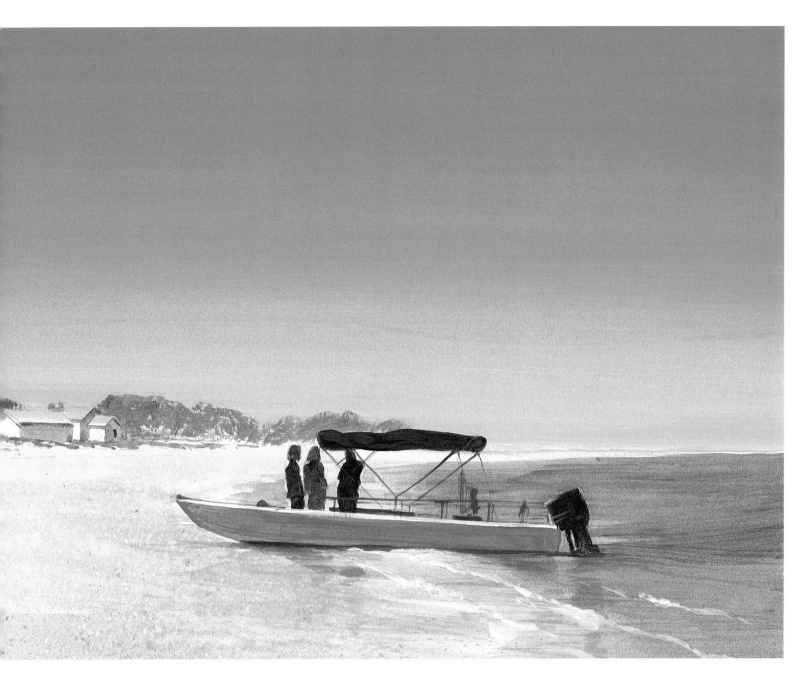

Many migrating birds find Cape Lookout a good place to rest up for a time in the spring and fall. Others nest here and raise families in the summer months.

49

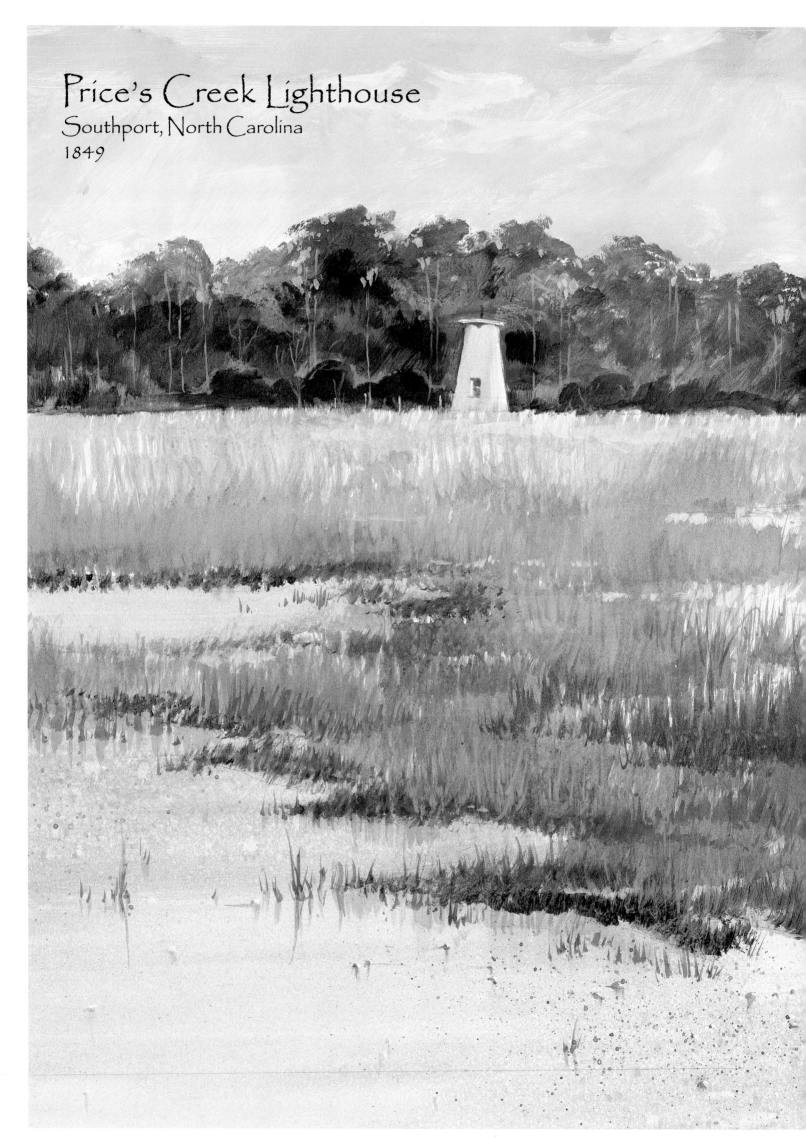

Price's Creek Lighthouse
Southport, North Carolina
1849

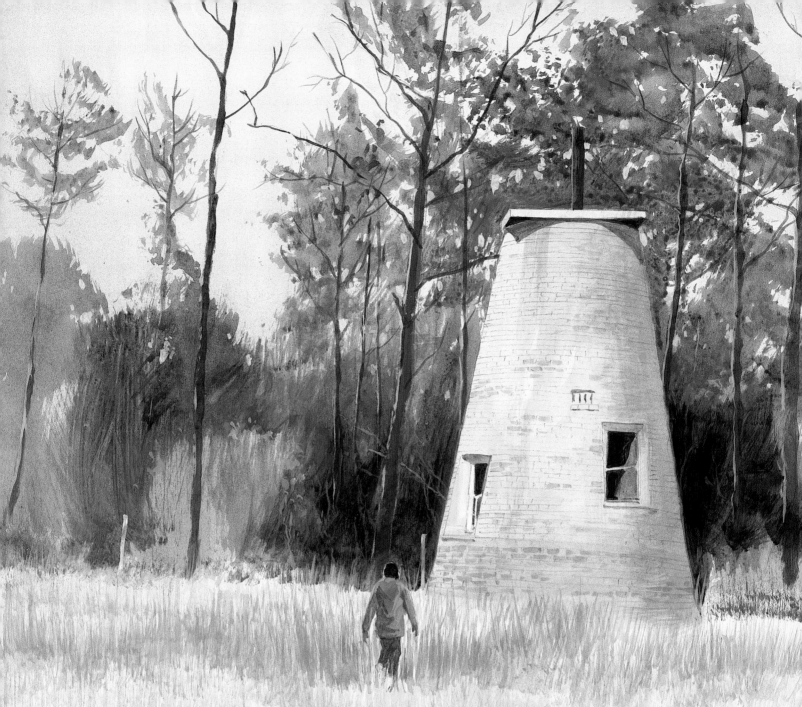

Not far from the Bald Head Lighthouse and just above Southport stands this little harbor light called Price's Creek Lighthouse. It was one of seven such lights along the twenty-five-mile stretch up the Cape Fear River from Oak Island to Wilmington, built to help vessels navigate the bends in the river channel. Now dark and abandoned, Price's Creek was never re-lit after the Civil War, when it was used as a Confederate signal station. The Confederates destroyed all the other river lights when they began to lose control over the river.

The small, twenty-foot-tall lighthouse is seventeen feet in diameter at the base with three-foot-thick walls at the bottom, graduating to two feet at the top. The lantern room is gone now, but originally it was fitted with eight lamps and eight fourteen-inch reflectors when it was built in 1849. These were the Lewis lamps that were in general use at the time and were not very effective. All the bricks for the lighthouse and the keepers' house were thought to be brought over from England. Years later, when the house was

demolished, many of the bricks were gathered up and used in the construction of a home in Southport.

Living with bare essentials back when this lighthouse was built was the norm, and life was difficult at best. Diseases such as yellow fever affected many people. Although there was not a huge epidemic here like there was at St. Joseph in Florida, where the entire population died from the disease, there were cases of yellow fever in the area around Price's Creek Lighthouse, Southport, and Bald Head Island. In the late 1800s, as shifting sands along the bank were washed away, residents walking along the shore sometimes found open coffins with skeletons of yellow fever victims.

All it took was one sailor to come into town with yellow fever, and within a short time the whole town could be wiped out. If you were one of the unfortunate souls to contract the disease, here is what would have happened to you. Three to six days after you were exposed to it, the disease would have finished incubating, and symptoms would manifest suddenly. It would start with a headache, backache, and fever. Then you would begin to have nausea and vomiting. Your tempera-

ture would return to normal for a few days, but then it would rise again. Your skin would turn yellow from an accumulation of yellow bile pigments in your body. Then you would begin to bleed from the nose and to vomit blood (It was called "black vomit."). Your kidneys, liver, and heart would begin to fail, and you would die between the fourth and eighth days after your symptoms began. If by some miracle you survived (and some people did), your convalescence would be quick. The jaundice would persist, but you would be immune to yellow fever for the rest of your life.

Now as busy travelers and businessmen take the ferry past this last surviving harbor light on the river, those difficult times are all but forgotten except for a few photographs and notes in history books. The lighthouse sits alone on the river as the only reminder, dwarfed by a large chemical plant owned by the Archer Daniels Midland Corporation, which produces citric acid, used to make many food products, including soft drinks, tart. In front of the lighthouse, a massive pier, where large ships dock to offload raw materials, further diminishes the already small structure. When I was there, new wooden stairs and window casements had been built, but other than that it was quite overgrown. The lighthouse is on private property, and it's unlikely that you would gain access to it by any roads on company property. Viewing it from the river is your best bet.

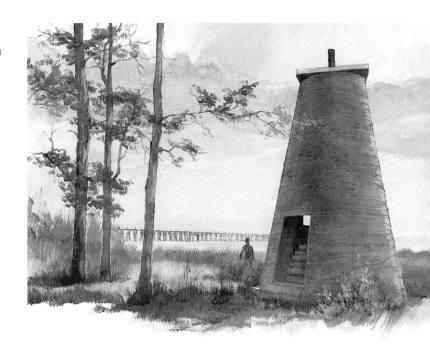

What was once an important aid to navigation up the Cape Fear River is now reduced to an insignificant landmark with a large chemical plant looming in its background.

The ferryboat landing at Southport is a good place to see the lighthouse (not the ferry that runs to Bald Head Island but the one that runs to Fort Fisher). Fort Fisher is where there was once another lighthouse called the Federal Point Lighthouse, but nothing remains of it now. If you have your own boat, there is a public boat ramp at Southport, but a hard current on the river up by the lighthouse warrants some caution if you're using a small boat. Of course, two other lighthouses are nearby that you can get close to: Oak Island Lighthouse, just to the south, and Bald Head Lighthouse, often called Cape Fear Lighthouse. It's within sight of Price's Creek.

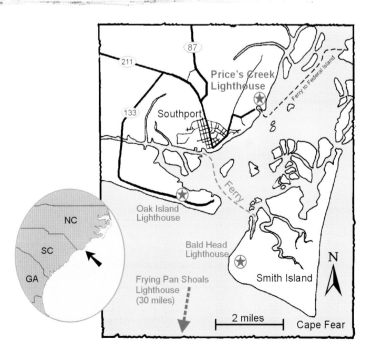

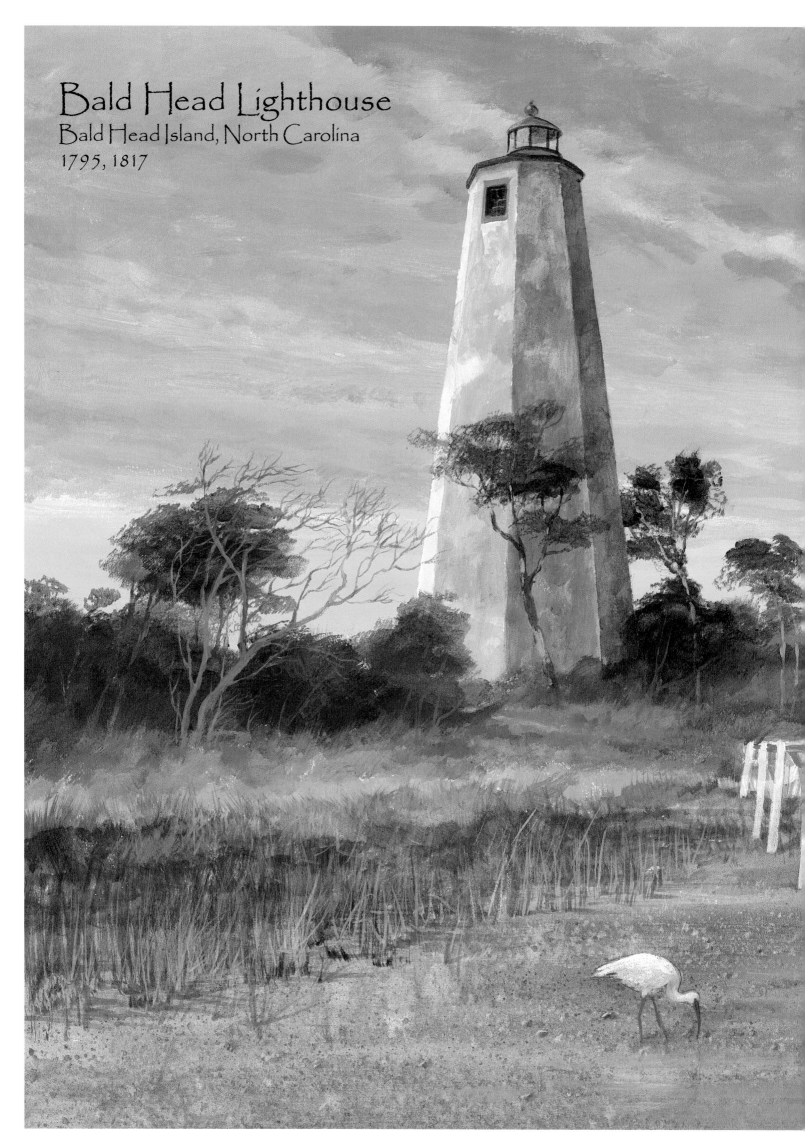

Bald Head Lighthouse
Bald Head Island, North Carolina
1795, 1817

Bald Head Lighthouse, also known as "Old Baldy," got its name because some nearby dunes, void of vegetation, resembled bald heads. They became that way, the story goes, because ship pilots wore down the vegetation from standing on the dunes watching for ships needing guidance up the Cape Fear River. That's the story anyway. The lighthouse is on Bald Head Island, also known as Smith Island. Nothing like having more than one name for an island to make things confusing. Bald Head marks the entrance to the Cape Fear River and is just a couple of miles offshore from Southport. Several names are used for the lighthouse also. Its official name is the Cape Fear Lighthouse, but it's most often referred to as Bald Head Lighthouse. It was built primarily to guide ships past the dangerous Frying Pan Shoals, which lie seven miles out in the Atlantic.

This is the oldest lighthouse still standing in North Carolina. The first one was built in 1795, but beach erosion caused it to be replaced with the current one built in 1817. A third lighthouse was built in 1903 at nearby Federal Point, about eight miles to the north of Bald Head. It was eventually shut down, leaving Bald Head again the only lighthouse in the area until a modern lighthouse was built in 1958 on nearby Oak Island, putting Bald Head out of commission.

The interior of the Bald Head Lighthouse is spacious and separated into several floor levels.

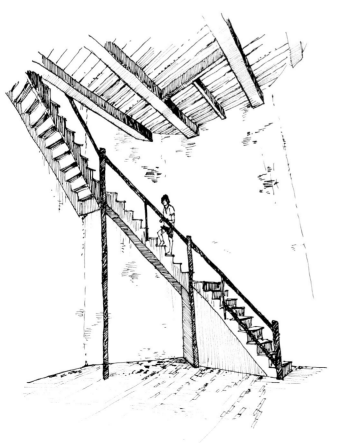

In a beautiful setting, the restored lighthouse now stands as a monument and adds to the mystique of the somewhat exclusive Bald Head Island, which until the 1970s stood undeveloped. Now, high-priced homes used mostly during the season dot the island. Bicycles, golf carts, and feet are the only modes of transportation around, as there are no cars there with the exception of some service vehicles. As much as I find development distasteful in places like this, I must admit that Bald Head Island is extremely attractive.

The octagonal lighthouse has a very wide base and is very spacious inside. At the top, a vertical ladder leads the way through a trap door to get to where the light used to be. The lantern room is set off-center from the rest of the ninety-foot-high lighthouse to better accommodate the vertical ladder that ascends the final few feet into the lantern room. (The lighthouse at Ocracoke has this same configuration.) There is no longer a light at the top, and the lantern room sits empty except for the visitors who climb the 112 wooden steps to get a bird's-eye view of the island.

The only way to reach Bald Head Island is by private boat or ferry. The ferry runs regularly, but since I already had my twelve-foot aluminum boat with me, I chose not to spend the $15 ferry fee for the couple of miles to the island. I won't do that again. The pass got quite rough, too much for

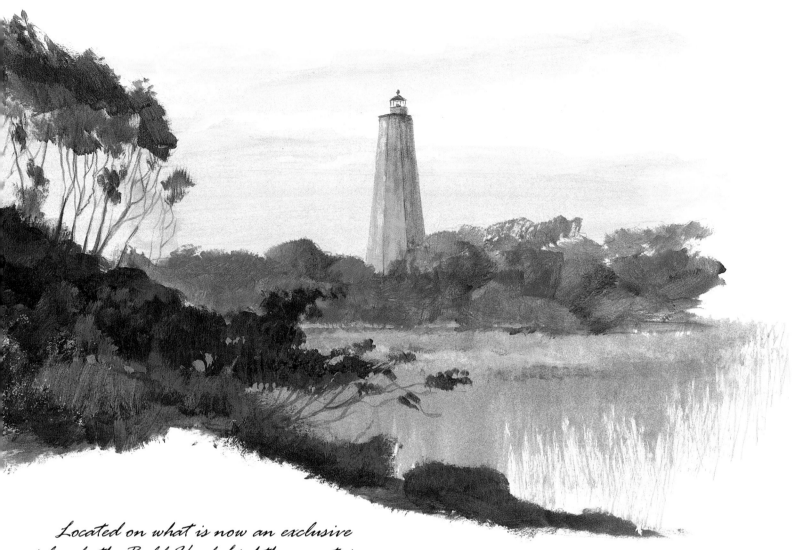

Located on what is now an exclusive island, the Bald Head Lighthouse retains its unspoiled charm as it sits among the marshes. It's open to the public, and you can climb to the top.

my little boat, and although I managed it, I learned something in the bargain because I nearly got swamped several times in the high surf.

While talking to the local residents on the mainland, I discovered that it was their opinion that the high cost of the short ferry ride was due in part to keeping the island exclusive, but after considering all there is to the ferry operation, I think that it's a fair deal. If you plan on spending the night on the island, there are several places to stay but they will cost between $150 and $300 a night.

If you stay in Southport, don't expect a selection of Holiday Inns and Hyatt Hotels to choose from. This small, quaint town, with just a few bed-and-breakfasts and home-owned motels, has managed so far to keep its charm. The streets are lined with large oaks, and the town is dotted with many interesting buildings, antiques shops, and a maritime museum.

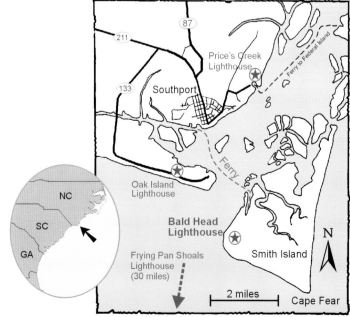

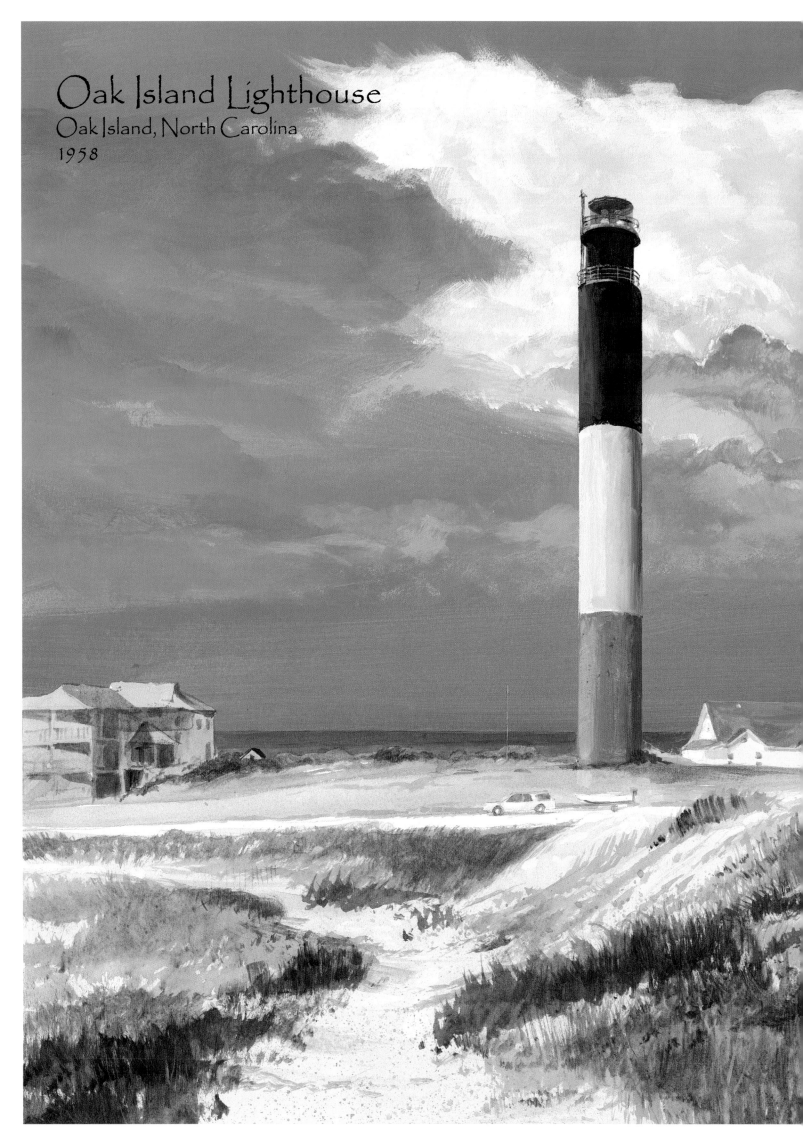

Oak Island Lighthouse
Oak Island, North Carolina
1958

Built in 1958 and standing 169 feet high, the Oak Island Lighthouse, like all modern lighthouses, has deviated from the traditional lighthouse look but serves the same function. The construction method used a round slip form consisting of a round steel tube inside another larger one. The space between the two tubes makes up the thickness of the tower. Concrete reinforced with iron rods was poured into the form and allowed to dry, then the form was slipped upward, ready for the next pour. The process was continued all the way to the top of the lighthouse. The walls are only eight inches thick the entire way to the top, as opposed to older brick

lighthouses, which could have walls as thick as five feet at the base, with the thickness tapering towards the top. Another interesting feature of the Oak Island Lighthouse is that colored concrete was used in the process, so the three different-colored bands never need painting. The foundation for the light reaches down seventy feet into bedrock, and the lighthouse is designed to sway three feet in winds of one hundred miles an hour.

Lightweight aluminum was used for parts of the lantern room, including the floor, and a helicopter was used to set the lantern room in place. The optics at the Oak Island Lighthouse consist of two clusters of four powerful revolving lights. They are so powerful on their highest setting, used during conditions of fog or bad weather, the beam of light can be powered up to reach an incredible 2,500,000 candlepower, ranking this the most powerful lighthouse in the nation. It's enough to scorch the skin of anyone standing in front of the lens.

The lighthouse isn't open to the public, but visitors are welcome to take pictures from the outside and to take a tour of the beautifully kept Coast Guard Station that is adjacent to the tower. In back of the lighthouse, there is a repair and service area for buoys and channel markers, as well as the docks where the Coast Guard moors its rescue boats.

There were several other lights at Oak Island in the middle 1800s similar to the one at Price's Creek, but they were used to guide ships up the Cape Fear River to the port of Wilmington and not to be identification for passing ships at sea. None of those are left standing except the one at Price's Creek, just above nearby Southport.

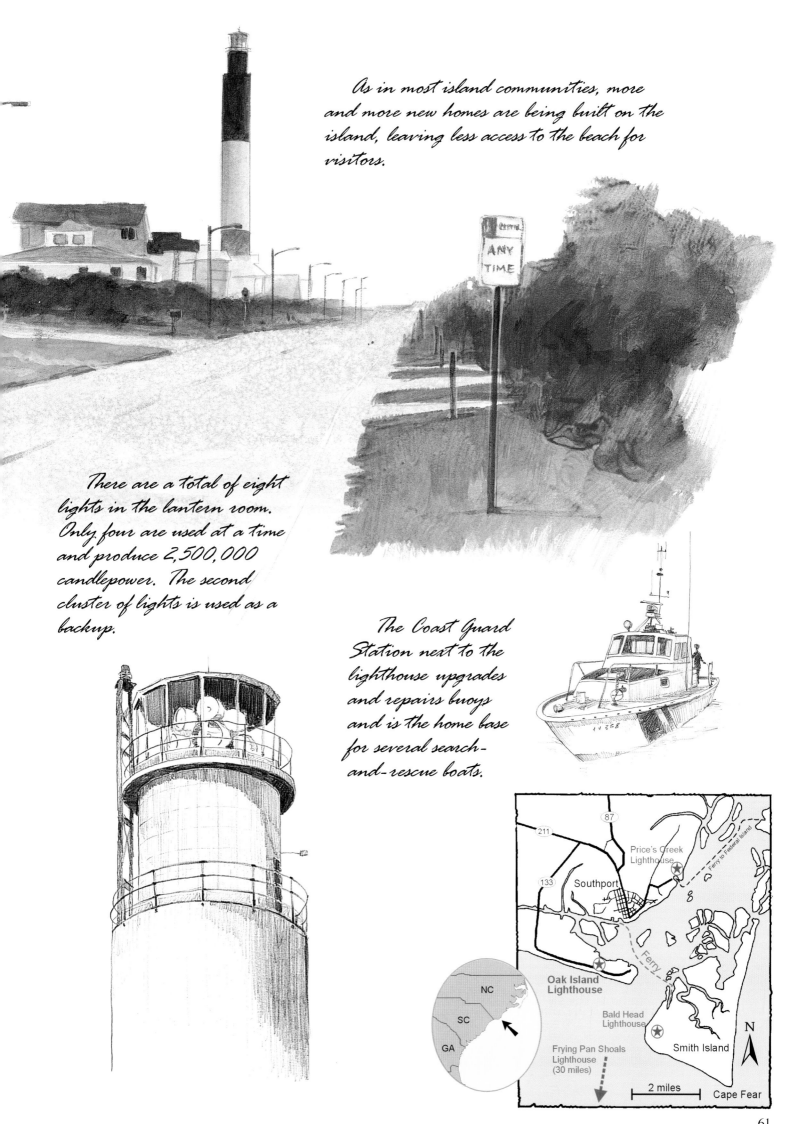

As in most island communities, more and more new homes are being built on the island, leaving less access to the beach for visitors.

There are a total of eight lights in the lantern room. Only four are used at a time and produce 2,500,000 candlepower. The second cluster of lights is used as a backup.

The Coast Guard Station next to the lighthouse upgrades and repairs buoys and is the home base for several search-and-rescue boats.

ANY TIME

87

211

133 Southport

Price's Creek Lighthouse

Ferry to Federal Island

Ferry

Oak Island Lighthouse

NC

SC

GA

Bald Head Lighthouse

Frying Pan Shoals Lighthouse (30 miles)

Smith Island

N

2 miles

Cape Fear

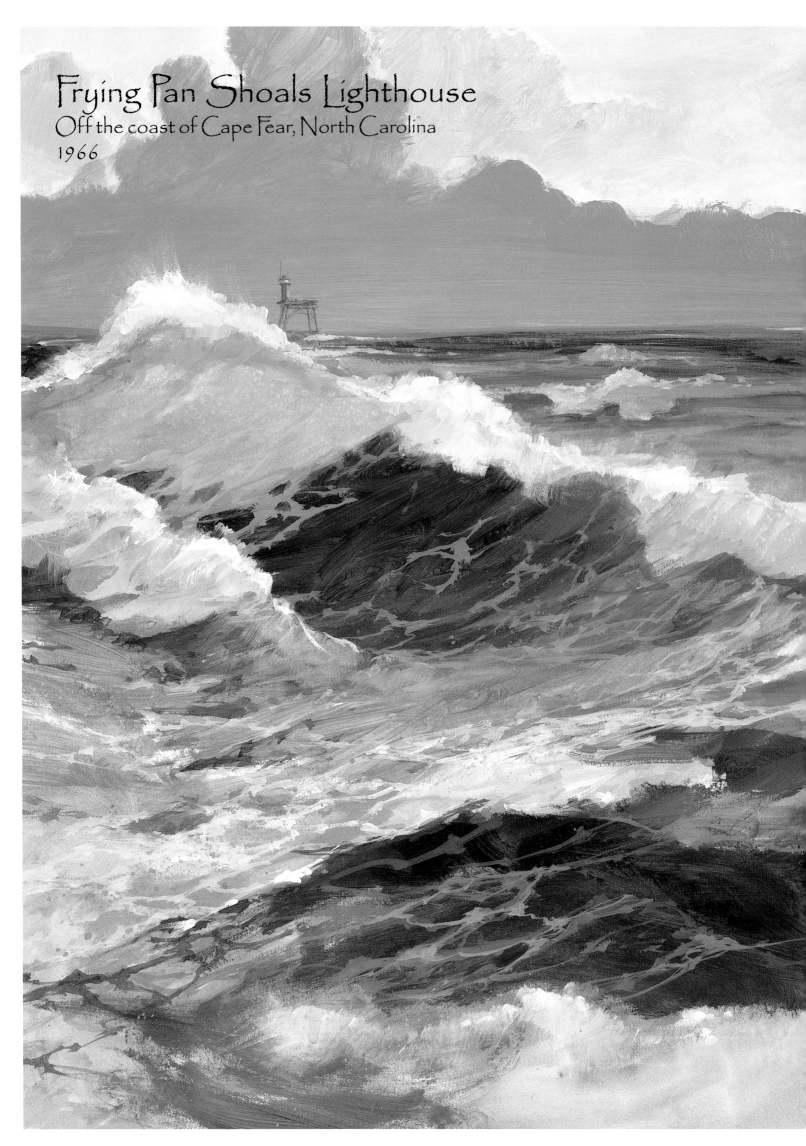

Frying Pan Shoals Lighthouse
Off the coast of Cape Fear, North Carolina
1966

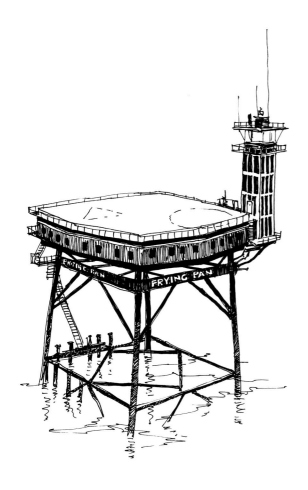

or used. Now only the helicopter landing pad is used to gain access to the lighthouse and that very infrequently. The Coast Guard inspects it four times a year and after big storms. The light station houses oceanographic equipment measuring the height and frequency of waves, along with the speed, flow, and temperature of the water. With the accurate satellite navigational aids that are now in use by even the smallest of vessels, the light station will most likely not be used for many more years.

Before the light station was built, lightships were anchored near the shoal to warn passing ships of the shallow waters. During storms, just when they were needed most, they sometimes broke away from their moorings.

Located in open ocean thirty miles southeast of Cape Fear, this "light tower" or "light station" looks more like a Texas oil rig or giant erector set than a navigational aid for passing ships. The 125-foot-tall structure has been used to guide ships around the shallow, sandy bottom that in many places is only three or four feet deep. Before the tower was built, a lightship was used in the area. There have been many over the years, but all had the name *Frying Pan* spelled out on the side of a red vessel in bold white letters. They were removed from service when the tower was built in 1966. Lightships have had a long but precarious existence: although they were successful for the most part, they were always plagued with such problems as breaking away from their moorings during rough weather and, even worse, being sunk during hurricanes. They were even hit by passing ships, which was once the case here at Frying Pan Shoals.

The tower was manned by six Coast Guardsmen when first built, but now it's automated and no one needs to live there. The sun takes care of the power supply through the use of eight solar panels that charge a twelve-volt battery to light the fifty-watt, twelve-volt lamp, enough to generate 58,000 candlepower within the Fresnel lens, which can be seen sixteen miles away. There is also a backup system in case the first set of solar panels fails. A foghorn is also in place and is automated as well.

The tower is rugged, with huge, round, steel legs that measure forty-two inches in diameter and are firmly planted almost three hundred feet into the ocean floor. A hurricane severely damaged the boat deck of the tower with almost fifty-foot waves. As a result, the boat deck is no longer safe

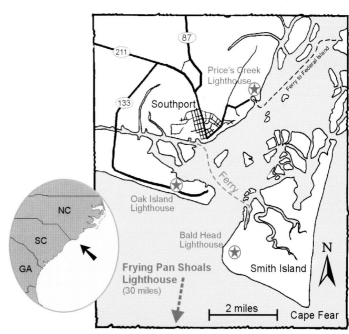

Sketchbook

Throughout the years I've carried a sketchbook with me. Here are a few of the interesting faces and places that I've seen.

These lapstrake boats have beautiful lines, and they really cut through the water nicely.

This is a reproduction of a 16th-century galleon. A friend of mine built it from the keel up. I helped do some of the sculptural work for the many figures that decorate its hull.

I've never owned a large
sailboat. It's a lot less work to
know someone who owns one.

Henry was always one of my favorite models, and I have made dozens of drawings of him.

Working boats have always fascinated me. I would much rather paint and draw them than pleasure boats.

The boats out of water are even more fun to draw.

These are all used as shrimp boats, but many working boats like this one have been changed and outfitted so many different ways, it's hard to tell what use the hull was originally built for.

This is Clark Mills, who lives not far from me. Years ago he invented the Optimist Pram, now used all over the world.

This once-elegant boat was neglected and now has become "hogged." The weight of it, from sitting out of the water for so long, has broken its back. The boat sags on both ends, beyond repair.

Here is another boat that has seen better days, all of its ribs showing.

If you own a boat, one thing is for certain: it always needs to be worked on.

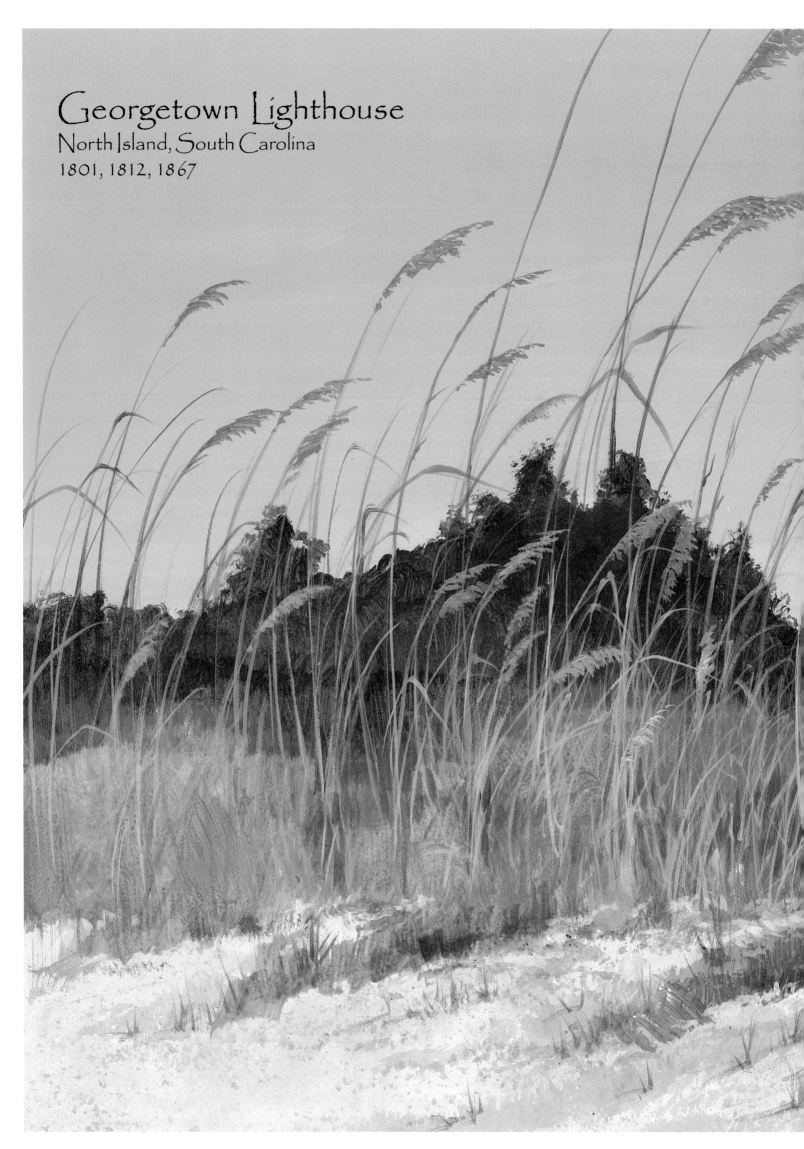

Georgetown Lighthouse
North Island, South Carolina
1801, 1812, 1867

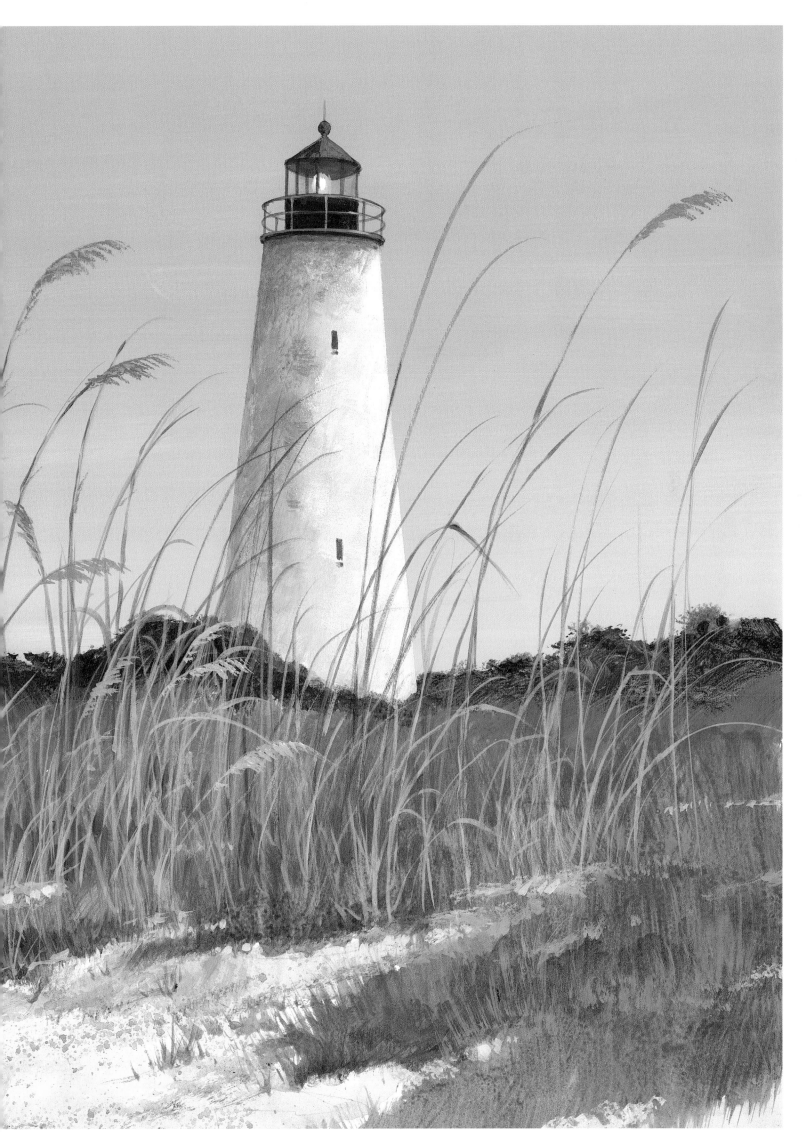

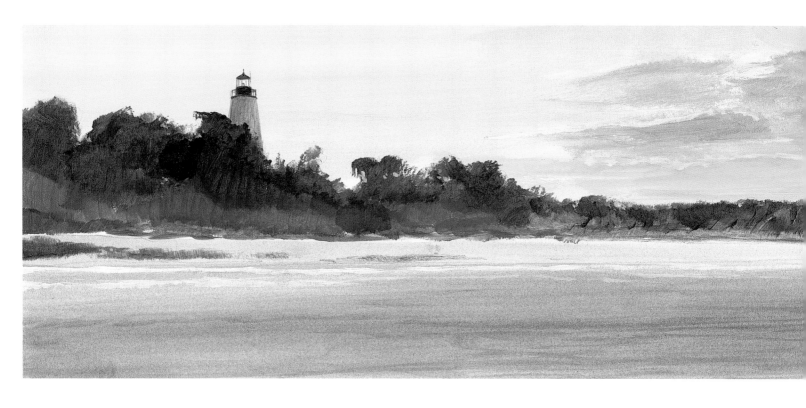

Looking out towards the Atlantic Ocean, the Georgetown Lighthouse sits at the mouth of Winyah Bay, leading into historic Georgetown. Many of the locals around Georgetown call it the North Island Lighthouse, as it sits on North Island. Some people didn't even know what I was talking about when I referred to it as the Georgetown Lighthouse. It is, after all, about twelve miles away from Georgetown by boat. The first lighthouse on the island was built of wood in 1801, and the lantern was lit with whale oil, plentiful at the time. Two years later, everything was washed away by a storm. Another lighthouse was built of brick in 1812, but major damage during the Civil War put an end to its usefulness.

The present lighthouse rose from the ashes in 1867. It's the oldest active lighthouse in South Carolina and stands eighty-seven feet high with six-foot-thick walls at the base. It has 124 spiral stairs inside cut from solid stone instead of the more common cast iron. A simple but stately two-story keepers' house just in front of the lighthouse, all surrounded by a white picket fence, once finished off the scene. Now only the lighthouse remains, along with the cistern and a few small buildings that were built more recently.

You can reach this lighthouse only by boat. The day we visited it was foggy. Not just a little foggy but can't-see-anything foggy. I asked a fishermen for directions, and he pointed the way with reservation but wished us good luck as we put our small boat in the water. I figured it could only get better and eventually the fog would lift. We hugged the shoreline for a mile or two, then made a left, crossing the bay. That would, according to his directions, land us at the lighthouse. The interesting thing about lighthouses is that when you most need them, they may not be of any assis-

tance. Just as I was almost ready to admit defeat and turn back with nothing but thick fog surrounding us, we practically ran into the beach. The light-house beacon normally seen from about fifteen miles away was only a faint beam of light struggling unsuccessfully to peer out through the dense cloud of

The flared base adds a little more area of foundation to help stabilize the lighthouse in the sandy soil.

white soup. If we had been a ship instead of a twelve-foot aluminum boat, we most certainly would have beached ourselves hard on the island. Foghorns, although used in the Northern states, were not commonly employed in Southern lighthouses. Mariners simply had to sit tight in foggy conditions and wait until it lifted before trying to enter an area along the coast.

As the bow of our boat plowed itself into the sandy beach, a young husky man approached and wanted to know our intentions in being there. After explaining that I was doing a book on lighthouses, his demeanor softened and he offered to give us a tour but not without first asking us to disable our outboard motor by removing the spark plug. I was confounded by his request until he explained that the lighthouse and small outbuildings served as a camp for young but hard-line felons. They were out there on the island trying their best to rehabilitate themselves, but I guess not to the point that the temptation of a small boat providing a convenient, unscheduled departure to the mainland might be impossible to resist. After we were shown around the grounds and lighthouse, the cover of fog lifted suddenly, exposing the full length of the handsome white-sand beach, with the lighthouse standing out like an exclamation mark against the contrasting dark foliage of the island.

Since that time, the boot camp–type program has been discontinued and the island is deserted. Today you can bring a boat over there, but since it's a private island, you're not supposed to walk above the high-tide mark. The best way to get there is by private boat, but there were several boat tours to the island from Georgetown, at least when I was there. Georgetown also offers tours of its historic downtown district.

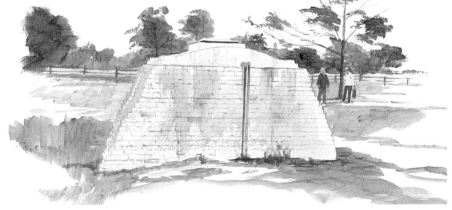

The original keepers' house has long since disappeared, but the oil house and this cistern still survive next to the lighthouse.

If you have your own boat, you can use the public boat ramp; otherwise there are also several small fishing and charter boat services in Georgetown that you can hire for a twelve-mile-ride to the lighthouse.

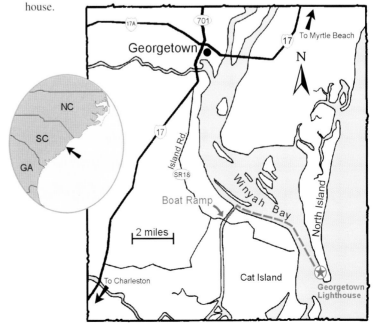

Cape Romain Lighthouse
Cape Romain, South Carolina
1827, 1858

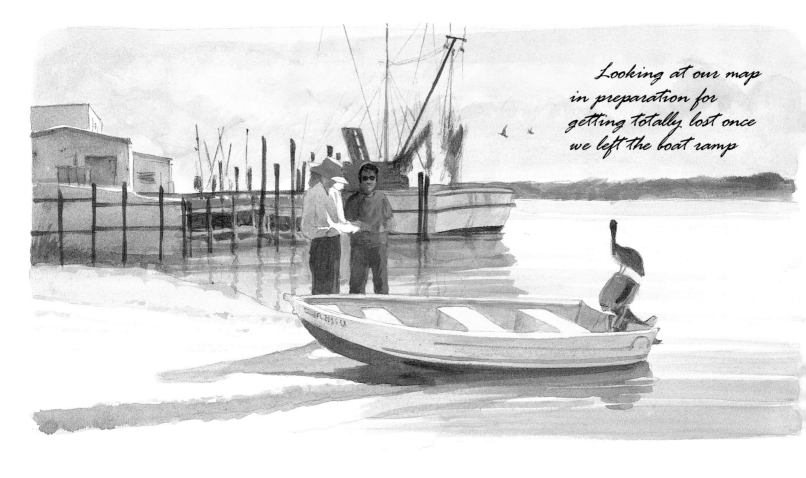

Looking at our map
in preparation for
getting totally lost once
we left the boat ramp

The thousands of saw grass patches made one gigantic maze, ideally suited
for losing one's way.

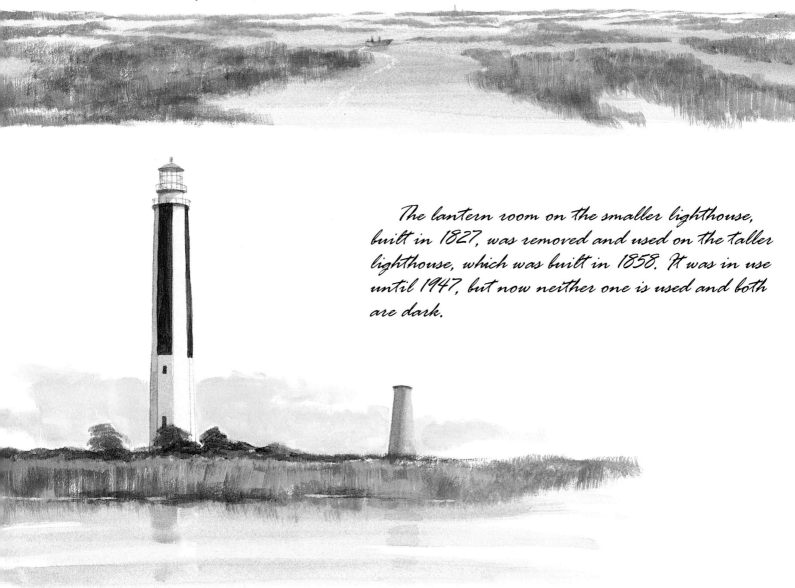

The lantern room on the smaller lighthouse,
built in 1827, was removed and used on the taller
lighthouse, which was built in 1858. It was in use
until 1947, but now neither one is used and both
are dark.

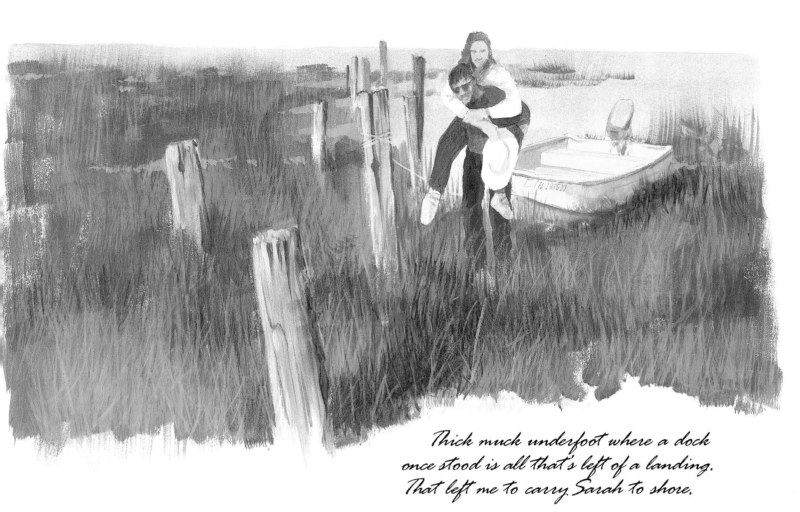

Thick muck underfoot where a dock
once stood is all that's left of a landing.
That left me to carry Sarah to shore.

Plenty of goats are around to greet
anyone who comes for a visit. Other
than that, the island is one of the most
remote places that you could ever visit.

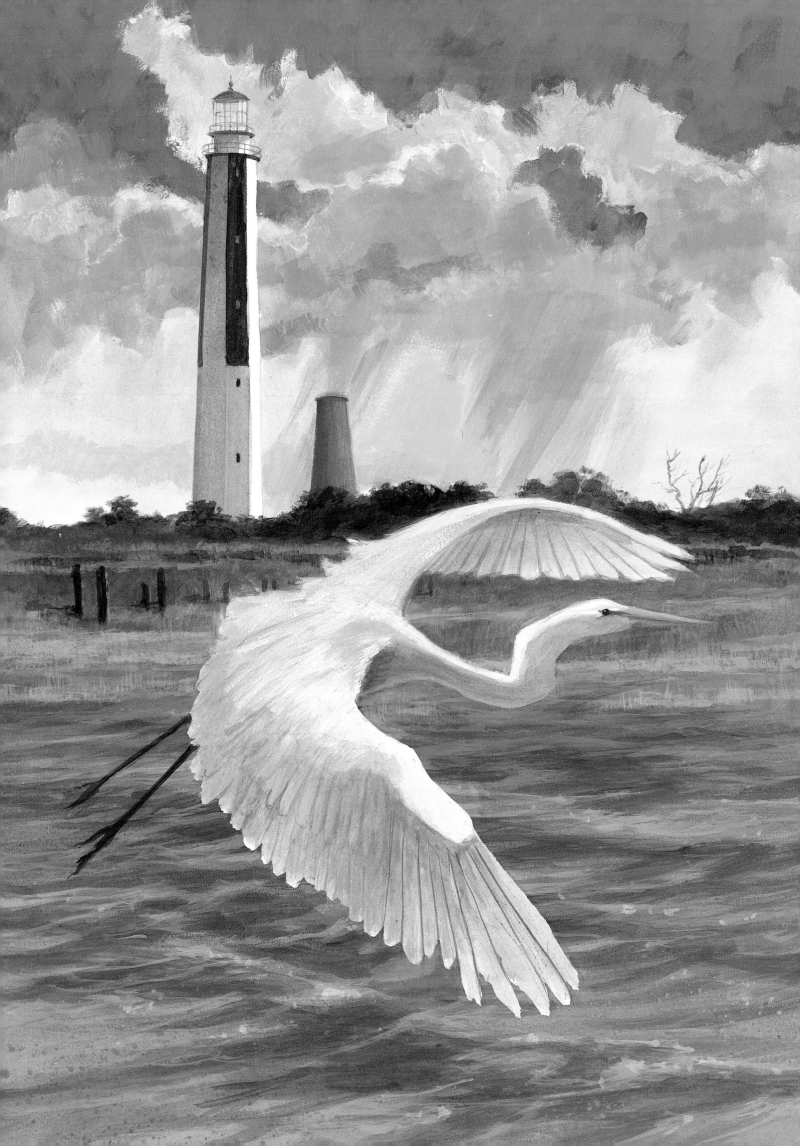

If you have an adventurous spirit, then Cape Romain is the place for you. It's not that there is a lot to see once you arrive, but the challenge is getting there, especially if you don't know the area well. When I was starting this book and getting together a list of the lighthouses to visit, Cape Romain didn't show up in most of the lighthouse books that I owned. I had heard it mentioned, but it really slipped my mind until we passed a sign on our way down Route 17 from Georgetown to Charleston. It read "Cape Romain Marine Sales" and had a small lighthouse pictured on one side. I drove a few miles, not thinking much about it, until a light went on in my head. We turned around and pulled into the gravel enclosure where I had first noticed the sign and where there was a variety of fiberglass boats on display. Inside the office, I inquired if there was a lighthouse nearby. After learning there was, I received a small map to help us find our way.

We drove down a side road a few miles and launched our small boat, with map in hand, but as soon as we left the dock we were lost, not once or twice but from then on. We found ourselves in a devious, never-ending maze of saw grass marshes just high enough not to be able to see over. They all looked exactly alike and were separated by narrow waterways. It was like one of those puzzles, straight out of the Sunday newspaper, where you have to find your way from one side to the other, only these were full size and we were the ones who had to find the exit. In addition, the lighthouse was so far away from our starting point, it was not even visible. After some effort and travel, we spotted what we thought was the lighthouse and slowly motored our way toward the tower. Eventually it became clear that we were heading in the right direction. The map we were so happy to have received actually became useless from the start, because once I took that first wrong turn, the map was totally meaningless. I didn't see one marker during the whole trip to tell us where we were.

After finally arriving at the lighthouses, we found what was years ago a dock with only a dozen or so short pilings remaining. They were camouflaged by marsh grasses and buried in a bottom of deep, soft muck.

I carried Sarah ashore and cautiously followed what was barely a path through the towering weeds and underbrush, shaking a stick ahead of me as I went. If I was going to startle some unsuspecting rattlesnake, I didn't want to do it by stepping on one, especially so far from the mainland, knowing the way back would be as difficult as getting there had been.

At the foot of one lighthouse, we heard noises nearby, and then it was evident who made the path—wild goats. Lots of goats. This was the most desolate place I have been in many, many years. I truly got a feeling of how desolate it must have been to tend a lighthouse at a place like this. If our outboard motor hadn't started, I think we might still be out there; that crossed my mind as we were looking around the lighthouses.

The two lights are close together, maybe five hundred feet apart. The older light, built in 1827, stood only sixty-five feet high and was meant to guide vessels past the dangerous shoals and to help southbound vessels from getting too far out into the Gulf Stream, which would slow their progress. Thirty-one years later, in 1858, a one-hundred-fifty-foot octagonal lighthouse replaced the first one. The top of the lighthouse, or lantern room, as it is called, was taken from the old light and used on the new one, leaving the red brick tower bare.

Within eleven years after the new tower was built, problems with cracking began to appear, and a few years after that, the lighthouse was leaning almost twenty-eight inches off-center, making it necessary to adjust and level the lens several times during that period until the settling stopped in 1891. The light burned brightly for eighty-nine years but was finally extinguished by the Coast Guard, and the lighthouse was reduced to a daymark.

We made our way back to the mainland, again losing our way several times, but the adventure was certainly worth the effort.

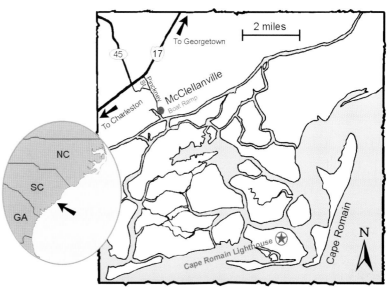

Sullivan's Island Lighthouse
Sullivan's Island, South Carolina
1962

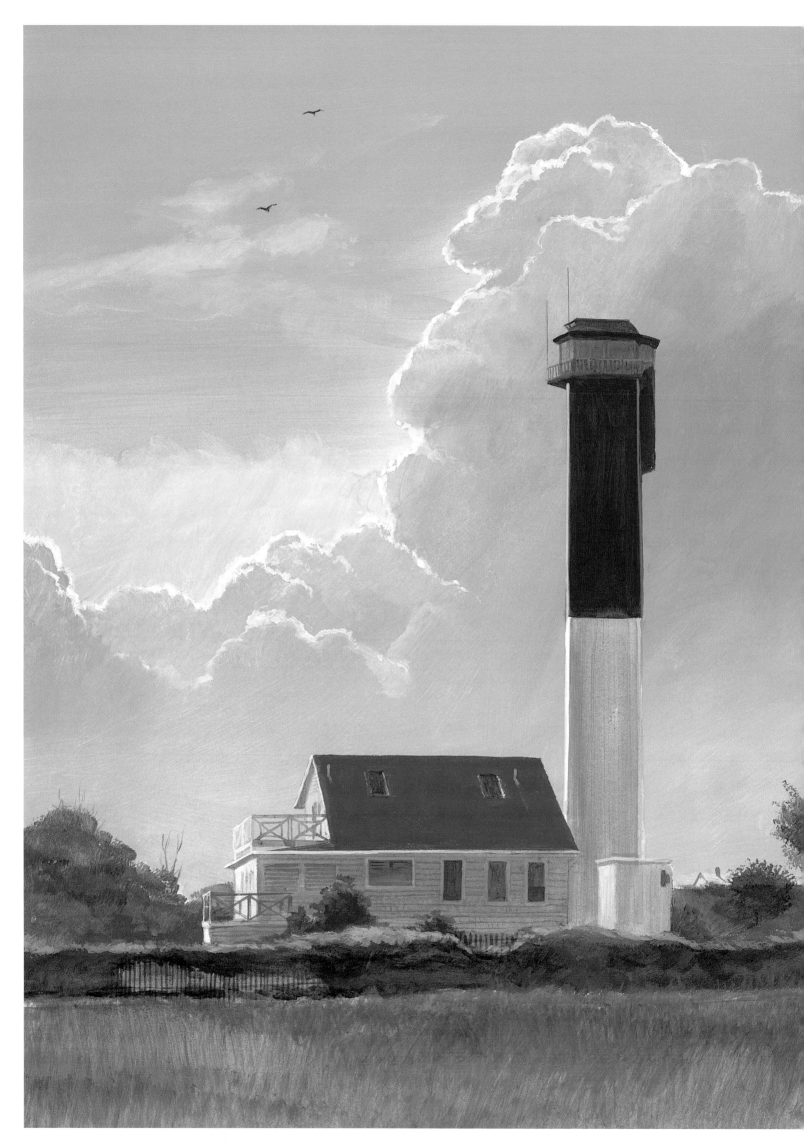

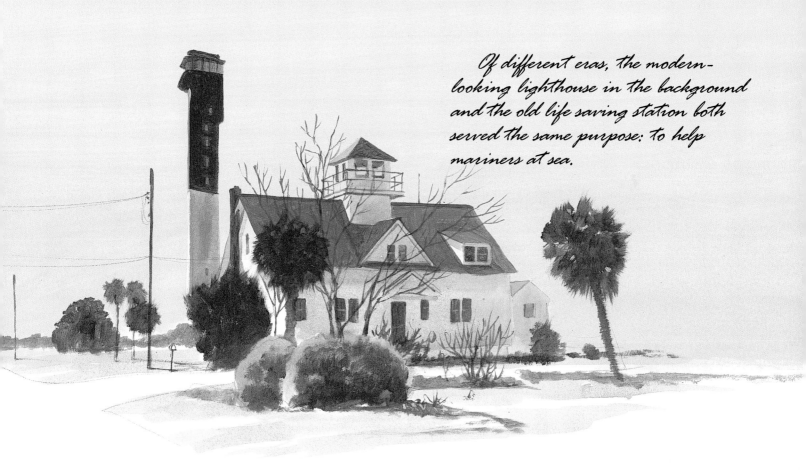

Of different eras, the modern-looking lighthouse in the background and the old life saving station both served the same purpose: to help mariners at sea.

The Sullivan's Island Lighthouse near Charleston, South Carolina, replaced the Morris Island light just across Charleston Harbor. Built with steel girders and sheathed with aluminum panels, it stands one hundred sixty-three feet high, almost twice as high as most lighthouses. The triangular-shaped lighthouse is the only one in the United States equipped with an elevator, and it's air-conditioned as well. There are two floors of office space at the bottom of the tower and office space in the gallery at the top. When first lit in 1962, the lighthouse had a complex array of high-intensity lamps that put out 28,000,000 candlepower. The bright light was intense enough to be dangerous, so in 1967 a lower intensity light with 1,170,000 candlepower was put into use. Today the lighthouse is automated and unmanned.

In 1898, a lifesaving station was established on Sullivan's Island just behind where the lighthouse now stands. The old building is still there and is used by National Park Service personnel as living quarters. Next door to it is the station's boathouse, which housed the rescue boats that would have been hauled to the beach and out into the surf during an emergency.

After visiting the Morris Island Lighthouse earlier in the day, we arrived at Sullivan's Island by late morning just as a huge fog bank unexpectedly rolled in, making it almost impossible to see the lighthouse even though we were right in front of it. The fog cleared for a few moments at a time, just long enough to get a good look at this powerful lighthouse before it was once again swallowed up by even denser fog.

The lighthouse isn't open to the public, but you can park, walk on the beach, and get very close to it, as well as to the old life saving station.

Just down the street from the lighthouse is Fort Moultrie, built in 1809 and once used for coastal defense. Closer to Charleston, you can also visit Patriots Point Naval Museum, where you can tour the world's largest naval and maritime museum and explore the aircraft carrier USS *Yorktown* as well as many other naval ships. Fort Sumter is also open for tours; it can be reached by one of two tour boats, one from Patriots Point and the other from the City Marina near downtown Charleston.

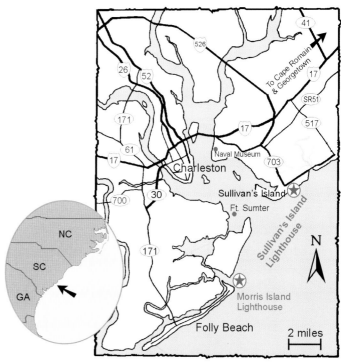

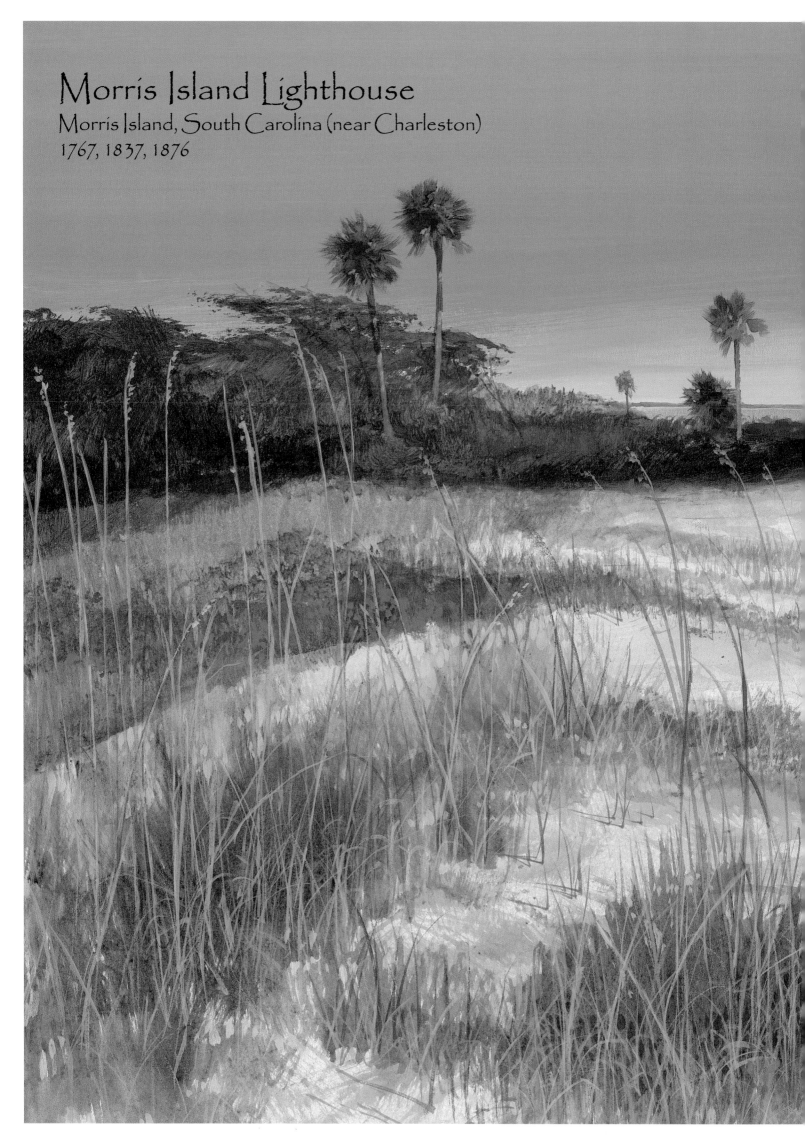

Morris Island Lighthouse
Morris Island, South Carolina (near Charleston)
1767, 1837, 1876

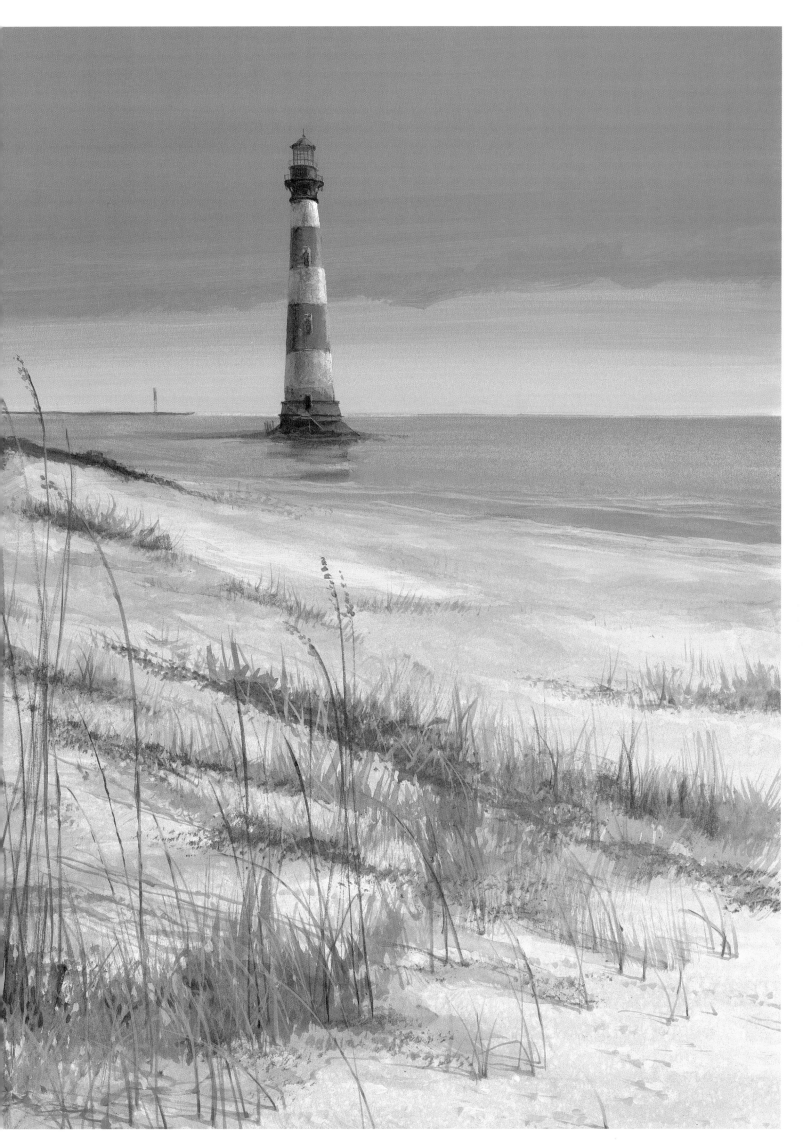

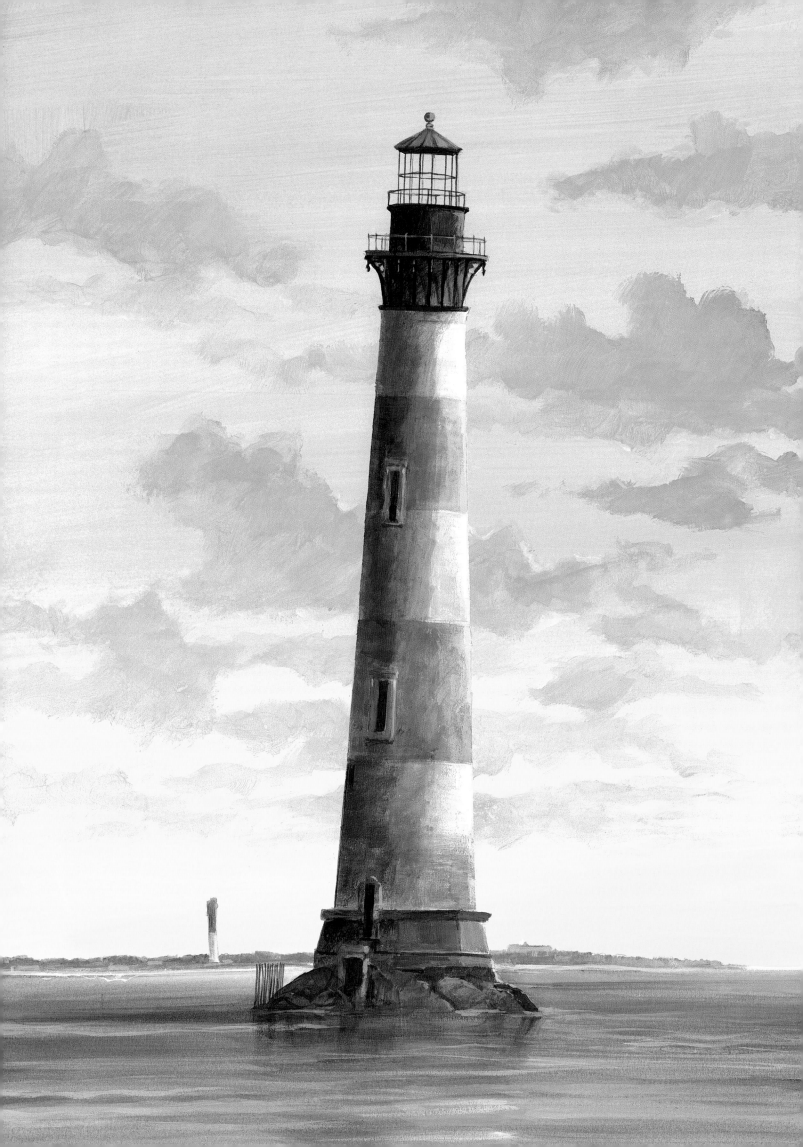

The first lighthouse at Charleston was built in 1767 just after the French and Indian War, when South Carolina was still a British colony. A copper plate attached to the cornerstone of the lighthouse reads, "The First Stone of this beacon was laid on the 30th of May 1767 in the seventh year of his Majesty's Reign, George the III." Burning pitch and oakum initially provided light, and later candles were used.

In 1837, the lighthouse was replaced by a new one at a different location, near Fort Sumter. It stood one hundred two feet high and received a first-order Fresnel lens a few years before the Civil War but was destroyed during the war.

Construction of the present lighthouse began in 1874 and was finished two years later. It sits at the mouth of the Charleston Harbor on what was once Morris Island and rises one hundred sixty-one feet. It was once surrounded by land and a graceful three-story, Victorian keepers' house, which looked more like a mansion than a home for the keeper and his two assistants along with their families. It was an elegant affair. Livestock, vegetable and flower gardens, and about fifteen buildings made up the complex that also included a small schoolhouse. A teacher came over from the mainland on Monday and stayed until Friday to help with the lessons.

The stately and well-kept lighthouse survived major hurricanes and even an earthquake, which devastated much of Charleston just fourteen years after the lighthouse was built. The passing of time, however, has not been kind, and years of beach erosion are forcing the old lighthouse into surrender. Despite the substantial foundation—consisting of piles driven fifty feet below ground, two courses of twelve-by-twelve timbers resting on the pilings and encased in concrete, then an eight-foot-thick foundation on top of that—the lighthouse is finally giving up. Its foundation is weakened, and the tower leans at an angle toward the sea, as if to bow to defeat. Erosion has also taken with it the keepers' house and all its buildings. The lighthouse stands alone, surrounded only by water, several hundred yards offshore.

A short but pleasant walk over the dunes at the end of Folly Beach is required to get to where the lighthouse can be viewed. It would appear that you could swim the several hundred yards to the light during low tide, and I considered it

A short walk over the dunes will get you to the lighthouse.

since there are no boat ramps anywhere in the area, but a swift current between the lighthouse and myself changed my mind. Better sense, along with my wife's strong suggestion, kept me from doing any more than thinking about it. The lighthouse is close to Folly Beach, so you should be quite satisfied with the view from there. A Holiday Inn is located several miles away, with a few small restaurants nearby, making it a nice place to spend the night.

A new lighthouse on Sullivan Island across Charleston Harbor currently operates, replacing the Morris Island light. It can be seen from Folly Beach as you look out at the old lighthouse. It's less than six miles away by boat, but to get to the Sullivan Island Lighthouse by car, it's twenty-four miles and takes close to an hour, as you have to drive around the harbor through Charleston.

Once surrounded by land and a beautiful keepers' house, this lighthouse has almost lost its battle against time and erosion as it begins to lean towards the sea.

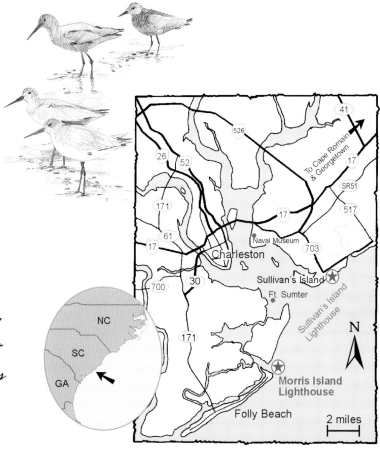

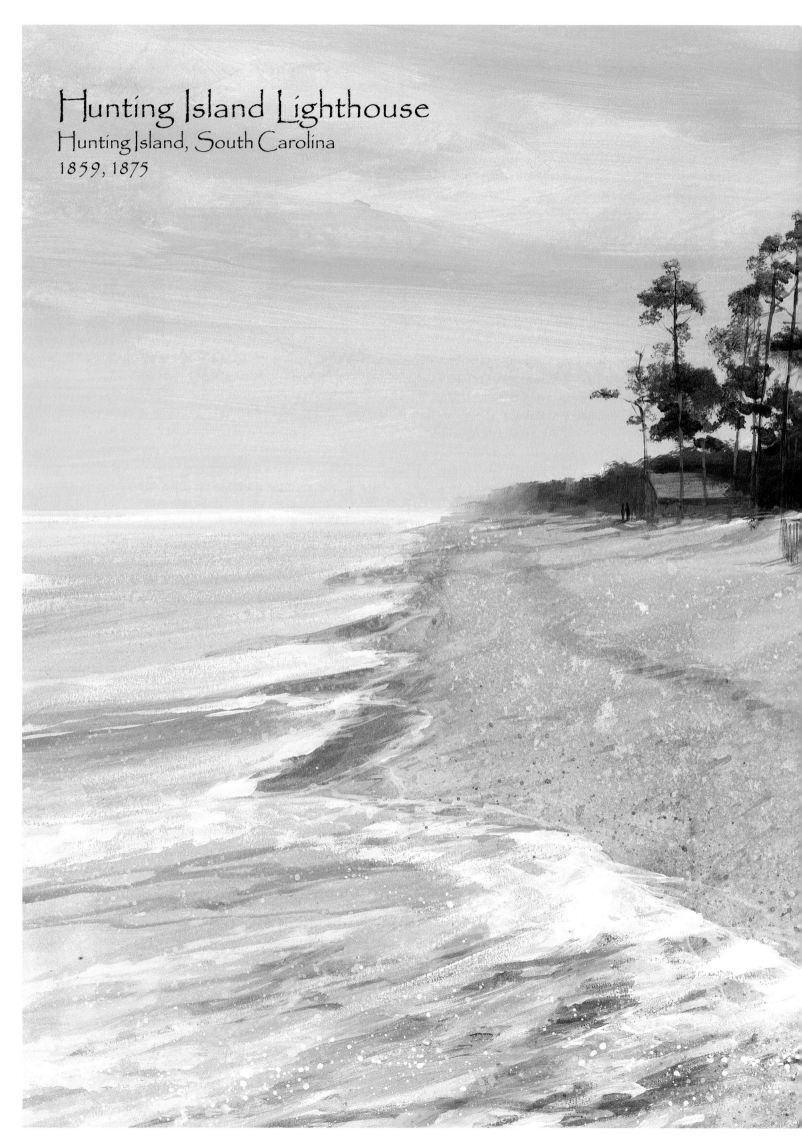

Hunting Island Lighthouse
Hunting Island, South Carolina
1859, 1875

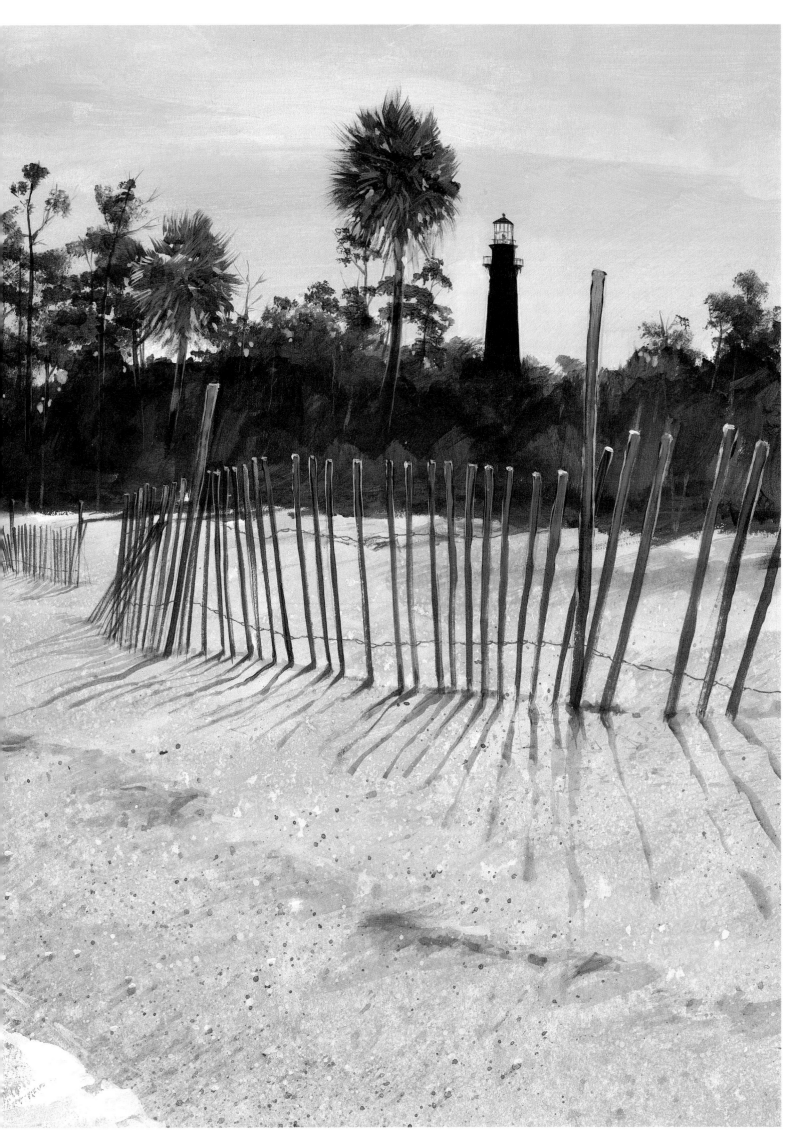

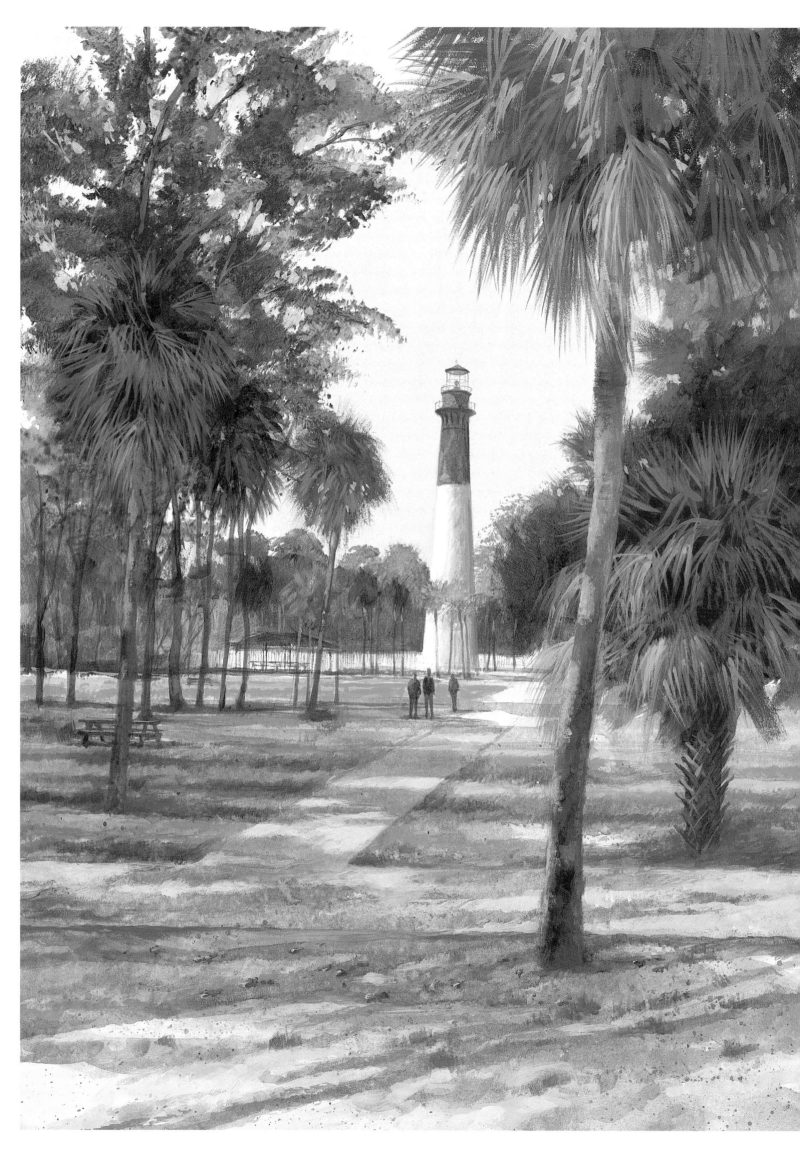

The Hunting Island Lighthouse was important because it served as a halfway mark between the ports of Savannah, Georgia, and Charleston, South Carolina. The lighthouse did not, however, guide ships into a safe harbor; rather, it warned them to keep away from the area's dangerous shoals and shallow waters. When a mariner sailing in the area saw the light, he would refer to a book called *Notice to Mariners*. There he could find the color pattern of the lighthouse, which in the case of Hunting Island is black on the top half and white on the bottom. At night, he could find out which lighthouse he was seeing by how often the light flashed in his direction.

An earlier lighthouse, standing ninety-five feet tall, was built of brick in 1859 but was destroyed during the Civil War. The Union had a much better navy than the Confederates, so the Confederates destroyed this lighthouse to keep the North from using any benefits that the structure could provide. Back then all lighthouses were Federal property belonging to the North, so for that reason alone the Confederates thought it was a good idea to blow it up.

A new lighthouse was built in 1875. Three lighthouse keepers along with their families were stationed at Hunting Island in the late 1800s, all in one large two-story house. They earned $740, $540, and $490 a year, respectively. Instead of being built entirely of brick like the first one, this time the lighthouse was constructed of large cast-iron sections and lined with bricks, similar in some respects to the one at Cape Canaveral, Florida. The idea was that if erosion

made it necessary to relocate the lighthouse, it would be possible to remove the brick lining and then disassemble the huge cast-iron sections. Just fourteen years after it was built, it became necessary to move the lighthouse, and the one-hundred-thirty-six-foot tower was taken apart piece by piece and rebuilt more than a mile inland. Today beach erosion has continued to make its way towards the lighthouse, and although it is in no immediate danger, it now stands only two hundred yards from the surf.

Thousands of palms and oaks line the winding roads that weave through Hunting Island State Park and lead to the lighthouse. The white sandy beach is a nice place to spend an afternoon swimming and picnicking. Hiking trails through the park can give you a better look at the stately cabbage palms and the variety of wildlife in the nearby salt marshes, which act as a nursery for much of the nearby sea life. There are no motels close by, but campsites and cabins are available in the park. Best of all, the lighthouse is open to the public. Modern technology has rendered this lighthouse, like most, a bit of a dinosaur so it is no longer lit, but you can still walk the one hundred eighty-five steps to the top for a great view of the island.

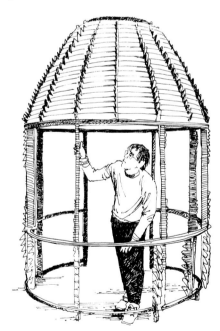

A first-order Fresnel lens is on display at the bottom of the lighthouse tower. Although much of the glass is gone, visitors can stand inside it to give them an idea of how large these lenses were.

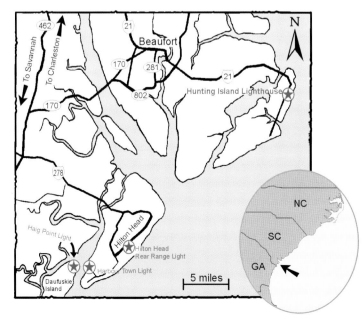

Hilton Head Lighthouse
Hilton Head Island, South Carolina
1881

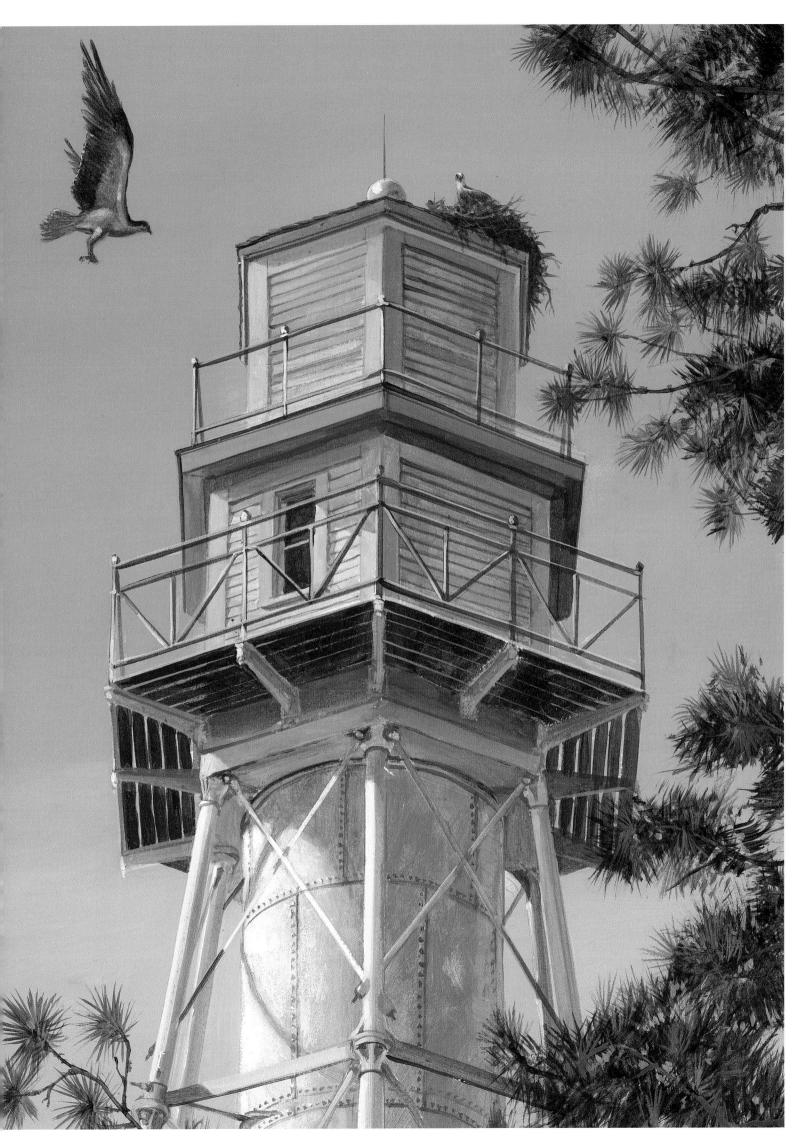

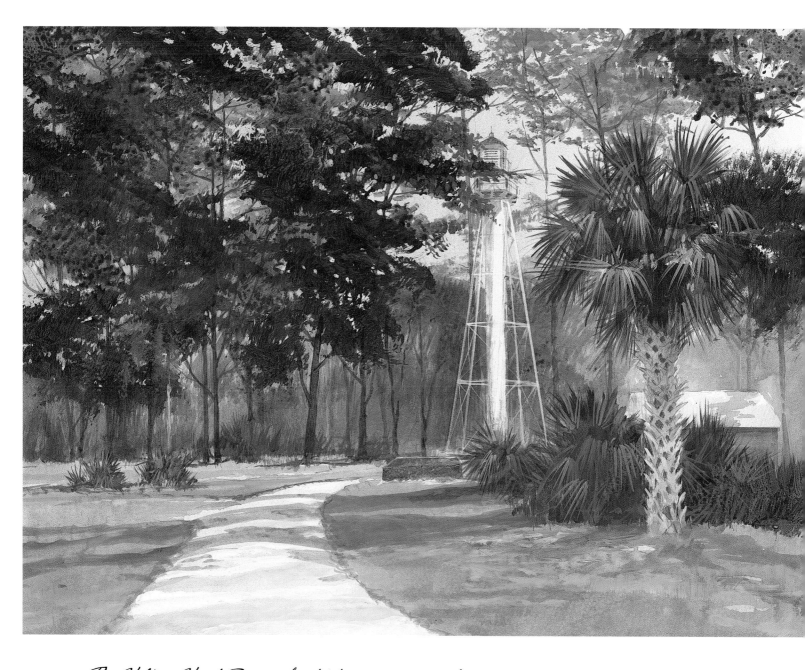

The Hilton Head Range Light has an unusual combination of steel legs and a lantern room made out of wood. When I was there, a pair of osprey made it their home to raise a pair of young. It's a quiet and peaceful spot above the manicured golf course.

This is the old brick cistern once used to collect water for the lighthouse keeper and his family.

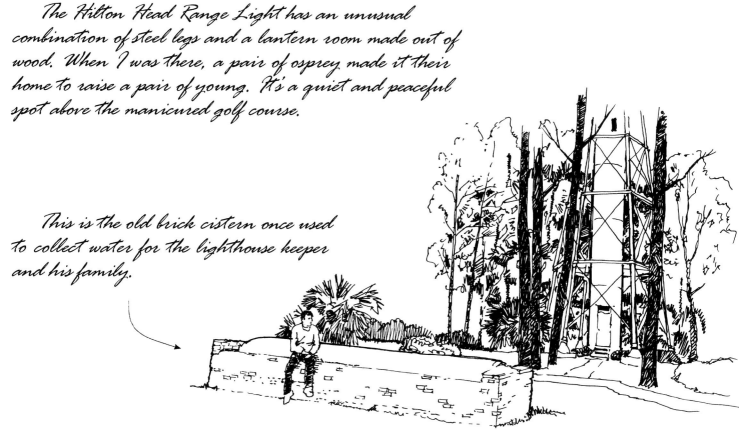

A range light, when lined up with a similar one behind it, will guide a ship safely through a pass. It's sort of like lining up the sights on a gun to get a straight shot. When both lights are lined up, the mariner knows he's on the right heading and won't run aground. Standing ninety-five feet high, this was one such lighthouse. The front beacon stood only thirty-five feet high and was constructed above the keepers' house, but it no longer exists. It proved impractical shortly after it was built as the channel was always shifting, so a movable lighthouse was put into operation in 1884 to compensate for the ever-shifting passage. Now only this rear range light-house remains, along with the keepers' house, which has been moved to the Harbor Town Marina several miles away. This skeletal-style lighthouse is the only one in the state and is an unusual combination of a cast iron crowned with a watch room and lantern room made of cypress.

This lighthouse, like most, has its own tale that has become part of its history. Hurricanes have visited all light-houses, and when the hurricane of 1898 hit the coast seven years after this one was built, keeper Adam Fripp died trying to keep the light burning. Just as a violent gust of wind tore through the lantern room, showering glass everywhere and extinguishing the light, Fripp had a fatal heart attack. In his last moments, he urged his twenty-one-year-old daughter to re-light the lantern and keep it burning. Her efforts were successful through the hardship, but the stress of it all was just too much: three weeks later she also passed away. Ghost stories were sure to follow, and they did. Sightings of the girl in her long blue dress, accompanied by traditional wails and sobbing, have made their way into the folklore of the light-house.

During World War II, the lighthouse served as a lookout tower for enemy ships. Temporary barracks and ammunition sheds, along with anti-aircraft guns, were positioned around the tower. Since then, Hilton Head Island has become a playground for the privileged few. Security is probably tighter now than when the military was here, and the lighthouse stands behind a gated community, where they scrutinize every soul who passes through hallowed portals.

Almost totally hidden behind tall pine trees on the Arthur Hills Golf Course at Palmetto Dunes Resort, this is not an easy lighthouse to get close to, but if you do get in, the setting is peaceful and pleasant. The oil house and cistern remain beside the lighthouse, and a well-maintained golf course now sets the stage for the once-important lighthouse. While electric carts loaded with enthusiastic golfers wheel past the long iron legs of the tower every few minutes, visitors driving from the highway will most likely miss it. You can barely catch a glimpse of the top of the lantern room above the trees. I drove by it several times before I spotted it.

Even when you're close to the lighthouse, it is so hidden among the pines that it's hard to see.

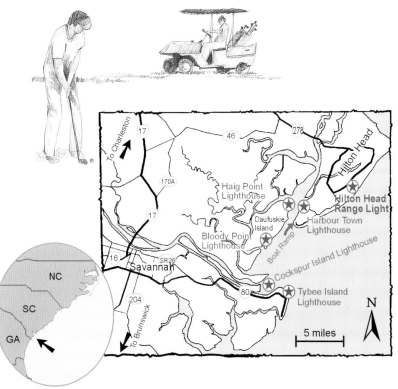

Harbour Town Lighthouse
Hilton Head Island, South Carolina
1970

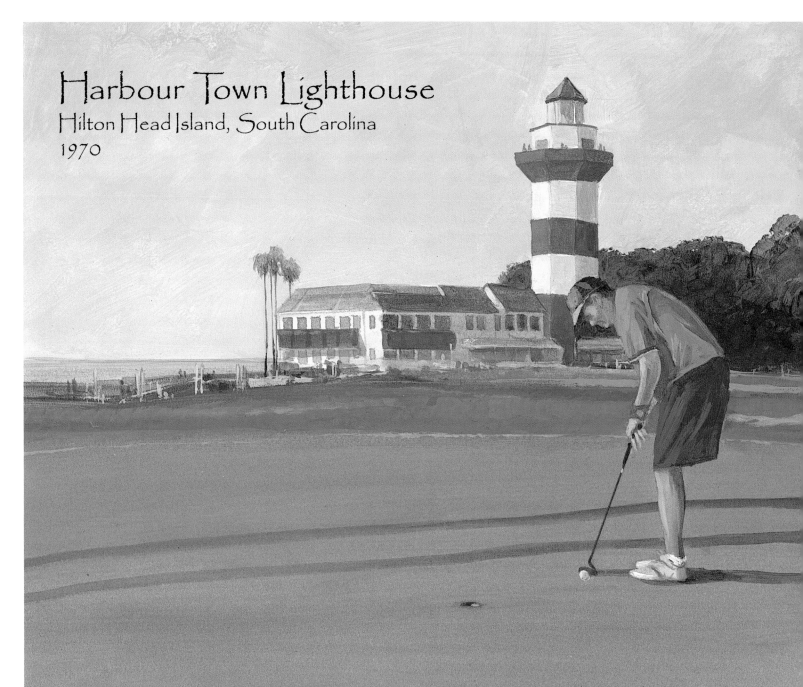

Surrounded by elegant shops, galleries, and restaurants at its base, the Harbor Town light at Hilton Head was built in 1970. It is quite well loved by residents and visitors even though many lighthouse purists resent it. The Coast Guard doesn't maintain it, and officially it's not a lighthouse at all although it does have a beacon inside. It does guide boats in from the waterway on the mainland side of the island, but the intention of this lighthouse is not to assist in safe passage. It was built for one purpose: to create an aid to commerce rather than an aid to navigation. It's basically a tourist attraction that acts as a three-dimensional sign and symbol promoting Hilton Head. The idea has worked and the beacon has become a prominent identification tool for not only the Hilton Head area but for South Carolina in general.

It will cost you a few dollars to get on the part of the island where the lighthouse is located. Many restrictions are in force on the island; for instance you can't trailer a boat in that area, as I found out. The whole island is designed to serve the privileged few. Not my kind of place, although I'll have to admit that the grounds are so well kept that it is impressive.

The lighthouse is open daily and there's no charge to walk the one hundred ten stairs to the top, where you can read plaques with information and pictures about Harbour Town and the lighthouse. Charles E. Fraser developed much of the island and built the lighthouse. Although his idea for this privately owned beacon met with skepticism at the time, over the years not only the lighthouse but all of Hilton Head has become more and more popular. The ninety-foot-high tower offers a nice view of the small harbor and the Harbour Town Golf Course, which is part of the Sea Pines Plantation development. When you get to the top, you'll find a gift shop full of typical souvenirs.

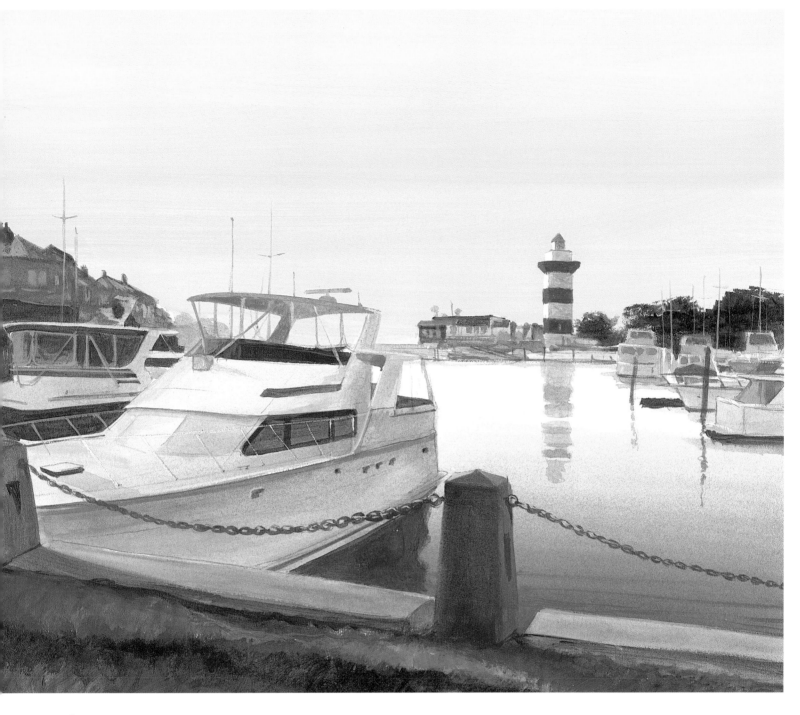

It's hard to paint this piece of property without making it look like an advertisement for a brochure. I'm sure it was designed that way to appeal to the aesthetics of a certain lifestyle. Although this area has an abundance of natural beauty, parts of it have been manipulated so much it appears a little too perfect for my liking. It tends to lose rather than gain character.

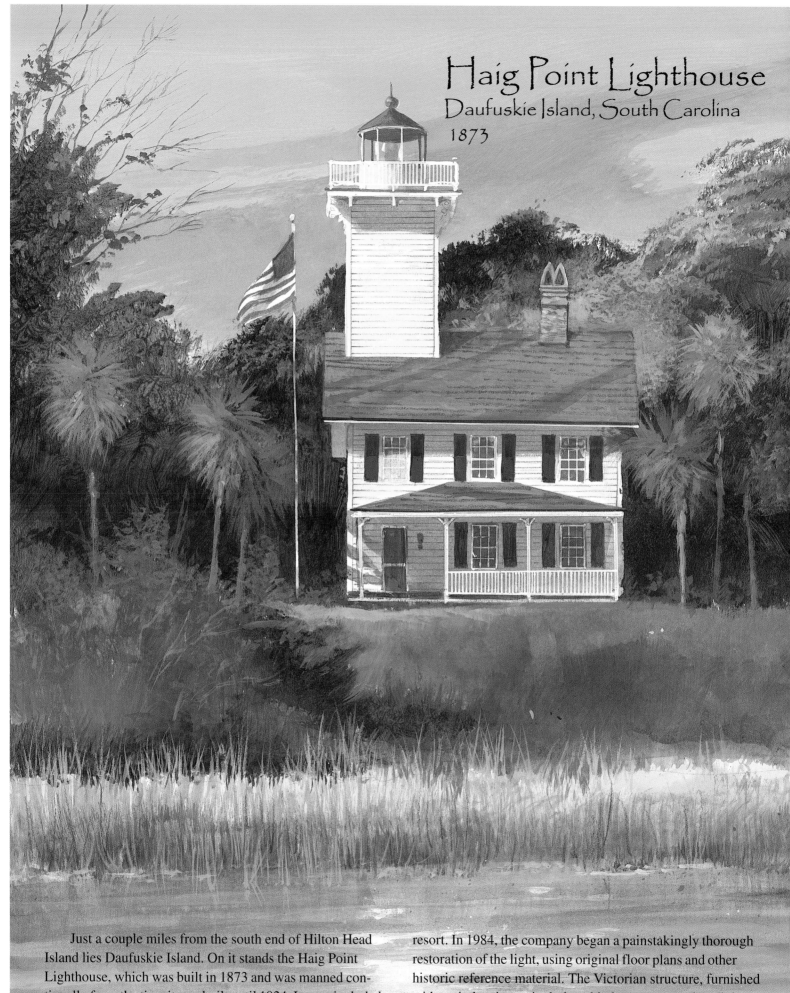

Haig Point Lighthouse
Daufuskie Island, South Carolina
1873

Just a couple miles from the south end of Hilton Head Island lies Daufuskie Island. On it stands the Haig Point Lighthouse, which was built in 1873 and was manned continually from the time it was built until 1924. It once included a wharf and boathouse, but they had fallen into major disrepair by the time the International Paper Realty Corporation of South Carolina bought the site to develop it as an exclusive resort. In 1984, the company began a painstakingly thorough restoration of the light, using original floor plans and other historic reference material. The Victorian structure, furnished with period antiques, includes a kitchen annex, parlor, dining room, and two upstairs bedrooms. It is used as a guest house by the organization that restored it, and although privately owned, the lighthouse is still listed as an "official aid to

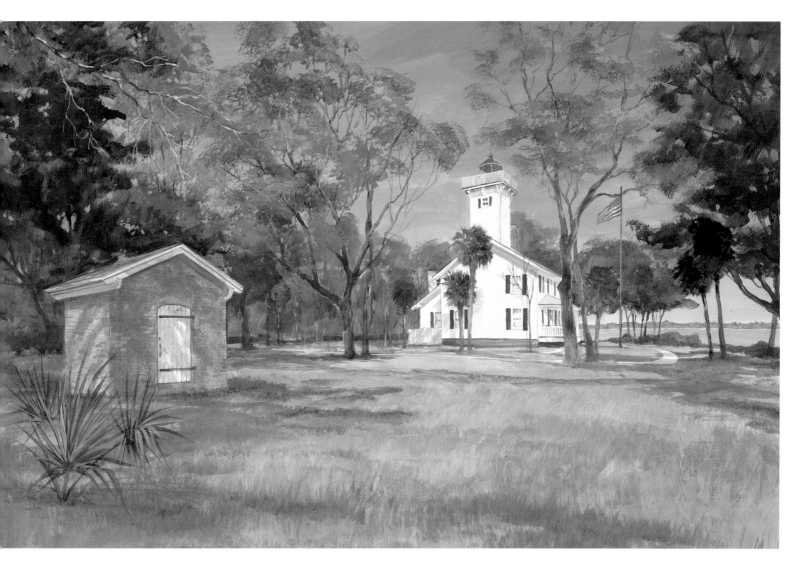

navigation." The original Fresnel lens is gone, and a modern acrylic, optic lens and solar panels powering batteries have taken its place. It's a gorgeous and well-kept lighthouse. Even the oil house and the six-thousand-gallon cistern are in fine condition.

Called a rear range light, Haig Point worked in conjunction with another nearby smaller light. When the two lights were lined up, ships could determine their position in the channel. Several like it were used to guide ships into the ports of Savannah and Charleston through the Intracoastal Waterway. Since the shoals were constantly drifting and changing, the channel would also change. To accommodate this, the smaller light was built on rails so it could easily be moved to reflect these changes in the channel. The smaller light no longer exists.

If you're thinking about visiting this beautiful lighthouse, I hope you have more luck than I did. The part of the island where the lighthouse stands its watch is an exclusive and very private resort, even more so than Hilton Head. With its golf course, tennis center, equestrian center, and large clubhouse, the island is off-limits to all but the rich. I called the resort and explained that I was doing this book and wanted to include the lighthouse. No amount of talking with the people in charge could persuade them to let me visit. This is a lighthouse that is not accessible to the public. Although they sent me a lot of information before

I took my small boat over to the island, I was told beforehand in no uncertain terms not to set foot on the island unless I was a member or the guest of a member.

A boat ramp is available at the end of Hilton Head Island, where you can launch for a fee. From there it's just a short hop over to Daufuskie Island. Just down from the lighthouse, there is a pier with a well-appointed reception center attached, but again we were met with some misgivings and told to leave after the people there saw my twelve-foot aluminum boat. It's a shame the lighthouse is not more accessible to the public. The good news is that you can actually see just about all you want to from the water.

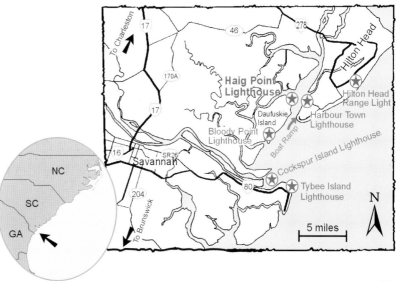

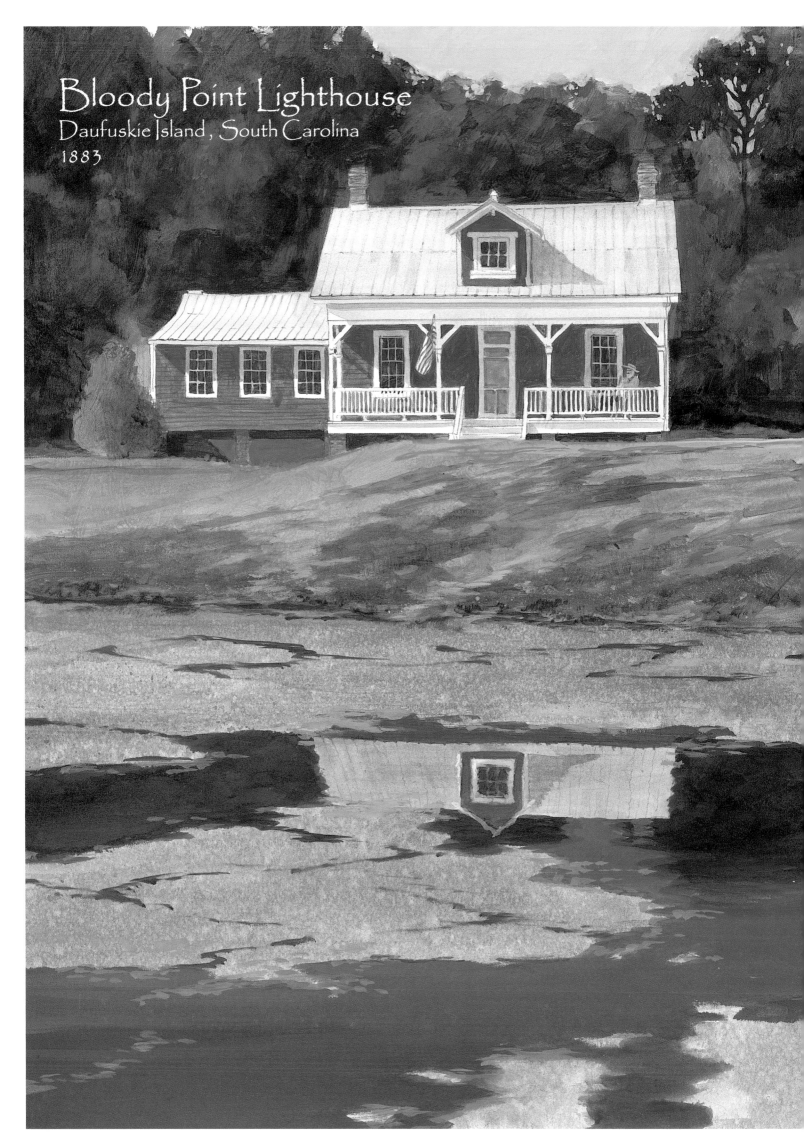

Bloody Point Lighthouse
Daufuskie Island, South Carolina
1883

Bloody Point lies at the southern tip of Daufuskie Island and got its colorful name because of several Indian battles that took place there in the early 1700s. Of all the lighthouses along the Carolina and Georgia coasts, the Bloody Point Lighthouse is probably the most ignored and forgotten. Most books I've seen don't even list this lighthouse even though it's unique and worth mentioning. Built in 1883, it was designed as a front range light. Its function was the same as that of the Haig Point Lighthouse at the northern end of the island, meaning that when a ship lined up the front range light with the rear range light, the ship was in the channel. The placement of these range lights was very important in the early days to ensure safe passage into and out of the busy port of Savannah, which is just to the south. John Doyle designed the light and was the first lighthouse keeper, receiving $620 a year for his efforts to keep the light lit and the buildings in order.

One reason that the Bloody Point Lighthouse is often disregarded is because it looks nothing like a lighthouse. The two-story structure is of the same design as the keepers' houses at Tybee Island. Except for the addition of a large dormer jutting out from the roof of Bloody Point, the buildings are identical. It was a typical-looking, residential structure of its day. The dormer is not what makes this lighthouse unique but rather the use of it. At night the dormer window was opened, exposing a fixed reflector lens that shone in the direction of the other positioning light, transforming this normal-looking house into a lighthouse. There was no need for a Fresnel lens as the light was meant to be viewed from only one direction, and the fixed lens served that purpose. At that time there were no other lights of any consequence except for the lighthouse along this area, so small range lights would not be mistaken for other buildings as might be the case today. Electric lights hadn't even been invented, so most of the coastline was quite dark. The lighting apparatus has disappeared, but evidence of it remains inside the house with the sheet metal exhaust stack, which vented heat from the light at the top of the dormer, still in place.

Nothing here looks like what we normally think of as a lighthouse. The Bloody Point front range light looked more like a typical house than a lighthouse, and the rear range light was altogether different. It was a steel skeletal tower with only three legs that looked like a large

tripod. Under it there stood what was called a wick house. There the lantern was stored and hauled out every evening. Then it was lit and hoisted on rails with a cable up to the dormer, where it burned all night. At daylight it was lowered and put away. The tower is gone now, but the oil house and wick house still remain.

As time passed, erosion ate away at the beach until it became necessary in 1899 for the front range light (pictured here) to be moved three quarters of a mile inland, with the help of oxen, to the exact spot where the rear range light had stood. History isn't clear as to whether the dwelling was used as a rear range light or strictly as a keeper's house after the move. It is certain that in its place on the beachfront, a new small, portable, steel skeletal light similar to the one at Sapelo Island was erected (pictured on page 113). This movable light had large, flat, circular steel pads on the bottom so it could actually be dragged to a different location. This needed to be done on occasion to keep the lights lined up with a sometimes shifting channel. Nothing is left of it, and the land where it once stood has washed into the sea.

During the 1950s, the oil house was converted to a small winery by Papy Burn, the last assistant keeper, who lived there for forty years. He fermented bananas, plums, oranges, and anything he could find to make small amounts of wine for his friends. Since then the oil house has been known as "the winery" to everyone on Daufuskie Island.

The northern end of Daufuskie Island is very exclusive and private, but the southern part is more relaxed. The Bloody Point Lighthouse has had several owners over the years, and although no longer in use as a lighthouse, it remains almost like it was when it was built well over a century ago. It is still difficult to see this lighthouse because there is no public dock on the island. Even if you get there, the lighthouse is privately owned so it's not available for public display. The only option is a tour that goes from Hilton Head Island to Daufuskie. Tour companies come and go, so check with the Hilton Head Chamber of Commerce to see if a tour is available.

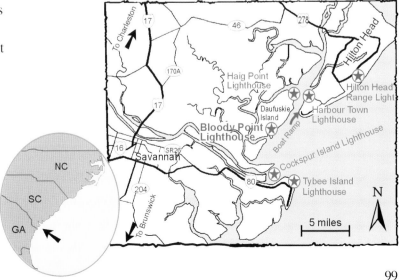

Cockspur Island Lighthouse
Cockspur Island, Georgia (near Tybee Island)
1848, 1857

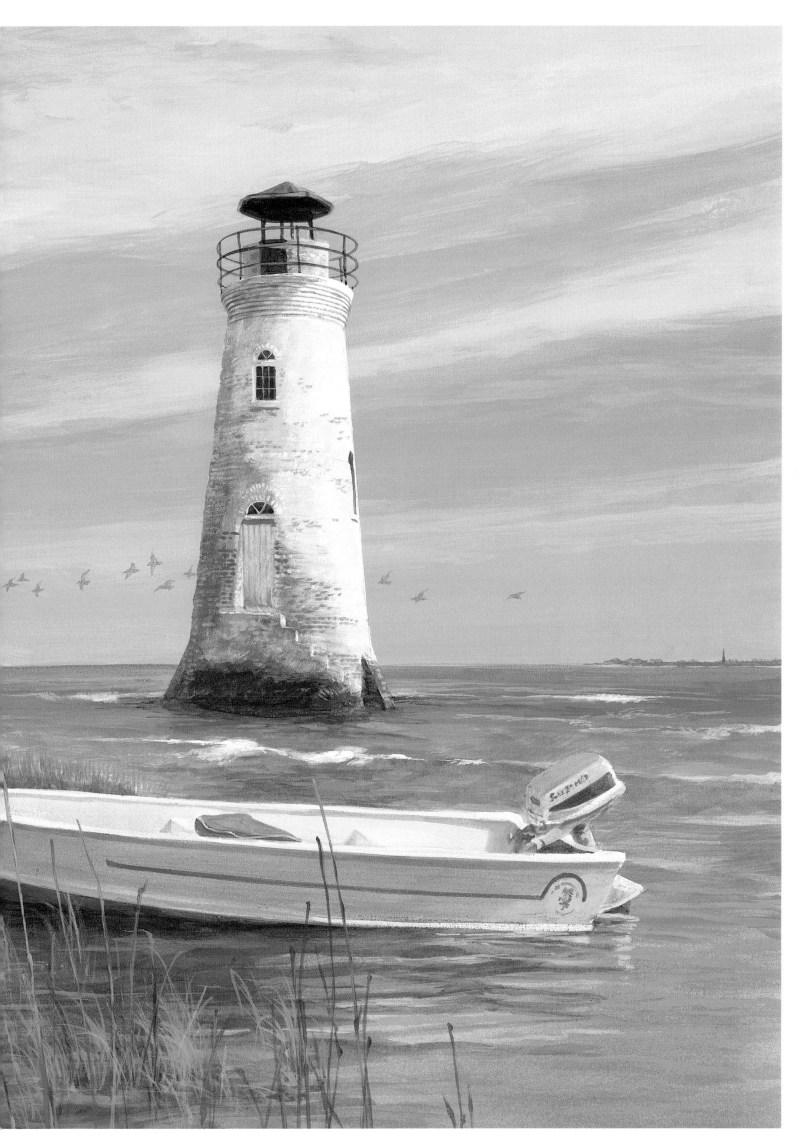

A little inconvenient to get to, the Cockspur Island Lighthouse was one of the most fun places to visit, not because there was much there but because the natural beauty of the entire area is just worth absorbing.

Most of the lantern room is gone. The little roof, built of plywood and held up by a couple of two-by-fours, was just put there by the park service.

One of the more delightful lighthouses that we visited was the Cockspur Island Lighthouse, just to the east of Savannah. The tiny oyster-shell island on which it sits is only two hundred feet long and about fifty feet wide, depending on the tide. Flocks of oyster catchers and other birds use it as a convenient feeding ground. As I explored the forty-six-foot-tall tower, the tide moved in around the light itself, and I had to wade back to the island almost hip-deep in water and surf.

The Cockspur Island Lighthouse, also known as the South Channel Light, was built in 1857, replacing another one built in 1848. It was used to mark the south channel of the Savannah River. It remained in service as an official aid to navigation until 1949, except during the Civil War, when it was darkened. It is little visited as it is inconvenient to get to but remains standing at its post, even though it has not been lit since it was decommissioned in 1909. Another lighthouse of the same design was built nearby around the same time, but it has not survived.

During the Civil War, a terrific artillery battle was fought between the Confederates at Fort Pulaski and the Union forces just across the bay at Tybee Island. The lighthouse sat in the middle of the bay directly between the two forces, but unlike so many other lighthouses that sustained damage during the war, the Cockspur Island light didn't even get bruised despite the hundreds of shells that passed overhead. That wasn't the case with Fort Pulaski, however, because a new type of cannon called the "rifled cannon" had just been put into use. Its devastating punch on the brick fort forced the Confederates into surrender within thirty hours and made brick forts obsolete.

The first lighthouse keeper to tend the light at Cockspur Island had the appropriate name of John H. Lightburn. Later on, another lighthouse keeper had a sister named

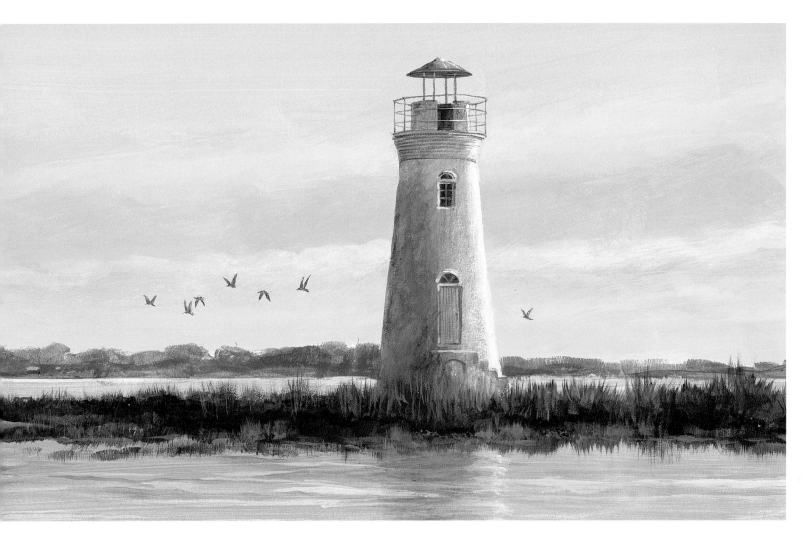

Florence Martus, who later lived on nearby Elba Island. Folklore has it that she was spending the afternoon with her brother when a sailing ship docked at Savannah. A few of the sailors rowed out to Fort Pulaski, just a stone's throw from the lighthouse. Florence's brother offered to give the sailors a tour of the island and lighthouse, and Florence went along for the ride. She and one of the mariners caught each other's eye. During his time in port, he visited Florence three times, and when he left, promised to return and marry her. The morning the ship left port, Florence stood in front of her cottage and waved a white handkerchief. The sailor never returned, but Florence faithfully greeted every passing ship with her white handkerchief for the next fifty years. She became a welcome site for all mariners who came to expect to see her as they entered port. During the years, many sailors brought her gifts. One even presented her with a llama from Peru. Today sailors and visitors alike can still see Florence at the port of Savannah, as a bronze statue in her likeness greets everyone who passes by.

The lighthouse is open to the public. The only way to get there is by taking a boat or by wading out to it through the marsh grass from Fort Pulaski. If you do that, plan on getting pretty wet because in parts, it's not very shallow. If you have a boat, the public boat ramp is just off the highway leading out to Tybee Island. You can see the lighthouse from the highway on your left just after you pass Fort Pulaski, but it's easy to miss if you aren't careful.

I couldn't help but think what an inhospitable little island this was for a lighthouse keeper, with nothing but sharp oyster shells to walk on and no shade trees to hide from the sun. Of course, one hundred years ago it may have looked quite different. If I have learned nothing else about lighthouses, I have learned this: beaches come and go, often taking lighthouses with them. It surprises me any of them are left standing.

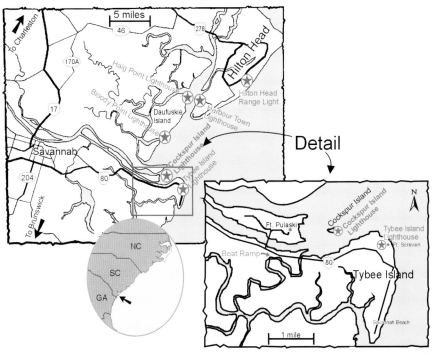

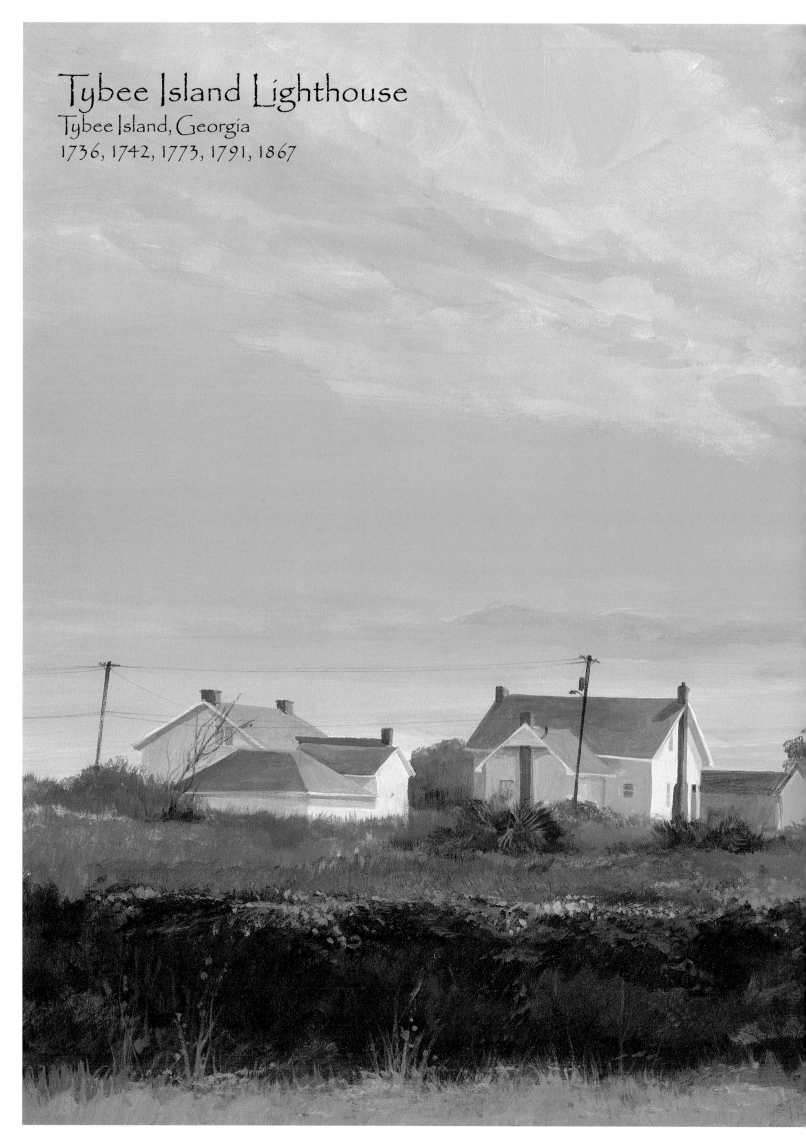

Tybee Island Lighthouse
Tybee Island, Georgia
1736, 1742, 1773, 1791, 1867

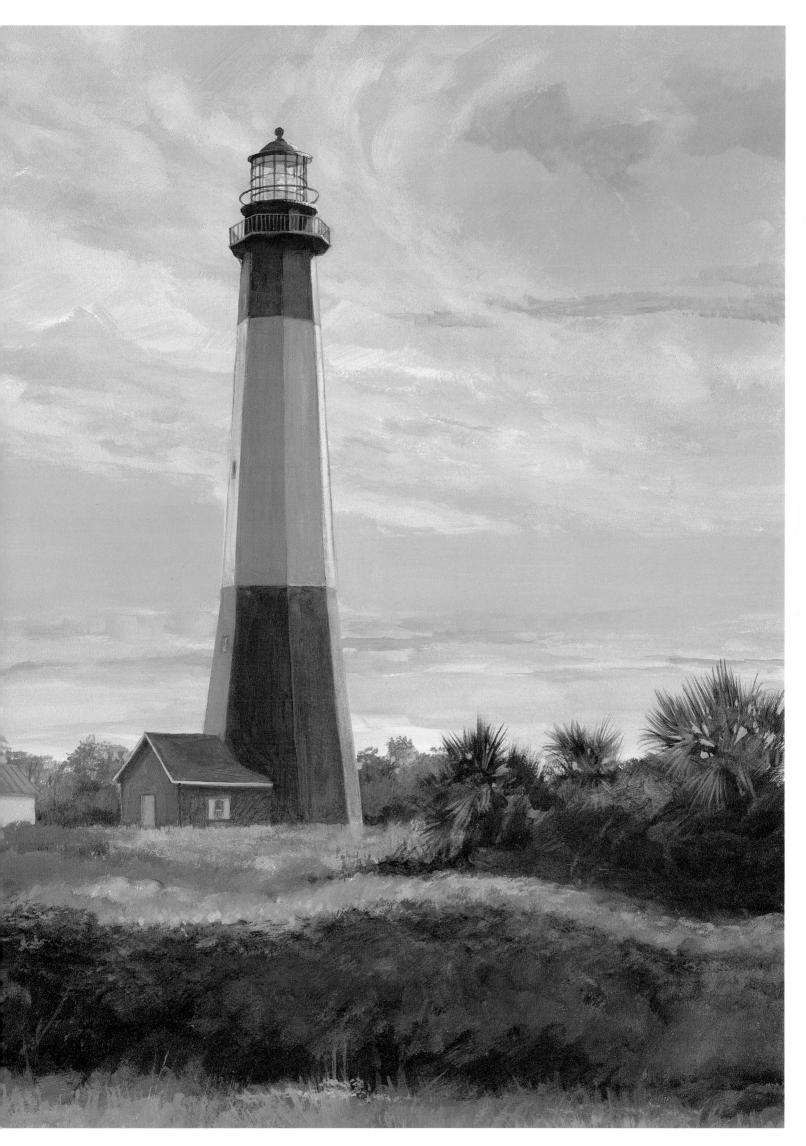

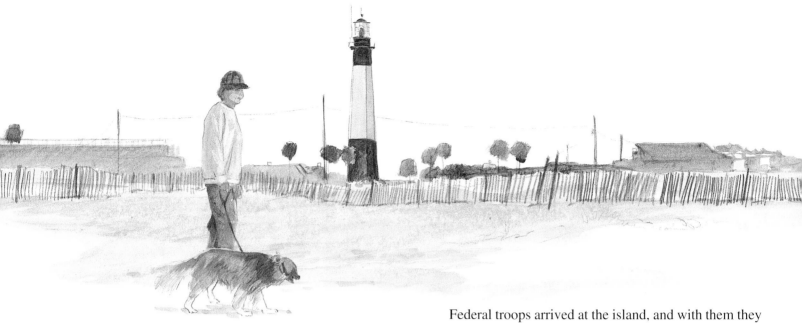

The lighthouse has had six similar but different color patterns on it since the Civil War. It's open to the public and is one of the best kept and enjoyable lighthouses you can visit.

Lighthouses serve the same purpose during daylight hours as they do at night, when sailors look for a particular flash or characteristic of light to identify their position. That's why lighthouses all have different colors, markings, stripes, bands, and so on, known and used as "daymarkers." The first structures that helped guide ships into the port at Savannah didn't have lights at the top at all and were used only as daymarkers. The first one was built on Tybee Island in 1736 and made of wood. It stood ninety feet high, was octagonal in shape, and at that time was reported to be the tallest building of its kind in America. Five years later it came crashing to the ground in a storm. Another tower was built of stone and wood in 1742, but bad weather destroyed it too. A third one was built entirely of brick in 1773 and placed inland a bit to prevent erosion and severe storms from pounding it. Eighteen years later, in 1791, after Georgia had become a state, the federal government took over the marker and placed a light on top. Candles were used as a light source, as was the custom at the time, but fire broke out and damaged the tower. It was repaired, and a new illumination system was installed. Instead of candles, the Lewis lamp used an array of oil wick lamps, each having its own reflector. It was better than candles but less than adequate. In 1857, the tower was fitted with a bright, second-order Fresnel lens.

Four years later, the Confederate army removed the lens and set fire to the lighthouse as they retreated from an attack by the Union. The lighthouse remained dark and heavily damaged during the war. Rebuilding started after the war was over, but the upper portion of the structure was in such bad shape that it had to be replaced, leaving only the bottom sixty feet of the original tower.

Federal troops arrived at the island, and with them they brought cholera. Some of the workmen died, and the others scattered to avoid the disease. When they returned, they found that the soldiers had done a fair job of vandalizing everything in sight, and most of the work had to begin again. The tower was completed in 1867, reached a finished height of one hundred fifty-four feet, and was fitted with a first-order Fresnel lens, one of the largest and brightest available, making the light visible from almost twenty miles at sea.

Powerful storms have hit the area several times in the past, so much so that they cracked the tower. An earthquake in 1886 furthered the damage and cracked the lens. The lighthouse board concluded that a new lighthouse needed to be constructed, but Congress disagreed and so the old tower still stands today. The color scheme of this lighthouse has been changed six times since it was built. At one point, part of it was painted gray, a very strange choice. Mariners must have also thought so, as it didn't last long. In years past, it was painted white on the bottom third and black the rest of the way up. Now the Tybee Island light has been restored to its historic 1916–1964 paint scheme.

A major restoration project began on the lighthouse in 1998. It was the first time in 131 years that the light had been turned off for any length of time. One hundred fifty days later, in February of 1999, the work had been completed and the tower beautifully restored. Bulletproof glass was even installed to further protect the lens, which is valued at over three million dollars. You can walk to the top of the lighthouse and also see the summer kitchen built in 1812 and the three keepers' dwellings. There is also a nice gift shop in one of the buildings. The Tybee Island Museum is across the street from the lighthouse and houses a collection of Tybee Island artifacts that includes everything from Native American to World War II items. If you like swimming, the beach is beautiful, and there are several small places to get something to eat right there between the lighthouse and the beach. I tried to get a different

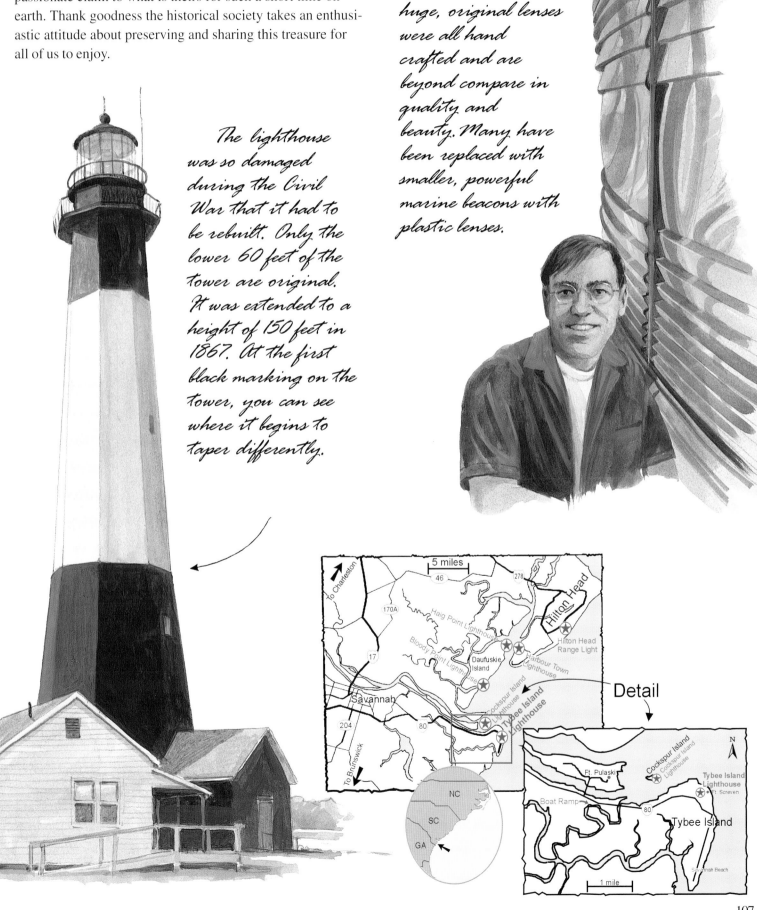

perspective of the lighthouse by driving through some of the new residential areas that have recently sprung up. They too have great beaches, but unfortunately those new developments are fiercely protective of their world and do all they can to keep everyone else out. There's still plenty of beach left across from the lighthouse for the enjoyment of visitors. I just get a little annoyed at how some people stake such passionate claim to what is theirs for such a short time on earth. Thank goodness the historical society takes an enthusiastic attitude about preserving and sharing this treasure for all of us to enjoy.

The lighthouse was so damaged during the Civil War that it had to be rebuilt. Only the lower 60 feet of the tower are original. It was extended to a height of 150 feet in 1867. At the first black marking on the tower, you can see where it begins to taper differently.

The first-order Fresnel lens at Tybee Island is one of the largest of all the lenses used in lighthouses. These huge, original lenses were all hand crafted and are beyond compare in quality and beauty. Many have been replaced with smaller, powerful marine beacons with plastic lenses.

Detail

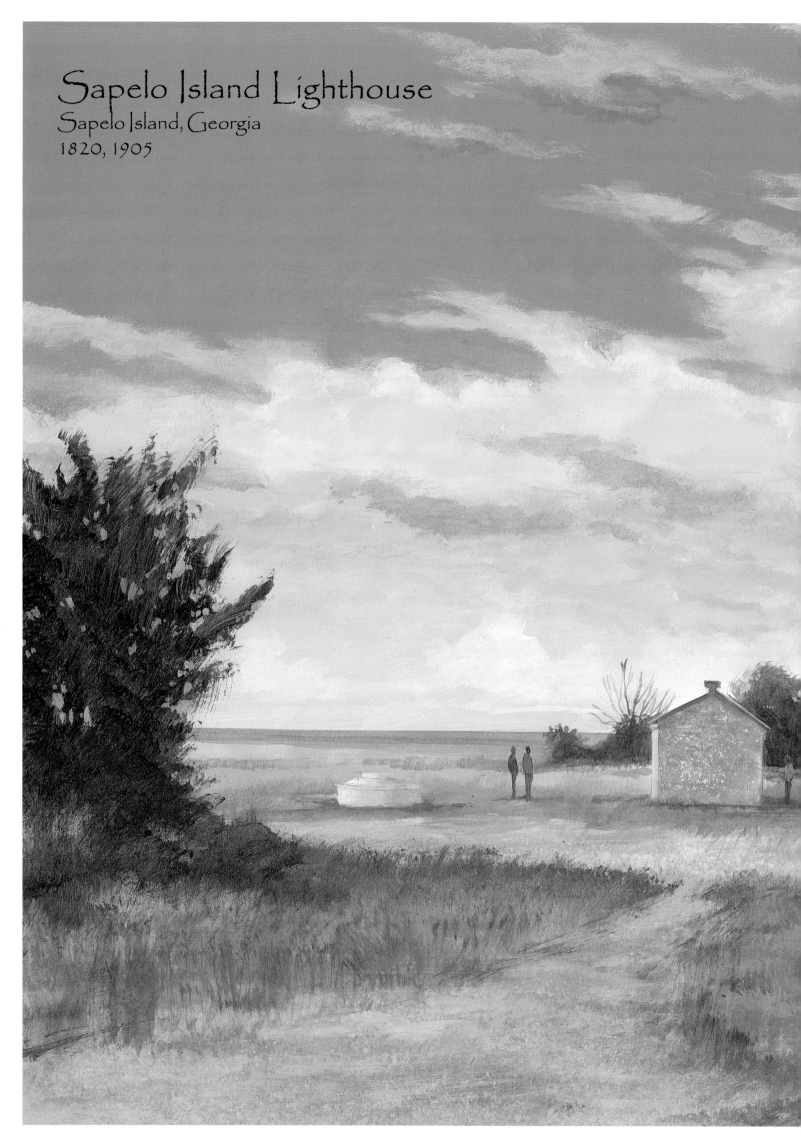

Sapelo Island Lighthouse
Sapelo Island, Georgia
1820, 1905

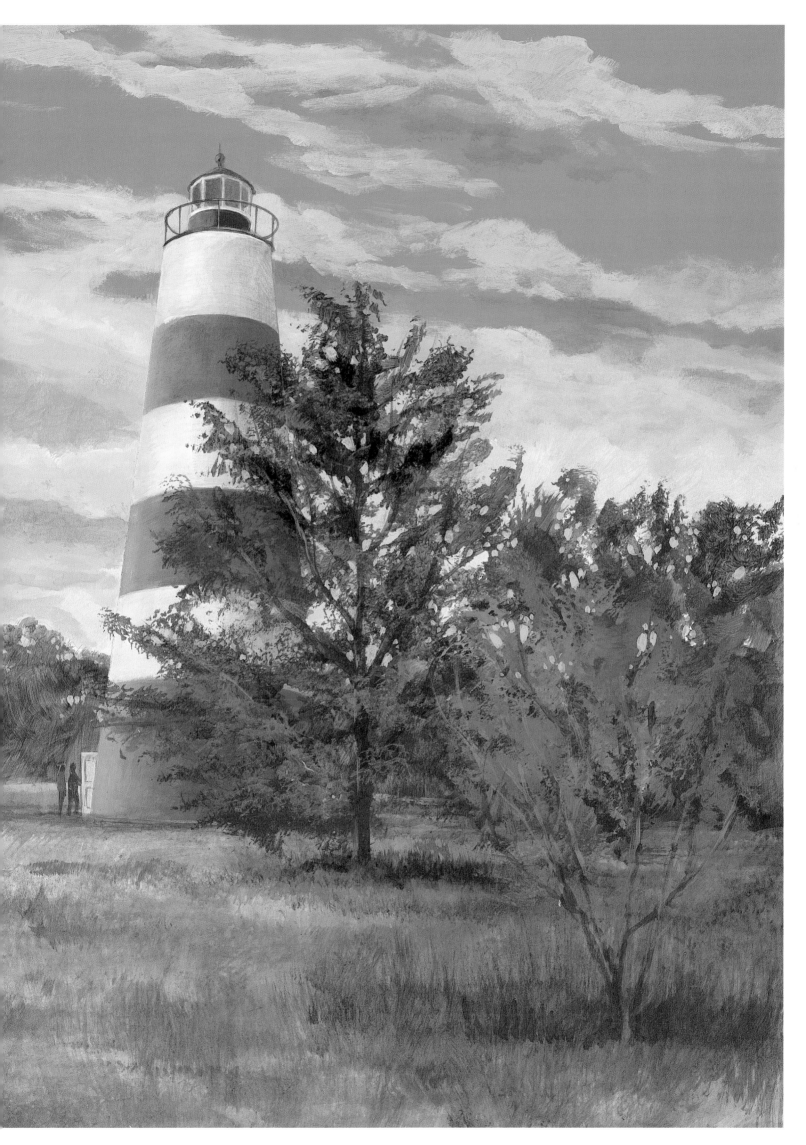

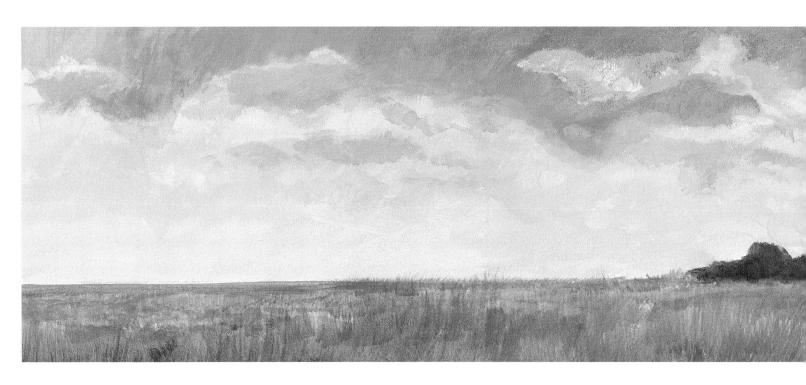

Sapelo Island is by far the most fascinating and unique place that I have visited while painting the lighthouses for this book. The island's eighty-foot-tall tower with its red and white stripes is a handsome sight as it sits in the midst of the tall cordgrass that extends out into the lush tidal salt marshes.

There have been two lighthouses at Sapelo Island. The lighthouse that is standing now was built in 1820, but a hurricane and tidal rise in 1898 left the lower part of the lighthouse eighteen feet underwater for several hours. This so severely undermined and damaged the foundation of the brick tower that it was deemed unsafe, and a second lighthouse was built in 1905 just a few hundred yards away to replace it. Called a skeletal lighthouse, it was made of cast iron, similar to the one at Sanibel Island in Florida. It had a cast-iron tube running up the center to the lantern room and was supported by iron legs that ran from the top outward to the bottom. It was deactivated in 1933, just twenty-eight years after it had been built, when shipping into the Darien area declined so much that there was no longer a need for it. Today the port at Darien is home only to shrimp boats. The lighthouse was dismantled piece by piece and moved to South Fox Island on Lake Michigan, where it stands today. Only the concrete supports for the base remain at the site, along with the oil house and the collapsed dock that once serviced the lighthouse. The two keepers' houses that once stood on each side of the light were also taken down at the same time the lighthouse was dismantled, and the lumber sold as scrap on the mainland.

The first lighthouse remained intact but stood damaged and in disrepair until 1998 when, one hundred years after the devastating hurricane put it out of commission, the foundation was once again made stable and a beautiful restoration was completed inside and out. The old cypress spiral staircase that had rotted away and fallen in was replaced with a new one made of Georgia pine. It was a major job, as each step is slightly different from the next. That part of the job, which involved dealing with the many snakes that had made the lighthouse their home between the interior and exterior bricks for so many years, took several months to complete. A modern beacon at the top now makes this lighthouse a working aid to navigation once again, but since the port at Darien hasn't grown, the restoration primarily serves the historic value of the community rather than the port.

More interesting than the lighthouses is the island itself, with its unusual history and rich heritage. There are only one hundred twenty-five residents on the island, fewer than at any other time in its history. Of these, seventy live in the community of Hog Hammock; most of them were born and raised on the island and have lived there all their lives. Their ancestors were slaves brought over from Africa. Lifetime resident George Walker showed us around the island and made us feel at home as we rode down the sandy roads in his old car. He was born on the island, like the four or five generations before him. LuLu, his wife, also grew up on Sapelo. Together they run a small restaurant that serves the local community, a place that day-tourists would never even come across as it is hidden on one of the small dirt roads in

This is George Walker. He was born on Sapelo Island and has lived there all his life, just like generations before him.

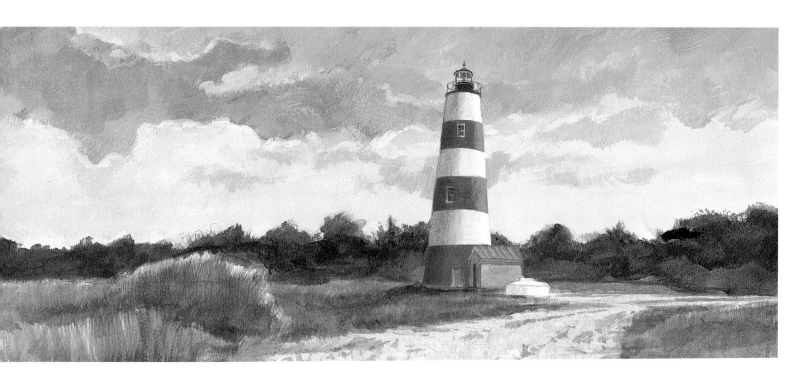

the woods. A few of the residents like George make themselves available for private tours of the island, and it's a good way to get a more personal look around.

When I was there, the park service offered tours on Wednesdays, Fridays, and Saturdays, and most people who visit take that option. Old yellow school busses are used for the job. There are some paved roads on the island, but most roads are

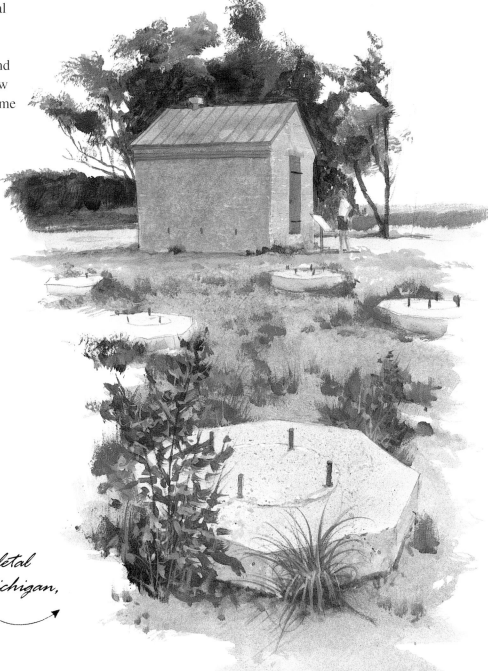

A skeletal lighthouse, like this one, once stood just a few hundred yards away from the red-and-white-striped lighthouse.

Now all that remains are the foundation and oil house. The skeletal lighthouse was moved to Lake Michigan, where it still stands.

winding sandy paths just wide enough for one vehicle.

Along the way, a stop at B.J.'s Confectionery is mandatory. It's the only store on the entire island. What you will get here, more than a salty snack, is a genuine trip back in time. The selection of groceries here amounts to less than what most kitchen pantries would stock. As the bus parks on the dirt road with its deep ruts, visitors flock out to get a cold drink. After they leave, the only activity is made by the many birds in the trees that shade the store, and by Viola, the owner, who quietly continues to weave her wreaths made from grapevines for the next batch of visitors, who will arrive in a couple of days. Groceries, for the most part, are ordered by each family from the mainland and shipped over to them several times a week.

I'm not sure I could live a lifestyle like this and do without my computers, digital cameras, copy machines, and all those wonderful gadgets. But the older I get, the more appealing it seems. If nothing else, B.J.'s Confectionery will give you a little perspective.

B.J.'s Confectionery is one of those wonderful places on earth that represent a lifestyle that most of us can only imagine in its simplicity. It's a testimonial to "less is more."

There is another lighthouse that sits near the brick tower, a third, so to speak, but it differs in that it serves as a front range beacon. When the light that shone from the window of the short tower lined up with another similar one down river, it guided ships on a straight path through the Doboy Sound up to Darien. Since channels sometimes shift and change over time, the cast-iron beacon was built in several sections so it could be dismantled and moved to another site to compensate for any changes in the channel and could still guide ships on a straight path. It never was moved, however, and the beacon sits where it always has, just one hundred yards from the Sapelo Island Lighthouse. Originally built in 1877, the beacon has been fully restored. The rear range beacon across the channel no longer exists.

The light from inside this rear range beacon was used to guide ships into the port of Darien. Another similar one was placed nearby. Ships would line up the two lights, as on a gun sight, to ensure their straight passage through the channel.

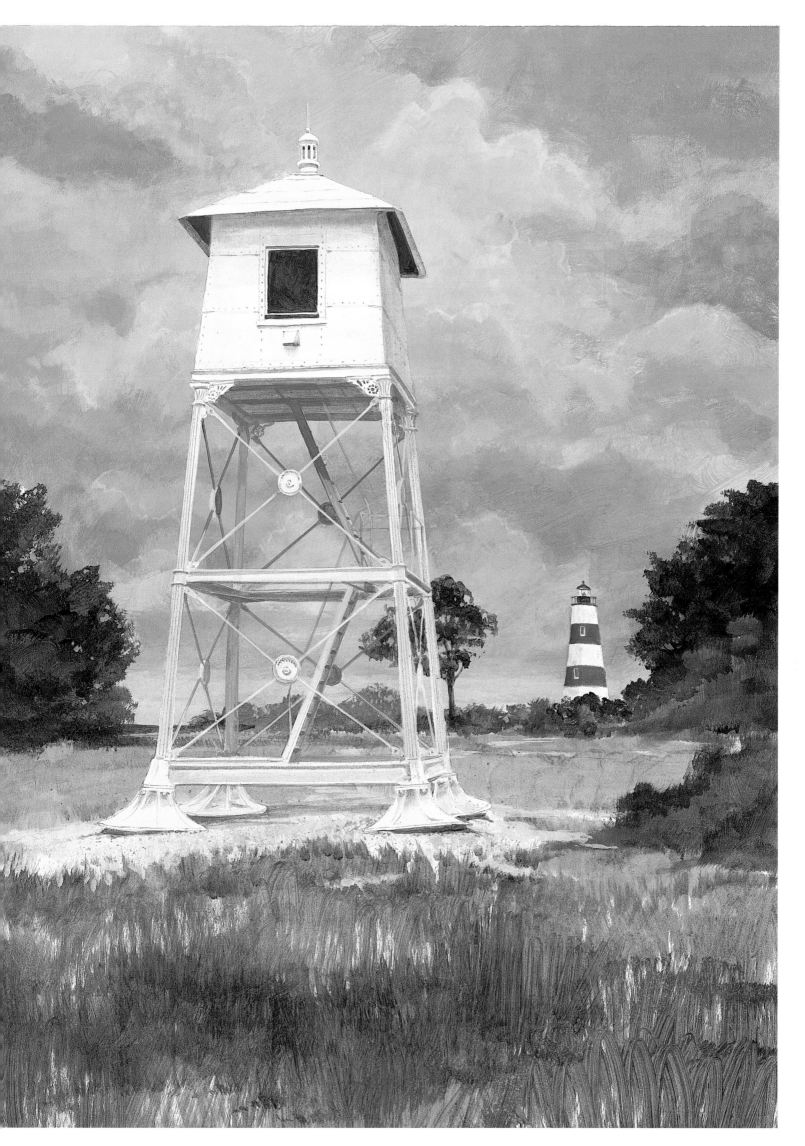

Another stop on the island is the plantation mansion built in the Jefferson Monticello style by Thomas Spalding. He ran the plantation from 1807 until 1861. His four hundred slaves not only built the house but also worked the fields of rice, sugar cane, indigo, and cotton. The house was vandalized during the Civil War and fell into ruin, but it was partially restored in the early 1900s. An executive from the Hudson Motorcar Company named Howard Coffin bought the island in 1912 and rebuilt the mansion almost from the ground up, changing the motif to a Spanish-Mediterranean style and adding an indoor pool and other rooms. Then in 1934, tobacco heir Richard J. Reynolds purchased Sapelo Island. He owned it until 1964, updating the house as the years went on. Now known as the Reynolds Mansion, or the "Big House," as it's called by local residents, it, along with most of the island, is owned by the state.

The mansion's thirteen bedrooms will accommodate twenty-nine people, and overnight rooms are available to visitors. You must register for at least two nights, and it's suggested you book at least six months in advance. The cost is $125 per night per person (includes meals); no children under eighteen are allowed. It's not your casual, drop-in sort of hotel, and if you decide you can't make it, your required $500 deposit is not refundable. If you can possibly stay there, I would certainly recommend it.

The alternatives are a few guest houses on the island owned and run by residents. They supply only the essentials, and you have to bring all your own food. Camping is another alternative, but three months' advance reservations and a two-night stay are necessary.

This is the mansion where the privileged few lived, back when slaves worked the island. Now it serves as a hotel for visitors.

Of all the places I've visited for this book, Sapelo Island is unique for its natural beauty and atmosphere. You can just feel a sense of the tranquility, tradition, hardships, and spirituality that have so long been a part of this special island.

When exploring the island, I ran across this old steam boiler and threshing machine wasting away in the weeds.

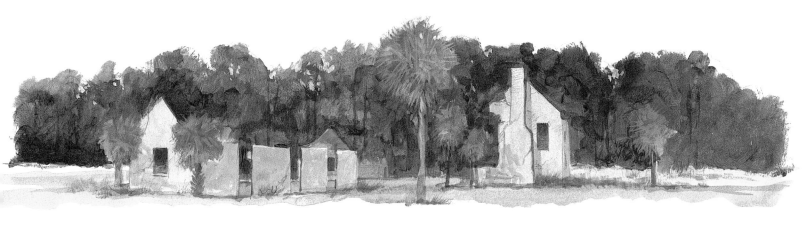

Other places of interest on the island include the "Chocolate Plantation." Built around 1819, it was a cotton plantation and got its name from a Guale Indian village on the island named Chucalate. The slave houses still stand today. The thick walls of tabby have held up for these many years. Tabby was made by burning oyster shells over a grate; the heat turned the shells into a powder and made lime. When mixed with equal parts of sand, water, and broken oyster shells to give the substance extra body, this lime substance turned into the equivalent of cement. It was used extensively in building many homes during that time.

Another important aspect of the island is the University of Georgia Marine Institute, established in 1934 by Richard Reynolds. Its facility on Sapelo Island has seven full-time scientists, many visiting researchers, and thousands of students who investigate and study the salt marshes, barrier island ecology, and wildlife. The facility operates year-round, and its studies are ongoing.

The tabby walls of the "Chocolate Plantation" still remain as a reminder of times when slaves lived here and worked the soil.

Sapelo Island's beauty is like a natural diamond, with its many facets representing everything from its culture and history to its wildlife. It is one of the few places that has not been altered to accommodate the whims of visitors who always seem to hunger for plastic gratification.

The only way to visit this remarkable island is by ferry boat. It runs only a few times a day starting at 8:30 A.M., and the tours run only three times a week. You can get information about Sapelo Island, as well as ferry tickets, at the Sapelo Island Visitors Center at Meridian, Georgia, where the ferry leaves the Meridian Ferry dock to go to Sapelo.

What years ago was a dairy barn is now the University of Georgia Marine Institute.

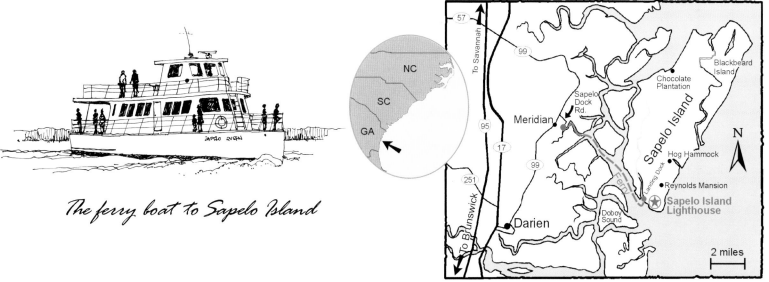

The ferry boat to Sapelo Island

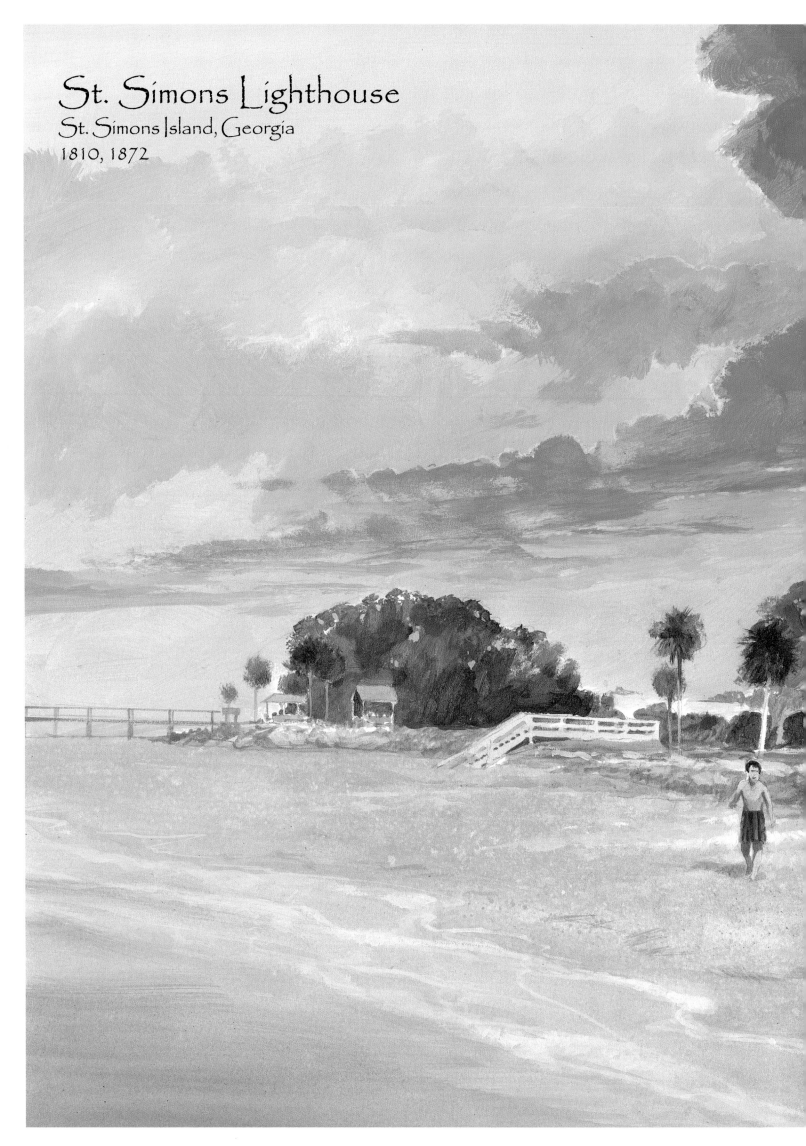

St. Simons Lighthouse
St. Simons Island, Georgia
1810, 1872

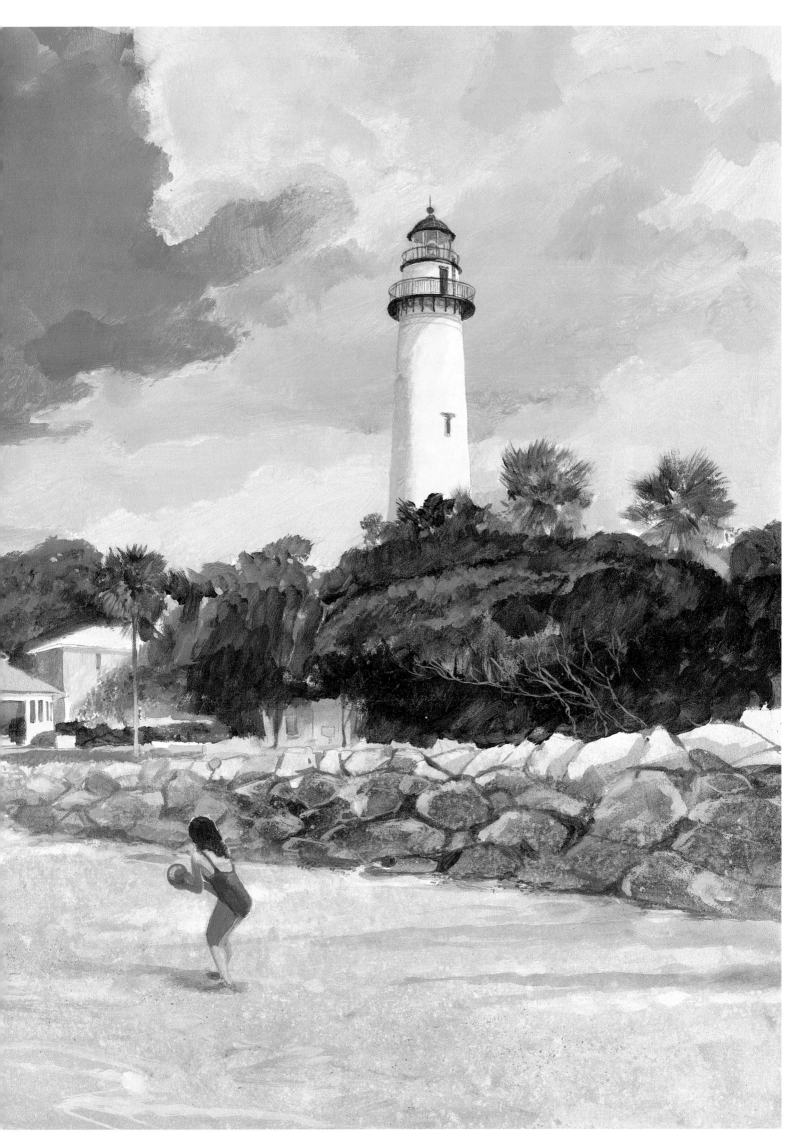

There have been two lighthouses on St. Simons Island guiding ships into the ports of Brunswick and Darien. The first, built in 1810, was made from a material called tabby, a mixture of lime, water, sand, and oyster shells. Nearby Fort Frederica, built in 1736, was in ruins, and the tabby was taken from the fort and used in the construction of the lighthouse. Upon completion of the lighthouse, the contractor applied for the position of lighthouse keeper and got the job, along with the four-hundred-dollar-a-year salary that went with it. For twenty-seven years, he remained there tending to the lighthouse. In 1862, the well-kept, seventy-five-foot-tall octagonal lighthouse ceased to exist when the Confederates thought it was a good idea to dynamite the tower and keeper's house. An excavation of that site took place in 1974.

In 1872, the present lighthouse was completed. Standing one hundred four feet high, it was built just a few hundred feet from where the first one stood. Construction wasn't an easy task, not only because of the normal hardships of getting supplies when needed or the lack of communications back then, but also because of several stagnant water ponds in the vicinity. Some of the crew died of malaria and never saw the completion of their work.

The original third-order Fresnel lens is still there in operation as it shines its light out to sea for a distance of eighteen miles. The sturdy keepers' house, designed to withstand the worst of storms, has walls that are twelve inches thick. It housed the keeper, assistant keeper, and their families. This was a typical living situation during that time, but later lighthouse builders built a separate house for each family. This one-house-two-families situation didn't always work out very well and often caused trouble. In March 1880, an argument between lighthouse keeper Frederick Osborne and his assistant left Mrs. Osborne a widow. After this incident, the central staircase was removed in the early 1900s, and additional stairs were put on the outside to better accommodate other families and put some space between them.

The lighthouse saw its last full-time keeper in 1950, when it became automated. Twenty-five years later, the Georgia Historical Society lovingly restored the lighthouse and opened it up for the public to enjoy. Today the central staircase has once again been reinstalled in the house, and when you visit you can view a short video about the lighthouse, enjoy the period furniture in each room, and then walk the one hundred twenty-nine steps to the

The architectural details are what make the St. Simons Lighthouse so attractive. I wish that people today would take such care with the design of buildings. It helps one feel a respect for our quality of life and our surroundings.

The furniture in the house is simple, stout, and functional, yet it still has a sense of timeless style.

top for a great view of both St. Simons and Jekyll Islands. Just beside the lighthouse, there is a handsome hard-sand beach where everyone seems to enjoy a stroll or a bicycle ride. A large gazebo, ideal for getting out of the sun, was also built between the beach and the lighthouse. It's an enjoyable place to soak up the atmosphere of the island. The lighthouse is open Monday through Saturday from 10 A.M. to 5 P.M. and Sunday from 1:30 to 5 P.M. It's closed on some holidays. The keepers' house also has a book and gift shop.

One of the most beautiful lighthouses anywhere in the South, St. Simons stands like a jewel on the beach and is certainly worth visiting. There are plenty of places to stay in the area, and if you find St. Simons a little pricey, Brunswick has more reasonably priced motels. Jekyll Island, just to the south, is also a wonderful place to spend some time. Its historic hotel is a great place to stay or just have lunch. Surrounding the hotel are many large summer homes once owned by wealthy families. Some of those homes are open to the public, and others have been converted into shops and an art center. This whole area is rich in natural beauty and historic interest.

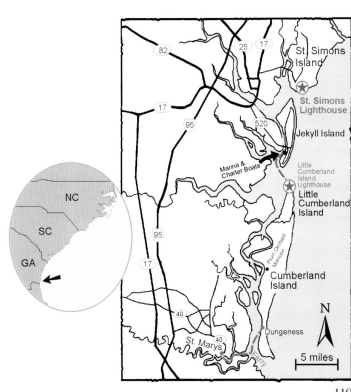

Little Cumberland Island Lighthouse
Little Cumberland Island, Georgia
1838

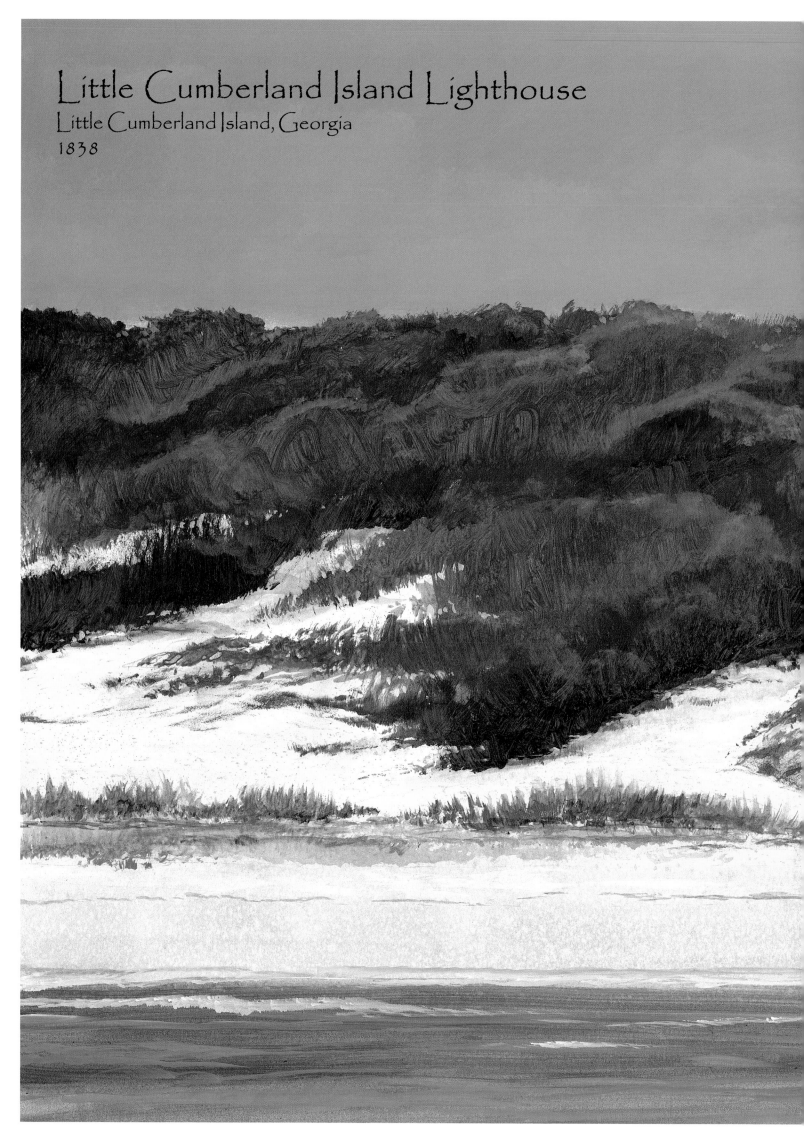

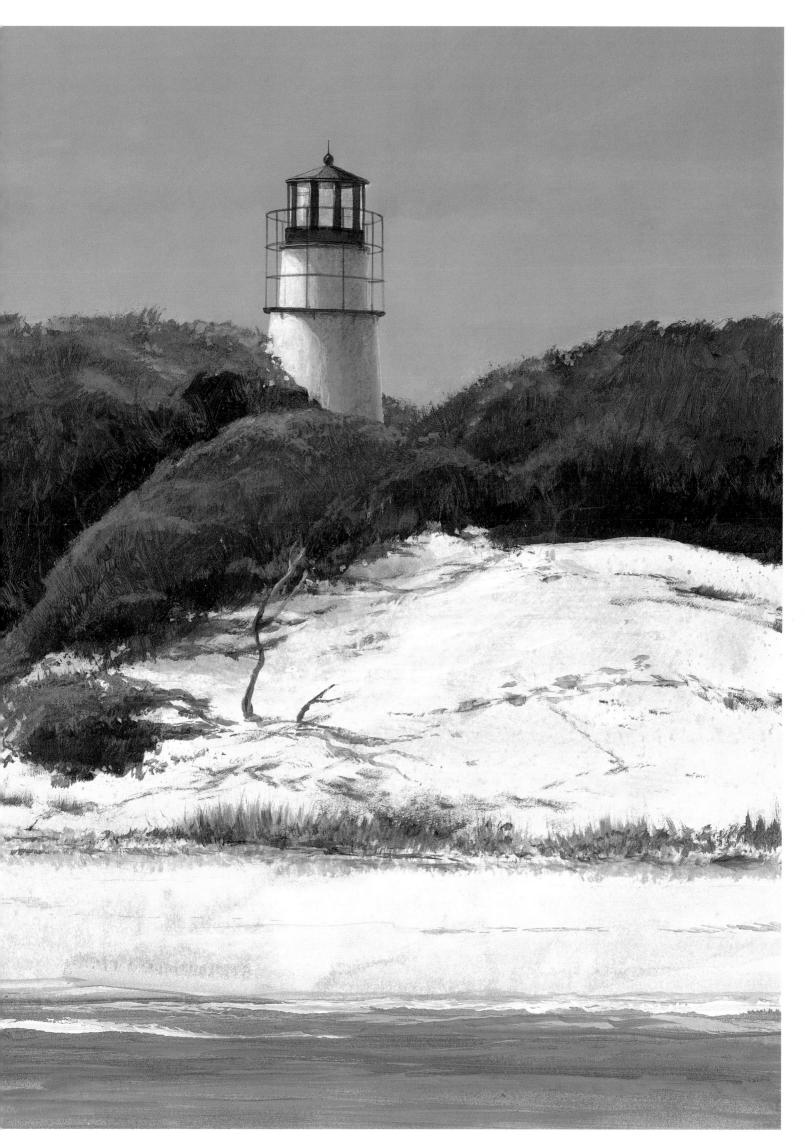

Cumberland Island and Little Cumberland Island are split by a narrow winding saltwater pass called Christmas Creek, which runs from the ocean through the marshlands on the inland side of the islands. Cumberland Island is owned by the state, and Little Cumberland is privately owned. The lighthouse sits at the very northern tip of Little Cumberland Island and looks over towards Jekyll Island. It's the last lighthouse on our trip and the most southern lighthouse in Georgia. Originally called the St. Andrews Lighthouse, as it faces St. Andrews Sound, the name was changed after the Civil War. The lighthouse stands only sixty feet high and has been out of service since 1915. Hidden behind a large sand dune, only the top part of the lighthouse can be seen from the shore. If the dunes roll over any more from the blowing sands, the lighthouse will disappear in the dune itself. When I was there the towering dune was almost touching the door of the lighthouse, waiting to engulf it.

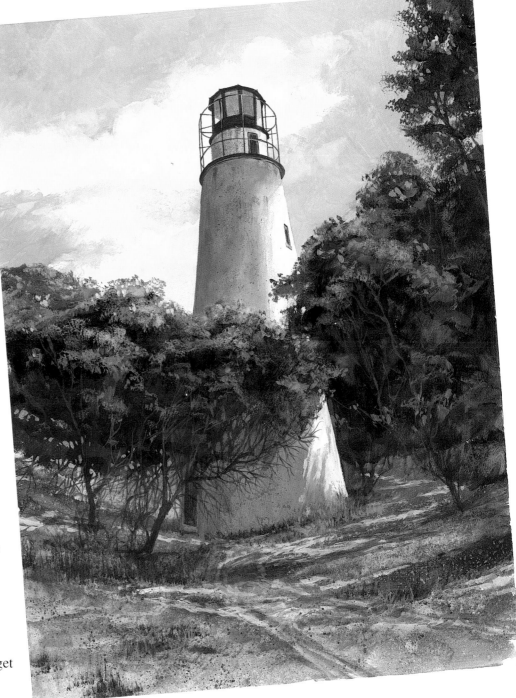

This is not an easy lighthouse to get to. First of all, the entire Little Cumberland Island is private property, and from my experience, it's just about impossible to get permission to walk up to the light. It isn't far from the shore, however, and anyone is free to stroll the beach up to the high-water line. This will put you within a couple hundred feet of the light.

You have to be a fervent lighthouse enthusiast to want to visit this one. Really, the only way to get there is to charter a boat, although you can see the lighthouse from the southern end of Jekyll Island. A marina just to the right as you enter over the bridge to Jekyll Island has several private boat charters available. We hired a captain and boat and, after visiting the lighthouse, took a delightful tour to the northern end of Cumberland Island. There we visited an abandoned mansion called the Plum Orchard, built by Lucy Carnegie for her son George. We enjoyed the marshlands and viewed the wild horses, turkeys, and nesting ospreys along the way. It's

Many lighthouses have become endangered because of beach erosion, but the base of this one is more likely to be swallowed up by large sand dunes that loom in front of it. Only from the back can you see the entire structure.

a delightful way to spend a few hours and will make a charter trip to the lighthouse worthwhile. If you have your own boat, there is a public boat ramp just a little south of the marina, but the pass between Jekyll and Little Cumberland is very rough most of the time so use caution.

The lighthouse at Little Cumberland Island wasn't always the southernmost lighthouse in Georgia. Another lighthouse was placed on the southern end of Cumberland Island in 1820 and was in service for eighteen years. It still exists but not where it was originally built. You'll have to drive down to Amelia Island, just across the border in Florida, to see it. The entire brick lighthouse was dismantled and

moved there. Cement was not as tough then as it is today, and the mortar between the bricks was easier to chip apart. I still can't imagine disassembling a tower some seventy feet high with five-foot-thick walls and moving it piece by piece, but that's what they did. It is the northernmost lighthouse in Florida and still operates today.

Even among the scrub brush along the beach, life abounds as a newborn bird emerges on its first day out of the nest.

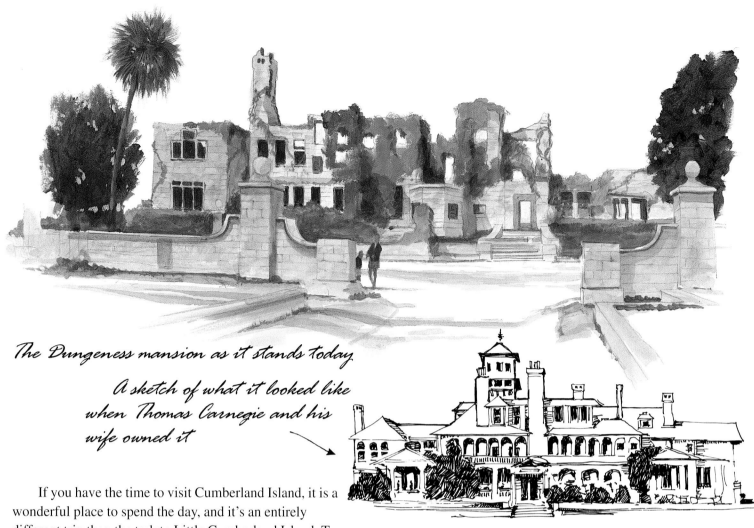

The Dungeness mansion as it stands today

A sketch of what it looked like when Thomas Carnegie and his wife owned it

If you have the time to visit Cumberland Island, it is a wonderful place to spend the day, and it's an entirely different trip than the trek to Little Cumberland Island. To get to Cumberland Island, visitors take a forty-five minute ferry ride from St. Marys. Once there, you can see wild horses, deer, wild hogs, and turkeys as they freely roam the unspoiled forests. Huge century-old oak trees line the dirt road that leads to the sixty-room mansion called Dungeness, once owned by Thomas and Lucy Carnegie. It was constructed mainly of tabby, like the slave houses at Sapelo Island. Burning oyster shells over a grate turned the shells into a powder to produce lime. When mixed with equal parts of sand, water, and broken oyster shells to give the substance extra body, this lime substance made a hard durable mixture and was the equivalent of cement. Tabby was used extensively in building many homes during that time. I once asked the author James A. Michener what he thought the most important invention of all time was, and he told me that he would have to say cement. At first I thought that was a strange response, but cement and its cousin tabby have indeed made a huge impact on the quality of life for everyone.

The mansion now stands in ruins after an arsonist burned it down in 1957, leaving only the tabby walls and stone work as a reminder of what a magnificent house it once was.

Unlike the mansion that was built of tabby, the recreation and bachelor complex next door to the mansion was built of wood. From what remains you can just imagine what a grand lifestyle the people here must have enjoyed.

A row of antique cars lay rusting in tall grass as a reminder of that passed era.

A complex next door to the mansion was also a splendid affair. Made of wood instead of tabby, it was once the place where guests could enjoy indoor swimming, a squash court, and billiards, get their hair done with a private beautician, or take advantage of the services of a full-time doctor. The recreation complex also doubled as a bachelor complex for those unmarried men who stayed at Dungeness for several weeks. It never burned down like the mansion but lies in ruins nevertheless, having totally collapsed from years of neglect. Even these remnants gave me a sense of awe and wonderment at what a truly grand place this must have been for its owners and visitors of the time. To know that this entire self-sufficient community was built on a remote island so many years ago is even more incredible.

Starting in 1880 and lasting forty years, three hundred servants and caretakers made this paradise a reality, raising their own vegetables and livestock, tending the fruit trees and flower gardens, and maintaining the carriage house, machine shop, carpentry shop, and commissary. The large carriage house and some of the smaller buildings still remain, such as the building that was used as a laundry for the many guests, and the ice house, where huge blocks of ice were brought down by rail from the North and then delivered to the island by boat. There the ice was stored and used throughout the summer. The task of creating this luxurious environment must have been a monumental undertaking, especially considering its remoteness. It all came to an end in the 1920s, when the owners either passed on or found other interests. Other mansions survive on the island, some privately owned; others, such as the Plum Orchard, remain intact but empty and in need of repair. The park service has left most of the structures to take their natural course of decay, and as a result they are beyond any type of repair or restoration. A few of the buildings have been maintained and restored. It is a wonderful mix of history that can only lead visitors to marvel at how life must have been back in a time when this was once a self-sufficient community built to serve a handful of remarkably rich owners.

Park rangers guide visitors on a walking tour of the island that lasts about an hour or so. Visitors are also free to explore on their own or trek over the dunes to spend time on the long expanse of beach. Camping is also available. Only three hundred people are allowed on this twelve-by-four-mile island daily, so it's never crowded, making the experience even more unique. If you want lunch or a snack, you have to bring it yourself. There is not so much as a soda machine on the entire island and not even a trash can. You take over there what you need and bring back the remains. A respect for the island seems to be honored by everyone visiting. More places should be like this.

The ferry to Cumberland Island leaves at 9:00 A.M. and 11:45 A.M. daily. From October 1 to March 1, the ferry doesn't run on Tuesdays and Wednesdays.

There are about 250 feral horses that roam freely on Cumberland Island.

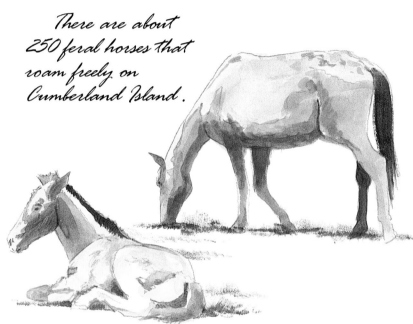

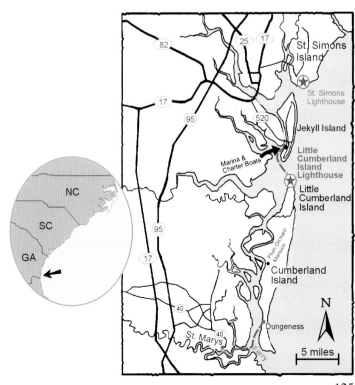

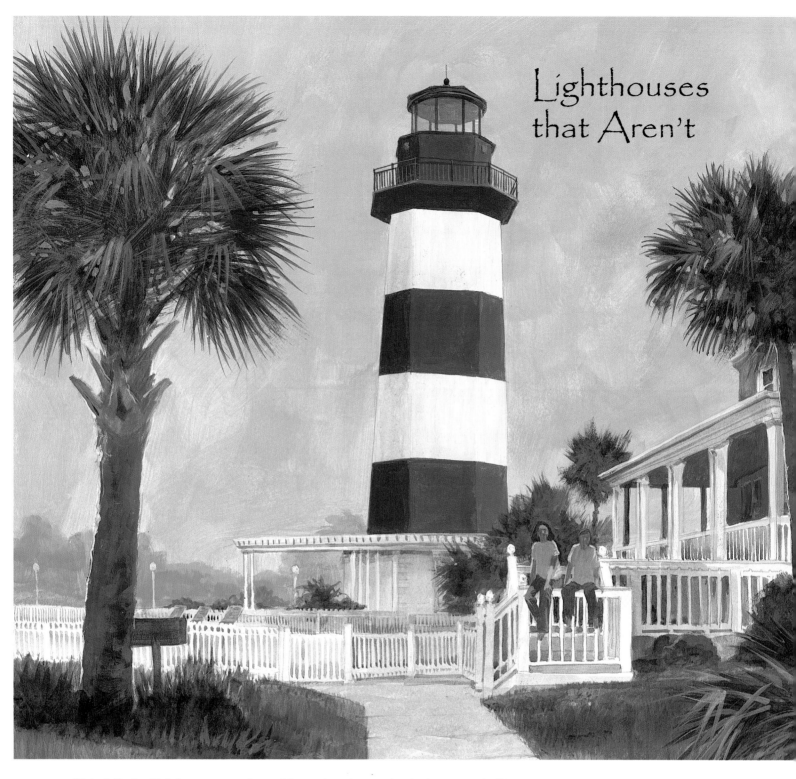

Lighthouses that Aren't

This full-size lighthouse, complete with a swimming pool at its base, was built to steer buyers into a residential community called Lightkeepers Village off Route 17 in Little River, South Carolina, about twenty miles north of Myrtle Beach. Shops here are full of lighthouse lamps and other decorative items, but some choose to make their own statements, such as with the cement mailbox below.

Lighthouses, in addition to being aids to navigation, have ultimately been an aid to commerce as they guided ships delivering goods. The image of that guiding light also helps to guide tourists and buyers. With the romantic notions of lighthouses we all seem to have, it's no wonder that businessmen have taken advantage of this magnetic and powerful image.

Timeline

Here's what was going on in the world when these lighthouses were built.

*Red denotes existing lighthouses

1732	Ben Franklin publishes *Poor Richard's Almanac*
1736	**Tybee Island (first lighthouse)**
1742	**Tybee Island (second lighthouse)**
1767	**Morris Island (first lighthouse)**
1769	James Watt patents the steam engine
1770	Ludwig van Beethoven is born
1773	**Tybee Island (third lighthouse)**
1776	Declaration of Independence is signed
1783	First manned balloon flight by the Montgolfier Brothers
1788	Georgia becomes the fourth state
1788	South Carolina becomes the eighth state
1789	North Carolina becomes the twelfth state
1789	George Washington is elected president
1790	Ben Franklin dies
1791	**Tybee Island (fourth lighthouse)**
1795	**Bald Head (first lighthouse)**
1798	United States Navy is established
1799	George Washington dies
1801	**Georgetown (first lighthouse)**
1803	**Cape Hatteras (first lighthouse)**
1804	Lewis and Clark expedition
1810	**St. Simons (first lighthouse)**
1812	War of 1812 between the US and Great Britain
1812	**Cape Lookout (first lighthouse)**
1812	**Georgetown (second lighthouse)**
1815	Battle of Waterloo
1817	Henry David Thoreau is born
1817	**Bald Head Lighthouse**
1820	**Sapelo Island Lighthouse**
1823	**Ocracoke Lighthouse**
1825	Erie Canal completed
1827	**Cape Romain (first lighthouse)**
1830	First railroad in America
1837	**Morris Island (second lighthouse)**
1838	**Little Cumberland Island Lighthouse**
1838	Cherokee Indians forcibly removed from Appalachian Mountains
1844	Bahá'í Faith established
1845	Florida becomes the twenty-seventh state
1848	**Bodie Island (first lighthouse)**
1848	**Cockspur Island (first lighthouse)**
1849	**Price's Creek Lighthouse**
1857	**Cockspur Island Lighthouse**
1858	**Cape Romain Lighthouse**
1859	**Bodie Island (second lighthouse)**
1859	**Cape Lookout Lighthouse**
1859	**Hunting Island (first lighthouse)**
1859	Charles Darwin publishes *The Origin of Species*
1861	Abraham Lincoln becomes president
1861	Civil War begins
1862	*Merrimack* sunk while in battle with the *Monitor*
1863	Henry Ford is born
1863	Lincoln delivers Gettysburg Address
1865	Civil War ends
1867	**Georgetown Lighthouse**
1867	**Tybee Island (fifth lighthouse)**
1869	Union and Central Pacific Railroads meet in Utah, joining east and west
1871	**Cape Hatteras Lighthouse**
1872	**Bodie Island Lighthouse**
1872	**St. Simons Lighthouse**
1873	**Haig Point Lighthouse**
1875	**Currituck Lighthouse**
1875	**Hunting Island Lighthouse**
1876	**Morris Island Lighthouse**
1877	Edison invents the phonograph
1878	U.S. Life Saving Service established
1881	**Hilton Head Lighthouse**
1882	Edison opens first electric power plant
1883	Brooklyn Bridge completed
1883	**Bloody Point Lighthouse**
1885	First practical automobile is built by Carl Benz
1885	George Eastman markets his first camera
1886	Statue of Liberty dedicated
1887	**Roanoke River Lighthouse**
1889	Eiffel Tower built
1892	Ellis Island established for immigration processing
1898	Spanish-American War begins
1901	Theodore Roosevelt becomes president
1903	Wright Brothers' first flight
1904	Subway construction begins in New York
1905	**Sapelo Island (second lighthouse)**
1908	Ford Model-T goes into production
1913	First talking picture
1914	World War I begins
1915	U.S. Coast Guard established
1920	Women win the right to vote
1920s	Commercial airlines begin operation
1931	Empire State Building completed
1937	Hindenburg explodes
1948	Roger Bansemer is born (that's me)
1950	Korean War begins
1958	**Oak Island Lighthouse**
1962	**Sullivan's Island Lighthouse**
1966	**Diamond Shoals Lighthouse**
1966	**Frying Pan Shoals Lighthouse**
1969	Neil Armstrong is first man to walk on the moon
1970	**Harbour Town Lighthouse**

Index

See table of contents for main lighthouse entries.

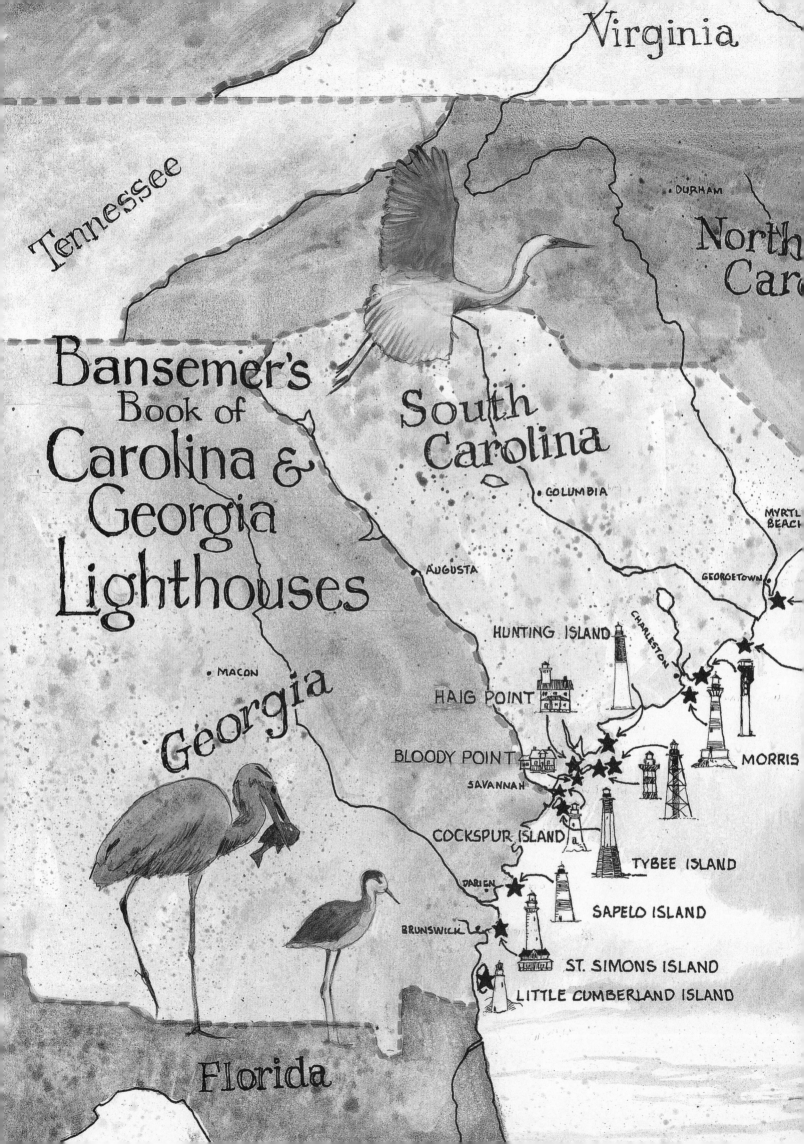

Virginia

Tennessee

North
Caro

• DURHAM

Bansemer's
Book of
Carolina &
Georgia
Lighthouses

South
Carolina

• COLUMBIA

MYRTL
BEACH

Georgia

• AUGUSTA

GEORGETOWN

• MACON

HUNTING ISLAND

CHARLESTON

HAIG POINT

BLOODY POINT

SAVANNAH

MORRIS

COCKSPUR ISLAND

TYBEE ISLAND

DARIEN

SAPELO ISLAND

BRUNSWICK

ST. SIMONS ISLAND

LITTLE CUMBERLAND ISLAND

Florida